# MAKING IT

# MAKING IT

## THE ARTIST'S SURVIVAL GUIDE

### JAŠA
#### with Noah Charney

ROWMAN & LITTLEFIELD
Lanham • Boulder • New York • London

Published by Rowman & Littlefield
An imprint of The Rowman & Littlefield Publishing Group, Inc.
4501 Forbes Boulevard, Suite 200, Lanham, Maryland 20706
www.rowman.com

6 Tinworth Street, London SE11 5AL, United Kingdom

British Library Cataloguing in Publication Information Available

**Library of Congress Cataloging-in-Publication Data**

Names: JAŠA, 1978– author. | Charney, Noah, author.
Title: Making it : the artist's survival guide / JAŠA, with Noah Charney.
Description: Lanham : Rowman & Littlefield, [2021] | Includes index.
Identifiers: LCCN 2021005848 (print) | LCCN 2021005849 (ebook) | ISBN
  9781538141991 (paperback) | ISBN 9781538142004 (epub)
Subjects: LCSH: JAŠA, 1978- | Artists—Slovenia—Biography.
Classification: LCC N7255.S563 J37 2021  (print) | LCC N7255.S563  (ebook)
  | DDC 700.92 [B]—dc23
LC record available at https://lccn.loc.gov/2021005848
LC ebook record available at https://lccn.loc.gov/2021005849

I dedicate this to you.

I dedicate this to you,

~~I~~ this book

I dedicate this to you.

# CONTENTS

CONTENTS

# INTRODUCTION

## The Art of Wire Walking: Career Making Versus Making Art

Did he crash back down to earth after he jumped, or did he linger up there in the air?

That may well be what you asked yourself when you saw the cover of this book. I know I did when I saw that photograph as part of my research, prior to my first meeting with Jaša. As an American art historian living in Slovenia, I was keen to interview an artist about whom I'd heard much, but whose work I didn't know.

As a specialist in Old Masters, contemporary art is out of my comfort zone, and I approach it with some reserve (and occasional eye-rolling). At least I used to. The time I spent with Jaša helped open my eyes to and deepen my appreciation for contemporary art that may not adhere to the traditional demarcations of greatness: that a work of art must be beautiful, interesting, and "good," as in exhibiting evident skill. That's how Aristotle defined great art in *On Poetics*. He was referring to poetry and drama, but during the Renaissance, his tripartite definition was applied to fine arts. Traditional art has sought to fulfill these goals. But in 1917, Marcel Duchamp, possibly in collaboration with Baroness Elsa von Freytag-Loringhoven, promoted a factory-made urinal, turned on its side and signed with an invented artist's name, as a great sculpture called *Fountain*. From that point forward, art split in two: the traditional and the conceptual. In the latter, art no longer needs to be beautiful or exhibit skill; it need only be interesting. I'll admit that I'm a passionate admirer of the former—I study Renaissance, Mannerist, and Baroque painting in Flanders and Italy. I respect the Duchampian path, but I like relatively little that I've encountered upon it. I had an open mind but little experience swimming in conceptual waters—until I met Jaša.

Jaša, like so many artists whose work could be described as conceptual, was trained in traditional methods and techniques and is entirely capable of executing classical-style art if he so chose. He simply prefers to do something more complex and multifaceted, focusing on site-specific installations, many of which have painting, sculpture, and architectural components to them, as well as performances. In his case, it's not a question of either traditional or conceptual: It's an alchemical cocktail of both. Now that's interesting. His work is also very often objectively beautiful, and I've seen the skill required to produce most aspects of his final creations. Duchamp would approve, but so would Aristotle.

Jaša (pronounced "ya-shah") was born in 1978 in Ljubljana, Slovenia—still part of Yugoslavia until Slovenia's independence in 1991. His parents were progressive 1960s hippie intellectuals, which makes him part of the generation that experienced the enlightened socialism of the 1980s that soured into the biggest tragedy of contemporary European history, the Balkan War. At the end of the millennium, he packed his things and went to study in Venice at Accademia di Belle Arti, to get lost in the narrow streets and canals of the city on water, but mostly to get lost in art. From his student years onward, he made a significant mark and continued to do so after he moved to Ljubljana and, later on, to New York.

Jaša has opened my eyes to a new way of looking at art: from the inside. I'm an art history professor, author, and cultural commentator. I *am* the outside, looking at what artists produce. While I've read historical accounts of the lives, training, and practices of artists, I've never had the chance to really step behind the curtain. My innumerable conversations and subsequent friendship with Jaša allowed me to do just that.

This led to our decision to write a book together. It wouldn't be a classic success story, told from on high, retrospectively, at the end of a gold-plated, champagne-soaked ideal of a successful contemporary artist. In his days walking the Accademia di Belle Arti in Venice in acrylic-stained jeans, he sought someone to show him the ropes, to answer his myriad questions about how it all works beyond the academy walls. He wanted a master illusionist to teach him how the tricks are done out there, in the field. Revealing their secrets doesn't detract from the magic; in fact it enhances it, and the admiration for the art. So many artists feel that, because they were self-made, they need to keep what they know to themselves, so as not to reveal their mistakes and to oblige younger artists to travel the tortuous path that they walked, while they observe from afar. It doesn't have to be that way.

He couldn't find anyone and had to learn on his own, alongside his peers, which led to the keystone of his work and this book: collaboration. From your

perspective in a gallery admiring the show, art appears to be utopian, projecting a world as it should be. But behind the curtain, it's one of the nastiest, dirtiest arenas you could imagine, a dog-eat-dog world. It's not about one-liners; it's about unveiling the multifaceted thought process behind the scenes that pushes us to act in certain ways. I'm also approaching this from the side of the audience, as an art lover and as a critic.

Between the two of us, you have the bases covered for this in-depth handbook for rising artists. We hope it will offer an engaging story of one artist's trials and triumphs, but what is most important is that this book is more than an artist's (auto) biography. Universal questions come to the surface as Jaša tells his story, and so we've included questions and his answers throughout the narrative.

There's a long tradition of this—top artists throughout history always ran studios and had assistants and apprentices, whom they would teach and groom to become, eventually, masters of their own studios. So this book is an ideal guide for the contemporary incarnations of those assistants and apprentices, today's students and aspiring young artists. As Jaša describes, the lessons contained here are "something I hoped and looked for, when I was climbing up, and found the art world so inexplicably hard to decipher. I couldn't figure out why the hell nobody wants to talk about how it really goes."

We originally got together when I thought to write an article, a sort of top-ten list of how to make it as an artist. But in conversation, we agreed that such a list does not exist. Making it as an artist is far more complex, individual, messy, and more interesting than that clickbait template implies. For this, we needed far more than a column's worth of space—we needed a book.

Jaša is also wonderfully eloquent, and it's easy to see why he's a popular teacher and mentor. He was brimming with practical and witty advice, born of his own experience, to pass on to others. He just needed someone to ask the right questions and provide a broader platform to explain it all. So we got the idea to do a book together.

And here we are.

This book presents portraits of the process, a tome of life-smoothing pieces of advice for younger artists, students, and early career professionals, as well as for anyone who is interested in what life is like for a successful contemporary artist and how they got there.

It's a continual balance, a wire walk between making art and making it. "Making it" remains in the present active. Even when you feel that you've made it, you're still making it, because the day after you've made it you've got to start again, to keep moving forward. Being an artist is a process without end.

How can you avoid pitfalls and have the best chance of succeeding in the art world? How can you survive and even thrive? We'll explain it all, answering the key questions through Jaša's own story. It's time I passed the mic.

Now, who's got the first question?

—Dr. Noah Charney

\* \* \*

## HOW DO I BECOME A SUCCESSFUL ARTIST?

If you know how then put down this book and come find me. We'll have a couple of beers, exchange our knowledge, and then we'll both probably go back to being our stubborn selves afterward. Artists are selfish beasts, as are most humans, but we also thrive when exchanging ideas and backstage stories. The fact that we do talk to each other helps us along our path. This dialogue is what this book is all about. You'll take whatever advice suits you and apply it to your own career and life. I'm here to engage and give you whatever I feel might help you.

If there's any one secret that defines the way to "make it," I'd say it's the strength of our own stubbornness, our determination, our passion, all of it nearer to obsession than rationalized decisions. Once upon a time, I made a "rational decision" about what I should do when I "grew up" and it turned out to be a nightmare for me. Then I followed my "irrational" gut feeling and became an artist.

If you have that urge to make art and do not follow it, it will make you miserable, sooner or later. But how do you turn that into something practical? How the fuck do you make a living? As with most professions today, it's a gamble, a constant dance. Every new day, week, month, year brings new challenges, even if you've already "made it." And what you achieved yesterday can quickly become a thing of the past. Is it fair? No.

You love it, you hate it, it makes you queens and kings for a day and drops you in the mud the next. Maybe none of it affects you and your glide is smooth and steady—if that's the case, *definitely* come and find me and show me how not to ache. But from what I've seen and experienced, the reality is just the opposite. It's wandering through a madhouse the whole length of the path.

Earlier in my career I made a statement that will be familiar to many of you: that "art is fiction." I wrote that at the beginning of a project that would directly lead me to change my opinion of what I'd just stated. I now firmly believe that art is not fiction but that it generates realities. And the first one to live them out is you.

—Jaša

# 1

# ON ORIGINS AND
# EARLY YEARS

## Do I Need to Show Great Potential Early on to Have a Chance?

I saw the Sistine Chapel as a lively and restless five-year-old. I was a major pain in the ass for my parents. At one point, they stopped taking me to restaurants, as I kept trying to sneak over and grab one corner of the tablecloth, my eye level at the time barely higher than the cutlery as it lay there. Then I would pull the tablecloth, filled plates and brimming glasses and flatware and all, onto the floor. There I would stand, the contents of the table piled at my feet, shattered glasses and chipped plates and lots of food, the tablecloth now hanging from my enthusiastic hands. I did this a lot, until my parents realized that it was best if I stayed home when they went out to eat.

The trip to Italy was a gift for me, though my two sisters were grumpy about having been left behind for the first time. My mother, father, and I were off to Rome for the wedding of the black sheep in the family, my lovably deviant uncle. Walking into the Sistine Chapel was the zenith of a trip that made me who I am more than I ever could have realized at the time. It is what led me to live in Italy, to study in Venice, once the idea of becoming an artist had infected me to such an extent that I knew there was simply no other way for me to live.

I remember holding my mother's hand that day. I remember the crowd, the voices, the immensity of the chapel. What I remember most was the gloom of the veil of human flesh, the browns . . . it was before the chapel was famously restored to its current (and original) Day-Glo proto-Mannerist brightness. Back then it

appeared stained, as if coffee had been spilled down the walls. At that point, the prevailing brown associated with human bodies left an indelible mark on me.

It was the climax of the trip thanks to my mother, who had hyped it up in anticipation of the visit. She talked about this Michelangelo guy, an artist who had worked for years on it, high up against the ceiling, rarely washing, eating, or sleeping, but managing to achieve, in the end and against the odds, this incredible thing, the Sistine Chapel. Holding my hand inside the colossal space, she leaned down toward me and pointed out Michelangelo's self-portrait, hidden among his army of saints and devils, saying, "You see, Jaša, this is him. He painted himself as the loose skin that Saint Bartholomew is holding. That is his self-portrait. That's Michelangelo."

The only thing I remember afterward is absolute and utter terror and panic. It all started shaking, and I started screaming like mad. My father came running, and they took me out of the Vatican immediately.

On the way back home to Yugoslavia from the wedding, we stopped in Genoa. My mother took me into a church. Seeing the inside caused an even worse reaction in me, and my mother had to promise that I would never again have to go into any church. And so it was, for years.

I only recently managed to overcome this fear, as entering a church always causes an overwhelming emotional, and in many cases physical, reaction. I experienced a similar sensation as a twelve-year-old when I walked into a modern art museum in Vienna. It provoked a similar fear that I knew well from those past panic attacks in churches.

## DO I NEED TO HAVE SOME ORIGIN STORY TO BE AN ARTIST, AS IT SEEMS THAT MOST ARTISTS HAVE THEM?

As artists, we tend to mythologize our youth all the time. Am I an artist because I was born one? Was there some lunar movement that set me on my path? Was it because my parents blasted Mozart or Pink Floyd into my crib? Or was it the laughter and all the fights I overheard while unconsciously cocooning in my mom's belly that made me who I am today? Does our origin really have anything to do with it?

So many stories of great artists, dating back to Giorgio Vasari's 1550 *Lives of the Artists*—the first great biography of artists that helped establish how we in the modern world think of art, its history, and the people who create it—begin with some origin story of miraculous talent or deed in extreme youth. Sigmund Freud published a whole book analyzing Leonardo da Vinci and beginning with

Leonardo's earliest recollection of being attacked by a vulture while still in his crib. Vasari's biography of each artist begins with some early trauma or demonstration of artistic talent, so maybe it's his fault that we all look for such origin stories to explain why we want to become that strangest of professions, an artist.

Perhaps it was thanks to my father, a renowned psychiatrist, who took me to lunch during a visit home after having left to study art at the Accademia in Venice, saying, "You always were extremely problematic. Apart from being hyperactive, your behavior was, from an early age, borderline. It was clear to me that, if we did not take the right measures, you would end up as a criminal. Probably a very successful one, but a criminal. As that did not happen, I knew that a different option had opened for you. You had to channel your boiling energy. I knew that, if you could maintain your course, you could do something great."

I know exactly what you might be thinking at this point. Another case of a parental experiment. I *was* a wild child, hyperactive (as he would put it) and adorable but often a handful without a pause button (as my dear mother would put it). I knew exactly what he was talking about, so not only did it not come as a shock, it came at the right moment. I just did not yet know how to fulfill his prescient comment, but I felt that he'd helped reveal one of my hidden secrets. It was liberating, like I could jump out of my skin, scream my lungs out, make love to everyone, ride on a cloud, while tiptoeing along the edge of an abyss, that ecstatic, intoxicating notion of beauty.

I never thought of drawing as my talent, as it was simply the most natural thing for me to do. It was normal for me, as a kid, to use leftover cardboard to build houses, bunkers, and passages; to throw stones at puddles; and to plot the most irresponsible scenarios involving my younger sister.

First, I learned how to fake a fever from watching *ET*. Hold your thermometer up to a light bulb and, voilà, you can stay home from school! This was my chance to experiment with pyrotechnics. I was mostly interested in using acidic dyes and fire to watch my toys change form. It went like this: the moment I got a new toy, I'd disappear into my room, and the sounds of banging and screaming would emerge from behind the closed door. My parents were used to this, so they did not think twice about it—until, that is, I came out and showed everyone the altered version of the freshly gifted toy. I would show off the result, stating, "*Kilalu*"—my invented word for "changed," because the new toy would be smashed, sliced, ripped, melted, or otherwise mutilated.

Fire was my weak point. The *ET* method helped me stay at home alone, which meant that home, and all the materials and spaces within, became an open playground. We had two fireplaces, and these would be ignited in tandem. I would marinate stuffed animals in dyes, medicines, or chemicals I found in the

cupboard. I would stitch an arm from one toy to the body of another. I would set various toys on fire: some would blaze, others would melt. Soon enough, I infected friends with this enthusiasm of experimentation. Our apartment was part of a block with a shared playground, and I was a ringleader for my peers, initiating them in the design and implementation of fire experiments and building traps to ensnare imaginary enemies.

Unsurprisingly, sooner or later one of these experiments went bad. I was lucky, but our apartment was almost burned.

My parents invited a friend of the family, a plastic surgeon, to come over. I liked him, and sidled up, unknowing. He said that he understood my interest in how fire changes materials like plastic. But did I know how fire changes skin? He successfully spooked me into going straight.

My parents grew strategic in looking for ways to harness my energy and use it for good. I would later look back on my *kilalu* as the start of a later-developed creative process, but thank goodness my parents intervened, otherwise disaster would surely have ensued. Instead, my father got me focused on sports. My restless nature made me want to try out one after another. He insisted that I train in-depth in one sport. I'd been skiing since age five, and I had talent. I was offered the opportunity to train with the national team in my early teens. There was one incident that was truly unforgettable.

It started one morning in an overly warm and bouncy 1980s Yugoslav bus from Ljubljana to Krvavec, the nearest ski resort. I was sitting next to a girl I really liked, while a guy in front of me slowly peeled a hard-boiled egg. Not a good combination. I was never really good with bumpy rides and was feeling nauseous. That damned egg put me over the top. The only container-like thing I could barf into was my ski boot. Needless to say, it never really worked out with the girl. But there I was, getting off the bus with a barfy ski boot, and I was expected to compete.

The story doesn't end there. Standing, geared up, wearing a puke boot (the left one, as I recall) and waiting for the ski lift, a pressing need to answer the call of nature crept upon me. I decided on a classic pubescent option of not going to the bathroom, thinking, "Ah, I'll just go at the top of the hill." I made it from the larger ski lift to a second, one-seater lift, which was extremely, comically slow. I was practically taking a whiz out of my ears.

And then the lift stopped.

And it didn't move. For ages.

I had no choice.

All pumped up for the start of the most important race of the season, I lined up with pants full of pee and a puke-filled ski boot. I did rub some snow on my

pants so it would look like I'd just fallen—I was nothing if not classy. But there's one more twist to the story.

This was a Super G race, which meant that I had to slalom between pairs of flags. There was a portentous-looking pair of flags that I assumed marked the finish line. And just beyond them was a guy standing beside another pair of flags, with a stopwatch in his hand. Well, I zipped down the course and stopped at the finish line—at least, what I thought was the finish line. I was about a foot or two from the guy with the stopwatch. He looked at me like I was nuts and said, "Can you please cross the fucking finish line?" I did, and it turned out that even with that little hiccup, I came in third. I may have been an idiot, but I had talent for skiing. I was invited to train with the national team, but I declined.

While my father sought an outlet for me in organized sports, my mother took me to any possible art opening, museum exhibit, or cultural happening. She got me into drawing, first informally in the studio of an artist friend and later in classes. When I got out of school, my parents were still at work, so I had two options. I could go to my mother's architecture studio and she would set me up with colored pencils and paper and tell me to go at it. Or I could go to my father's office in the major psychiatric hospital of Ljubljana and watch his patients in the hallway. One of them was in the teen department. While the rest of the residents seemed "happy crazy" to me, the teens had this gloom, this darkness, about them. I remember them as hunched figures sitting on the sills of oversized windows, smoking. (In those days, everyone smoked indoors.) I remember my father approaching in his long, white doctor coat, a T-shirt and jeans underneath, and a cigarette ever-present in his hands (which he later swapped out for cigars) and a smile on his face.

During one of my visits to the clinic, we were seated in his office. It was sunny and warm outside, and I sat facing a large, open window. While the room was bathed in sunlight, my father sat on the edge of his desk, his back to the window, facing me. While we were chatting, I heard one of the strangest sounds I could imagine, followed by the sight of a young man "flying" past the window. The split second, that image of the window as a frame and the body zooming past it, downward, stuck with me. The jumper got away with just a broken bone (and he didn't look too happy about it).

My parents were hippies, letting me do my own thing. I was always good in school, until school became more of a competition, the looming final test (the dreaded *matura*) piling on the pressure, and I wasn't handling it well. By the penultimate year of school my marks were so bad that there was no way I would get into the high school I wanted to attend.

Without any external prompting, I took matters seriously. I trimmed away almost all extracurriculars, even playing with friends, and just studied. I saw that I was at a fork in the road. I could sense that our class was dividing along these lines, and it was time for me to decide where I would head.

In the summer of 1991, major shifts occurred in Yugoslavia. Slovenia declared independence and was involved in a short, ten-day war against the Yugoslav Army. We became a sovereign democratic nation, while the rest of Yugoslavia crumbled into a tragic ten years of fighting, ethnic cleansing, and devastation. We were teens, and this felt like it all came out of the blue. We had family and friends throughout Yugoslavia.

## IS IT TRUE THAT THE GREATEST ART EMERGES FROM UNHAPPINESS AND DYSFUNCTION?

At the beginning of high school, I was the exact opposite of what I'd been in elementary school. I grew quiet, introspective, shy, and buried in a laundry list of complexes, from low self-esteem to self-loathing.

One day while walking to high school, I was waiting for the green light at the crosswalk. When I stepped off the curb to cross, I felt this punch of nausea as I realized just how small I was in the context of the world. It was like an out-of-body experience, as if I could suddenly see myself from above, from as far back as the moon. The dark Mordor clouds slid into place over my head entirely. I was officially in my depressive teen phase.

I remember going through my own wardrobe and thinking, "Okay, what makes me special? What's my shtick?" That's when I remembered: I know how to draw. When I started again, everything was different. That borderline untamed, whatever-he-touches-turns-to-gold approach that I once had was long gone. I was oversaturated with newly gained knowledge, comparing myself to others in terms of grades and accomplishments, while I felt clouded, even suffocated, by my own ambition. But I picked up a pencil again.

When you embark on a mission to imbue each line with meaning, to have each line bear a weight, you eventually realize it's just impossible. The attempt to do so starts limiting you. This is what happened to me, and I had to learn the lesson.

Sometimes your whole life changes in a week, or in a cascade of moments; the tightrope walk between ups and downs. It's a constant effort to maintain the balance while you fight for acceptance and recognition to achieve all you can on your own during that early stage. Looking back, I now know that this

was my first encounter with a beast I had to grapple with in the mud-crusted pit many times later: depression. If, out of the blue, you rise to unimaginable heights, somehow you drop into the abyss too, right? Having my first break-through with my early work and simultaneously garnering the recognition of my peers and elders would rocket me into ecstasy. But the next moment, the bottom dropped from beneath my feet. Early on, I got to experience what it felt like to fall and unknowingly dwell in the abyss. And sometimes darkness, for its intoxicating strength, feels more meaningful—and that can be danger-ous, especially to yourself.

What saved me then was music. It came from a rediscovered old friend from primary school. High school saw us scattered among various institutions, but it was a period in Ljubljana of a punk renaissance, leading to grunge and Gen-eration X. This social scene opened a door for me, blasting Nirvana and Pearl Jam. It was one thing listening to that on my own, but what was far better was going out with friends, drinking beers and talking out our dreams. At the time, it was about the social dynamic, the vortex of punk, grunge, loose energy, too much beer, and cheap wine fueling passionate talks about art and music and what we should be doing *now*. That shift from future tense to present, making ideas an actuality, was new for me: urgent, critical, and life-altering. Fridays and weekends were times when idea and action unified. It might be a silly teenage notion, like taking a friend's car and driving to the beach, crashing at someone's parents' house, writing music and drinking the weekend away, but we would *do* it. Think it, then do it: a continuous burst of raw, creative energy. It didn't have to be great, whatever we concocted this way, but it had to happen. It was the opposite of my overthinking of every line.

## IS EXPERIMENTING WITH SUBSTANCES BENEFICIAL TO CREATIVITY?

For me, alcohol and drugs were never a taboo. My parents were constantly hosting dinner parties with the young bohemians, and wine was present in abundance. Drugs? I'm not talking about lines of coke on my living room coffee table, but marijuana and even LSD were common enough. If I was interested or curious to know more, my parents would engage with me about these sub-stances. So I had my first glass of wine at one of my parents' parties.

I remember calling my father to ask if it was okay to go to a party and sleep over there—it was the first sleepover party I'd ever been to. He just said to me over the phone, "All good, you're on your own. Have fun." He did not burden

me with the list of things not to do, which I would probably have rebelled against. I was expecting such a talking-to, but instead, he shifted the responsibility onto me, and I felt ready to take it, to take my own chances.

In that period, due to a more acute self-awareness and that suffocating feeling of insignificance within the world, I wanted to fix a loose socket in my room. I was home alone, and within my overall numbness due to a proper and self-indulgent *weltschmerz*, the "world fatigue" of which Goethe wrote that seems so right on for the teen attitude and self-indulgent experience. Trying to move forward, I wanted to do something useful. It ended in an electrical shock that threw me across my room. I was lying on the floor for some time.

As a reaction to this, after I picked myself up again, bought myself a diary, and started filling it with pages and pages of automatic writing and occasional drawings—streams of consciousness to let what was inside of me pour out, the pressure to release. In that same week, a good friend of mine who was part of a band had a proper 1990s grunge party at his home. I had one or two too many, and as the world started spinning, the last image I saw that linked me to the real world was the green glow of 12:12 on a digital clock before I envisioned a forest on fire in the bathroom. What later on developed into a story (and a never-published book) was my reality that night. I followed a figure, a warrior covered in blood who had lost his most important battle, but not his life—not yet, anyway. What I wrote later on became my hidden manifesto.

This idea of a "warrior" was actually a projection of myself at the time. I was in this great school, surrounded by students who I felt were intellectual powerhouses (at least within the context of our teenage selves) and who had developed academic passions. I read loads of books in an attempt to keep up with schoolwork and with my peers. I had the good fortune of being athletic enough that I showed potential in each sport I tried: downhill skiing, rock climbing, basketball, tennis, shot put (I even won two gold medals—one of which I got while throwing the shot in my basketball uniform, as I'd come from hoops training), and, at this phase of my young life, fencing.

I was trying one sport after another and kept feeling like I was quitting, even as each coach encouraged me to drive deeper, choose only that one sport, and, if I worked hard enough, I might even compete at the national level. In that phase, I was experimenting with fencing and had this amazing, hard-core Russian fencing instructor—a proper old-school Russian: *The only tears will be tears from sweat and burning muscle.* He pulled me aside early on in the context of a group class, and said, "Look, you're too old for the normal course of training, but you've got a lot of potential. If you focus only on fencing, if you give it your all, we can really make something of you." Such conversations were,

at this stage, the best thing for my self-confidence, which was not very high. I was shifting from a strange, tablecloth-pulling, fire-loving, anarchic kid. I was still figuring myself out, but my ambition was blooming—it remained to be seen how it would manifest itself.

For about six months, I threw myself into fencing. The Russian coach worked with me one-on-one, and I could feel the progress I was making. But it was a time when I was still divided and uncertain where my main passion lay. My mother had just allowed me to use one of her architecture studios as my personal art studio. I was pouring myself into art, spending some nights in the studio after a working frenzy, and was splitting my time, energy, and passion between school, fencing, and art during the week.

During the same period, I started to work with another "coach," Tone Rački, who taught me drawing. He was an underdog outsider of the Ljubljana academic art scene, largely because he focused on teaching. Most artist-academics taught drama: I attended a lot of night classes where drunken art "teachers" would come in, wasted, screaming about what art is and what isn't, practically spitting on whatever you were making. Only when you were drowning in tears and sweat, and your drawing started to look like a cloud of smudged carbon, would they delightedly say, spitting booze breath in your direction, "Now you're getting somewhere."

Tone wasn't like that. In one of the first classes, he put a normal drinking glass on the table and said, "Draw this." There were about ten of us in his night class, and we threw ourselves into that drawing with everything we had. We were trying to embrace the whole world in this drawing of a glass. He was silently observing us until he stood up and shouted, "Everybody stop!" He looked around angrily and said, "What the hell are you doing?" I can't remember who found the courage to reply, but someone said, "We are trying to put ourselves into the drawing."

"This is the thing I don't get with every new young artist who comes my way," he erupted. "Why would you have to invest yourself in this drawing, when this is happening automatically during the process of drawing? Now forget about all that *trying* and just focus on the glass."

I wasn't flowing, and I knew it. What I realized after many weekends and nights spent drawing is that this hard work was the only way to get my expressive freedom back. I had to learn the basics, lay the foundations, to accept that drawing was rational and technical too. It showed me the strength of a conceptual understanding of expression and the value of getting the technique down. This helped me recall my childhood love for drawing and later opened my options in style and expression.

One day the Russian fencing coach sat me down and said, "You're spending less time training and more in your studio, aren't you?" I felt ashamed to admit it to him at the time, because I was disappointing him and, to some extent, myself. Yet again, I always seemed to circle back to art. "Then," he continued, "you should go and devote yourself to art. Now, never come back here again." That was the end of my sporting career. I was too busy being a young bohemian. I determined not to waste my passion in other, extracurricular diffusions, but instead bring the drive, sweat, focus, and discipline I learned from training in sport at a high level to developing my art. I was out of my depression phase. No longer a young poet, no longer a Romantic; I was in the proactive, hyperactive rebel phase. Drinking beer and hunching over my sketchbook took over from athletic training.

So that blood-painted warrior vision that floated up after too much postrock booze was some sort of athlete, primal spirit, rebel warrior, swordsman talisman that I realized I could harness and thrust into my artwork. I swapped the sword for a pencil and brush.

It was 12:12 for me from that point on.

## DO I NEED TO ATTEND AN ART SCHOOL IN ORDER TO BECOME A SUCCESSFUL ARTIST?

The end of my high school period featured concerts on the weekends; my first serious, formative relationship (with a girl called Nina); and my first art show, a dark and gloomy performance with a friend of mine. We came up with a guerilla publication of our poems and organized concerts that became events, happenings that combined a bit of everything: performance, music, poetry, installations.

How can one embrace all of that? I simply did not bother at the time, until I had to synthesize it. When I had to—when school ended and I was obliged to choose a single career-driven direction—I made a U-turn. I chose architecture.

I was convinced that everything I was doing, by then on a daily basis, could and should remain my secret passion and should *not* become my job. I passed the entrance exams to study architecture at the University of Ljubljana with flying colors. I entered the faculty as a promising future architect—a delight to my architect mother, of course.

Then came the first official architecture lecture of my freshman year. That was when it dawned—or should I say doomed—on me. It felt like my life was ending. In choosing architecture, the profession my mother had hoped I would

choose and that I felt everyone around expected me to choose, I had made a wrong choice, and there was no way I could change it.

Some say that good schools, if you can afford them, will throw you into a tighter selection pool, and that may be the case, but it will in no way guarantee your success. If you can afford to go to school, your path will be easier, that's certain. If your parents can support your studies and the long years of producing your art on your own, that is a gift, a blessing, a random lottery ticket that fell into your hands.

Whether or not you attend, it's important to be aware of the problem with "good" schools. Besides costing so much, they can cocoon you, offering you a beautiful "reality" that lasts for those four years only and does not prepare you for the dog-eat-dog realities of the art world beyond the campus. Do not mistake life and success at art school for life and success outside of it. The two are worlds apart.

In my experience, the "top" art schools (which are usually the most expensive) do not offer much more than others would. The best way forward is to find an institution that is affordable, but notable enough that your association with it will help you in applications for scholarships and grants, because you do need time to grow up and develop as an artist, and that can't happen if you have to work ten-hour shifts pulling pints.

The best art schools are open and loose enough for you to feel unsafe there. That may sound odd, but it is better for you in the long run, so you start chasing other options from the get-go, yet still find some guidance from professors who were not only big in the 1970s in some godforsaken style or movement but still have relevance and an understanding of the art world today.

Of course, you can become a successful artist without going to art school. But if you want to be a rebel, you need to know what you are rebelling against.

If nothing else, art school makes your starting years easier. You feel like you are part of the gang already, that you have been given the legitimate right to become somebody someday within this given field, the arts. Even if you do not attend a formal art school, you will need some form of training to have a base from which to depart. You have to learn somehow, and art school will be full of kindred spirits to inspire, befriend, repel, and otherwise provoke reactions and ideas within you—which is a good thing.

But a caveat: the worst thing is finishing school loaded with knowledge (and debt) but with no real hands-on experience of how the hell it works out there. For the rest, for all the other disciplines shaping the art world, there is really no school that is sleazy, dirty, and, well, *human* enough to get you ready for the

ride. So art school is good, but it doesn't really prepare you for being an artist. That takes work, failure, triumph, upset—all the good stuff and the shitshow that is real-life experience.

Dropping out of architecture and enrolling in an art academy seemed like an impossibility for me. The local academy was so impenetrable, postmodern, expressionistic, full of the drama-burdened and governed by mostly outdated artists who were looking for new mini-me's. I was aware of this at the time, but I didn't see another art academy as a possibility. Just the thought of entering that school was dreadful—that was not the environment I wanted—but even worse was the idea of not entering an art school at all, of feeling trapped in architecture.

I endured two months of the Faculty of Architecture and felt like a living corpse having to attend those classes. Leaving our apartment one morning, instead of turning right to walk to the faculty, I instinctively turned left to walk to my studio. That's when I decided that I had to follow the fine art path.

I stopped attending architecture lectures but didn't tell anyone. I was afraid of disappointing people, especially my mother. I was constantly in my studio, at all hours. One morning, my father stopped me and said, "Why the heck are you smiling?" He had been used to me in zombie mode going to architecture lectures and found my smile suspicious. So I confessed.

That night, he gave me absolution. He literally said, "Go for it." But in the morning, he and my mother had to confront me as a joint unit. Though I came to know it only later, my parents had just begun their own separation process and would be divorced not long after that. But at the time they made a show of solidarity. They sat me down and said, "Either finish your architecture faculty year and then transfer to the art academy, so you don't lose a year, or, if you decide to drop out now, we understand, but we will not support you financially. You need to earn your own money." I dropped out and moved out of my parents' home and started living with Nina.

I had to grow up quickly and realized that this was all on me. That was scary but also empowering. I managed to focus this energy into anger, and enough anger led to determination. It helped me muscle past my doubts. From that point on, I moved with purpose. I knew what I wanted to do.

I started waiting tables and doing dishes at a local café to make ends meet while I cooked up a plan. I later got a gig sketching archaeological findings at an excavation of a portion of the ancient Roman city of Emona, upon which Ljubljana is built. This work was no fun, but at least it involved a pencil in my hand, something paying me because I was good at drawing.

By that spring, my parents realized that I was locked in, focused on art, and they wanted to help me with the exams to get into the art academy. I went to a

new series of night classes at the academy, in addition to Tone's. These night classes were packed with those half-drunk, screaming artist-academics, still pointing at the gloomiest portions of our work, the parts we thought were mistakes, saying, "This is it! This is art!" My mother called up one of her friends, a painter called Šule, with whom I began to work in further classes. Tone had really helped me with my foundations in drawing techniques. Šule was different. His understanding of line, what a line should address and communicate to the eye of the viewer, was something new to me. If Tone's approach was conceptual, Šule was all about sensibility. His studio was beautiful, all gray and white, bathed in ideal light, otherwise completely empty. There was not one work on display, neither finished nor in progress.

He set up three chairs. I had to bring a friend as a model, a wooden board, and a stack of paper. We would all sit down, and he would say, "Start drawing." Šule showed me the importance of attention toward who (or what) I was drawing.

At the start, he was far from convinced that I could ever become an artist. Šule allowed me to attend three times. He didn't like what I was doing at all, but his wife insisted that he give me a proper chance. He showed me how to draw what I felt. He showed me poetry within thin air. I spent months with him in that empty studio of his, where I learned how to be stubborn.

I entered the art academy exams with a strong set of newly acquired skills and a mightier mentality, a healthier self-esteem, and new directions that I felt were truly mine. In order to get accepted, I understood that I would have to follow the teaching of the academy. Instead, I felt propelled by Tone and Šule, who were not academy teachers. The exam consisted of five days of drawing: portraits, full-figure, still life, and abstract (free-form). What I produced was insufficiently smudgy and gloomy. I was the only one using a pencil in the exams. Out of 115 people taking the entrance exams, 15 were accepted.

I got insight into why I was rejected, and it turned out it had nothing to do with my drawings. It was prejudice: entirely personal reasons about the family I'd come from. One of the main decision makers, Bovinec, was all about choosing students he could mold in his own image. He was also a renowned alcoholic who had spent time on more than one occasion at the psychiatric clinic where my father was director for some time. This clearly didn't help my chances. But at the moment I didn't know this, and so it was irrelevant to my immediate reaction. I felt at the time that everything I'd worked toward and believed in had crashed into a wall.

I'd had the support I needed. My parents were back on board, and they saved me. The two external classes I took had hugely improved and motivated me. My parents encouraged me to try again. Then Bovinec contacted me and

offered a one-on-one evaluation session with him. I gathered every good draw-ing of mine I could find and stuffed them into an oversized folder. I went to the academy one dark night. The halls of the academy were so stuffy, it felt hard to breathe. Tension permeated. He kept me waiting. The door was open; I saw his profile inside his office as he stared at nothing for about an hour. I was just sitting in the hall, waiting to be called.

I saw immediately that he was planning to chop me into pieces, before we'd even met. He said something along the lines of, "What I saw you do during the exams is one of the worst examples I've seen in my career. But I've been told that you might have hidden talent . . . somewhere. So I've offered to see some other examples of your work, because maybe you didn't perform at your best under the pressure of the exams." He opened the folder and flipped through the drawings, turning over one page after another, in silence. Then he started ripping up my drawings, throwing them to the floor, and shouting at me: "This is nothing! These are wires! This is death on paper! This, you see this"—it was a bottle on his desk—"you don't see it! I see it!" He was a head and a half shorter than I was, which I noticed when he started actually hitting me on my chest, saying, "You see this, there is no heart beating here!" I switched into Zen mode and just let it flow over me.

This sort of situation probably sounds inconceivable to you, if you are a younger twenty-first-century artist or student. But I grew up in a system that al-lowed for these kinds of aggressive ego explosions. Your system probably does not allow it, but the feelings that the professor articulated (and gesticulated) may still be present, even if the current teachers and professors are unable to express them (due to fear of lawsuits or viral news or simple propriety). There was fear because I was the son of the psychiatrist who knew about his issues. There was latent jealousy because I was young and doing something different and full of potential. A psychologist could unpack various other symptoms. (I was tall and not bald.) I certainly don't expect you to have encountered anything similar, but the feelings of that professor in a position of power is still present in some academic-student dynamics, particularly in the realm of unfulfilled dreams that is the art world.

I had a bent-eared ace up my sleeve. I included in that folder two draw-ings made the way the academy wished—smudged, messy, dreary. And when Bovinec came to those two drawings, intentionally the last in the folder, he stopped. "Oh," he said, "did you do these with us? Well, here we can finally see that you did get some of the right teachings. Maybe you're not completely lost yet." He'd stepped into my trap.

He wrapped up his hour-long rant and ramble. "Continue attending our night classes"—which were extremely expensive—"and maybe there's still hope for you." That implied, "If next year you follow our regime, you will be accepted." I got up, left the room, spat on the threshold to his office, and realized that I never wanted to attend this goddamn academy.

At that moment, I remembered a friend mention the art academy in Venice, and my focus pivoted. Leaving home, going abroad, really hadn't occurred to me as a possibility until now. That night the thought stayed with me, painting different images in my mind. What about Venice? It was only three hours from Ljubljana, but conceptually it was a world away. I discarded the idea at first, but waves of thought pushed it back into my thoughts.

# 2

# THE MAKING
## OF THE ARTIST

## How Do I Choose between "Real Life" and Schooling?

Who gives you the right to become an artist? The school had said no. It was eating away at me. What will I become and how can I become that? What elements can I control that mold me, eventually, into what I will become, without my willing engagement? It's a wire walk between the artist as a lone rider and the constant need to be a part of something—to be part of a movement, of a moment that's not in the history books, at least not yet.

Now eighteen, I was literally a dropout. I'd started and abandoned the Faculty of Architecture. Now what? I felt I had to start from scratch, so I went back to the basics. Whatever I'd done in high school was a closed door, and I had to prove myself anew. I was trying to enter the academy, so I immersed myself in painting, spending days and nights at work. I remember my girlfriend at the time told me, "You know what? Your breath smells of oil paint and turpentine."

It is incredible how things can flip in just a matter of months, and everything just starts running again after it seemingly ground to a halt. After the hard-core isolation, due to the pain of the no from the academy, things started pouring into and out of my studio.

I felt like an outsider and had no idea how to penetrate the self-sufficient and, in my eyes, privileged group of art students who'd made it through the exams. I would come up with all sorts of excuses in my mind, rationalizing that I was actually better off outside of the system already, where the true art was happening. But every time I crossed paths with a young art student, a painter non-

chalantly buying a stock of carbon sticks for art class while I was weighing the cost-benefit of a new tube of beautifully heavy (and pricey) Lefranc oil paints, I would shrink, hide within myself. Once my father overheard my rants about the snobbish and privileged students of the academy and how I was riding the true rebel artist wave. He looked at me and said, "That is the main reason why you need to get into an art school. So you will get rid of this frustration and focus on what you can really do."

One day at the end of the winter I was working on a painting and I brought it outside to dry. I experimented a lot with various techniques at the time, as it felt so goddamned bold to do so. Then I felt something above me. I looked up and saw, many floors overhead, a huge head of blond surfer hair. That head screamed down to me, "Is that your work?"

I shouted up, "Yeah."

Then he ran down and came blazing out on the ground floor. "Is this work really yours?"

"Yeah."

"It's fucking *amazing*!" That was my introduction to Gregor, the guy with whom I would eventually move to Venice and launch a new period.

Gregor was an athlete who'd gone to America on a track scholarship. He had a Californian sunshine to him, not the typical Mittel-European bitterness. An injury had led him to art, which brought him to Ljubljana, where he studied at a private academy, one I'd never heard of (and such academies were rare to non-existent in this area). Through him I met his tutor, Marko Zatler, who taught him at this private academy.

Marko was the talk of the town. He was about ten years older than we were, but his work, and indeed his legend, flitted into my ears along the winds of urban chatter. They would say, "He's a fucking amazing painter . . . but he's a nutcase." In his craziness, he was known to be extremely dangerous.

## IF I DON'T GO TO ART SCHOOL, WHAT CAN I DO TO PREPARE FOR A CAREER AS AN ARTIST? HOW EARLY SHOULD I SHAPE MY ARTISTIC IDENTITY?

Today you have so many schooling options, it would be a shame to miss out on them. Having said that, I did drop out. Remember, I had started studying architecture. In a moment of crisis, I had embraced an idea that had been given to me by the environment in which I was brought up. I had to pass through a period of loneliness to find and embrace an idea that became mine: to be an

artist. In my opinion, that was the best thing that could have happened to me at this early stage. It built up my bones and hardened my skin. In this way, while I harbored many doubts as to my art, I never doubted my path.

Most people talk about golden origin stories: *Someone saw me drawing and that was it.* For me, it was like that . . . until it wasn't. But for most, it never is like that. In my case, I was from a family of many wannabe artists who never were (my mother and grandmother, to name a few), so I was brought up to become an architect, to take over my mother's studio. But I had a painting studio in high school, I worked with music, I was never interested in architecture. Still, when asked what I would become, I always answered, "Architect," as this is what sounded secure and what people around me wanted to hear. Don't we all do this for a while?

Of course you can become an artist, and a successful one, without going to art school. Before the sixteenth century there was no such thing as an art school, just the bottega studio system of apprenticeship. For centuries the ones who went to academies were the traditionalists, while the "proper" artists, doing the most exciting things, were independent.

But today, not going to an academy will be much harder. Reading someone else's well-known origin story results in cinematic material spinning through your mind and can sooner frustrate you than inspire, or at least it can derail your focus. It is perfectly normal to feel that your own path has nothing mystical about it, that it is insufficiently mythic, and that can cause some gut-punches that knock you off track, at least for a while. But being part of an academy has the advantage of helping you to not feel like you're missing something.

## IF I DO WANT TO GO TO ART SCHOOL, HOW CAN I CHOOSE THE RIGHT ONE?

Now it's normal to apply to various academies, keeping your options open. For me, it seemed like there was only one option—Ljubljana. Then a friend pointed out how close Venice was (a three-hour drive) and that it had a much better academy.

That year, I did go to Venice. Just by chance, I joined an art history trip a friend of mine frequented, so an image, an idea, formed: first the scent of it, and soon enough the taste. Looking back, I would say that it's best to sample potential academies—several different ones, if possible—by sitting in on some classes to get the feel of the place. Art institutions around my country have too much of a formal distance, or at least they most certainly did in 1999. The

scent, the rhythm, the quiet, the art that was being produced there . . . it all felt institutional, which isn't normally a good thing for creative types. If you can visit, ideally do so unofficially, not on an open house day. Instead, ask someone who goes there to bring you along to sit in on a class. Open house days aren't authentic. An average day is.

See if you can imagine your place there. The Ljubljana academy I was trying so hard to enter . . . I hated everything about it. The smell, the dense air. The arrogance. And that awful night with that monster of a person, the short, bald, chest-banging professor who'd shouted that I knew nothing, only helped me to understand that clearly. Everyone knew it was so hard to enter, so the students there thought they were godly. Who created this atmosphere and attitude? A bunch of small-change artists who'd made that academy their own diminutive dominion. That's not a good atmosphere. The first time I saw the Accademia di Belle Arti in Venice, it was full of color, voices. It felt loose. As I snuck in, on a regular day during that quirky art history trip, I could perfectly imagine myself within that Mediterranean chaos far more easily than in the Prussian arch formality in Ljubljana.

Anything that pushes you out of your comfort zone will be beneficial for you. Anything that makes your pants drop, that makes you cry in the evenings and tremble in the mornings, that makes your voice grow hoarse, not knowing, forgetting what you learned before—out of that, finding those moments when you distill all you are into previously unimaginable, encapsulated magical moments . . . fuck yeah, that's what you want to hunt. New, unfamiliar, foreign places can do that.

But sometimes life throws a most unexpected learning curve at you, when you cannot see it coming but you most need it. Something that has nothing to do with any kind of school, book, course, or movie. Sometimes life throws you a living and breathing artist, a volcano of a person, close to you, but just far enough to see and feel the big difference between you and him. And for me, that was Marko.

## SO MANY ARTISTS HAVE BEEN MELANCHOLIC FIGURES. DO I NEED A FORMATIVE TRAGEDY AS MY PERSONAL SECRET IN ORDER TO BECOME A GREAT ARTIST?

Marko's work was incredibly classically ambitious. Painterly. He was into still life, which sounds boring, but in order to get attention, he decided to paint dicks and pussies. The genius of his formula, of his artistic strategy, lay in juxtaposing

classic *natura morta* with objects that were, shall we say, *natura viva*: dicks and pussies. He was smart, devilish but brilliant. With this, he could concentrate on things he was into, which meant up to nine layers of color to get just the hue he needed. But, of course, he got attention because of the dicks and pussies.

He gave off an aura of having no time to lose. Every moment was an opportunity to dig out artistic growth and to network. Getting drunk at a bar was not just a chance to get buzzed, argue with other artists, and otherwise become the core of the party. He'd somehow manage to have a show there the next week. He was good at getting money to do stuff, but also at getting artists together. Gregor said about his tutor: "If he saw potential in you, he just kicked your ass until you were all black and blue!"

One night my studio doorbell rang. I wasn't expecting anyone. And there was Marko. He had come to *me*. It was like a god showing up at my studio. There he was, with a bottle of cheap red wine in each fist. He said, "I hear you're the new talent in town." This kicked off one of the craziest nights of my life. He had this amazing neurotic energy. He couldn't sit still. He'd drink and move and talk all the time. He downed one of the bottles by himself in a matter of minutes, and soon after sent me out to bring more bottles. Later that night, spitting red wine in my direction, Marko said to me, "You still have a lot to learn, but you have incredible talent." No beating around the bush, no gift wrapping, totally straightforward. If it was crap, he would say it was crap. I was used to that from night classes at the academy, but unlike at the academy, which felt wholly negative, Marko would say of another work, "This is fucking beautiful."

One of things he taught me was to not be so melodramatic. Young artists gravitate toward melodrama. Don't bow because you got some noes. Go against the flow, elevate yourself, don't sulk. "Why do you think I paint dicks and pussies? So I get up everyone's nose, so I get attention and then they leave me to do whatever the fuck I want."

We spent time together over the course of about a year, and it changed me. He brought me into the Ljubljana scene. I exhibited. I met young artists. I ceased to be an outsider even though I was not accepted into the academy. He slammed open doors. I was in the middle of a vortex, with all these styles, influences, and media whirling around me. I'd had two shows before that I'd set up on my own, but now I was gaining experience in hyperdrive and helping to organize things, seeing him set up big group shows, even in godforsaken spaces. Marko propelled everyone along with such momentum that I might display works on Friday that I'd painted on Monday. At night he'd drink himself into a stupor, but during the day he was a workaholic energy bomb.

## SOMETIMES IT FEELS DIFFICULT TO DISTINGUISH FRIENDSHIPS FROM RIVALRIES AMONG ARTISTS. HOW CAN YOU TELL WHICH IS WHICH?

Friendships and rivalries among artists often overlap. In Gregor, I'd found a colleague who embraced my talent. We drew and painted together every day. He lived in this bohemian nest with a crazy friend of his. There we had numerous mad nights, swimming in alcohol, colors, dust, and body heat. For a while, we bonded so much that we were mistaken for brothers, or for a couple. So we would play with that too, coloring our fingernails and dressing up.

At the core of this relationship was rivalry. It reared its head with each new work either of us would do. At that time, it felt stimulating. This wasn't just two new friends bonding and spending all their days together; this was a young artist talking to another young artist, which is to say it was one bag of doubts talking to another bag of doubts.

My bag was bigger. I was in a confidence deficit period. He helped me through this. He showered me with compliments, growing my self-esteem, and this could be seen in my work. His oversized personality compensated for his ever-more-obvious lack of artistic talent. Through him I met a girl who, like Gregor, was from Gorizia, on the border with Italy. They were outgoing and vivacious bons vivants. She was from a rich family too, so out of the blue I was taken places, literally.

Since Marko had come along, we had a way to actually exhibit what we were experimenting with. We felt like Beatniks, poets. It was fresh and happening. More and more I would find my role within the tornado of it all. Did I mention that there was a lot of drinking and arguing? Marko regularly quarreled at late night bars with members of our group. We all knew it would happen somewhere along the way. But overall, it was encouraging and stimulating. Nights would all roll into this one, long, intoxicating period of living the haze of a young artist: waking up in different beds (or floors or couches), rolling cigarettes and diving into black coffee, among endless scrambled sketches of ideas, poems, projects, arguments with half-empty or filled glasses and bottles of red wine. And that constant smell of paint. That intoxicating scent, that "I love the smell of napalm in the morning" thing, where we would get up and go into the studio because we all knew we had to prove ourselves. No matter the hangover, we all knew that crazy motherfucker Marko would be the first to lift his brush and just continue working right on into morning.

## WILL I STILL BE CONSIDERED A GOOD ARTIST EVEN IF I SURVIVE MY EARLY HEYDAY? IT FEELS LIKE SO MANY LEGENDS ARE BUILT UP AROUND GREAT ARTISTS WHO DIED TOO YOUNG.

I'd heard before of his crazy binges, and then became part of them, where you'd start drinking on Friday and end up on Sunday . . . somewhere . . . possibly wearing a strange outfit and possibly in the middle of a forest, with no recollection as to how to connect the dots. We'd start at a bar in the center and drink all we could think of at that bar. When it started closing, we'd head off to the last, dodgiest bar that was still open—a hangover or dive bar from the socialist days. Then we'd somehow shift away from Ljubljana to head to some rural retreat where Marko miraculously knew that local drunks were still up for partying. This is how driving and drunkenness came into play.

There was often a girl in a wheelchair who partied with us. Marko's friend had died in the car accident that had put the girl in the wheelchair. I never knew the whole story, but I inferred that Marko was somehow part of it, that he felt responsible or guilty for having gotten away unscathed, at least physically. In the same period, I became very close to one of his best buddies, a strange creature named Matjaž. He was someone with whom I would spend more and more time, and he had an immense influence over the person I would eventually become. He always wanted to see my works, but he never showed me his. And yet, he seemed to me to be the pinnacle of what it is to be an artist. He also helped me to understand Marko and what Marko was giving me. What Marko would say abruptly and harshly in five seconds regarding my work, Matjaž would then take time to further explain. There are friends who inspire you through their art and there are friends who fulfill a more theoretical, abstract role. We benefit from both. For me, Matjaž was the latter.

It was clear to all of us that Marko was a deeply troubled guy who had experienced a tragic loss, and he'd had a hard time coping with that. I could never get the whole story, only fragments, but enough to understand that it involved drinking, driving, and death. His craziness would push him continuously back into similar scenarios, like he had a death wish. Closeness to death can be dangerously invigorating and intoxicating.

He had this infamous ceremony. While someone was driving, he would roll down the window, start in with some reassuring laughter, then provoke anyone who was in the car to follow him. He would crawl out the window while the

car was still moving and climb onto the roof. He would sit on the roof, holding onto the underside of the open window. Whoever crawled out with him was the Chosen One for the next week.

He once showed me, in a nondrunk moment, that he had a special technique to do this, how to climb up and hold on. That was him: He would apply structure even to a death-wish activity. This usually happened when we shifted from Ljubljana to a smaller town's drinking location. (I can't say a bar proper, because we'd head off to fire stations or cellars or whatever place might be drinkable.)

Bottle after bottle, Marko would drink until he literally dropped. Normally, that's a figure of speech. Not with him. He was so full of energy that he managed to keep himself unconscious but somehow moving around, like a still-walking and gibberish-sputtering corpse. And he would get more aggressive, way more aggressive, verbally. He could destroy you in a split second if you showed any kind of reluctance toward riding the vibe he'd laid out for that night. If, at midnight, he would be blunt and say, "This is lousy, throw that painting away," by 2:00 a.m. he would actually throw it away himself.

That night, when he came by my studio, he did just that, and not even metaphorically. He was literally picking up my paintings and throwing them around. I was open to listening, but this was my art. At that point, I was working on a bigger canvas that featured many Egon Schiele–like contorted figures, a painting about many-faced personalities. I was proud of it. It had a lot of red and brown in it. Right off the bat, he was spitting red wine with his lubricated lips and sputtered, "Why are you using so much brown? It's like shit all over this painting. Fuck this drama. Create some contrast. Use yellow!" To prove his point, he looked around my studio, grabbed yellow chalk, and covered my painting with it.

You know what? He was right, it was better with yellow. Way fucking better. It stung how right he was. But still, my pride stood high. It turned into a fight and I threw him out of the studio.

I didn't sleep much that night. I returned to the studio the next morning: bottles everywhere, spilled alcohol, artworks on the floor. I somehow felt raped, walked upon, ashamed, but still strangely illuminated—as if somebody had pushed open a door to a well-kept chamber deep in my mind, from which I drew my inspiration at the time, and then messed it all up.

I cleaned the studio, all but that painting on the wall to which he'd added the yellow chalk. I kept on looking at it. I knew he was right, so I nodded, alone in my studio. I picked up a wet towel and gently rinsed off the chalk.

I saw him as this batshit crazy older brother mentor figure. I sensed the extreme disruptiveness in him. And I needed that at the time, badly. You only

let someone like this into your life if you want it, if you feel something is missing. He shook my comfort. If someone pushes you, you cannot embrace that person's conclusions, you have to find your own path. As a mentor, Marko was enough of an egomaniac that he bullied you into embracing his solution to your situation. But in order to love him, and make him love you back, you had to fight him. There was no way around it. So the yellow had to go from the painting, but it stayed in my mind, my thoughts stained with yellow chalk.

The further we went on together, the more I became like his peer rather than his apprentice. I was the one who would contest him. I'd be the one who would tell him not to climb atop the car. To counteract this dynamic, he was pushing me away more, but also putting more responsibility on me, giving me more important roles, especially organizing events.

Once I did climb onto the roof with him while the car was moving. I had secretly wanted to, to become part of that inner circle. I'll never forget it. It was like entering a special zone, head-on into the mists of my own fear and righteousness (which was eventually the only thing that kept me in one piece). That night, I broke the spell around me, some force field dissipated, and the blast-back of air in my face from the speeding car tasted of absolute freedom, screaming my lungs out beside him on the roof as our velocity increased. I was as close to him as one could be, part of that euphoria, part of that leaning into the moment. He lived in the moment more than anyone I'd ever met. We had been growing apart, but that night on the car's roof, I was right next to him, as we screamed into the nothingness of the night wind.

One incident signaled to me that things were going too far. I was out of school, but I was active and, in our generation of artists in Ljubljana, I was Marko's wild card. He would bring me to events and bars, and his established group of followers would look me over, like, "Who the hell is this guy?" I was a dropout, so in their eyes, being all students, I wasn't worthy of a place at their table, much less at its head. Marko liked that and used me to shake up the dynamic of the group.

One night we were around a fire. Marko was letting loose on the quietest, shyest of his students. The student wasn't doing his best work, but Marko was so blunt about it that it was pummeling. And then Marko got up, grabbed the student's drawings, and threw them into the fire.

I got up and removed the drawings from the fire before they burned. I said, "Marko, you have a point, but this is too much." Marko just watched me, in shock, and turned around. His gaze spoke volumes. We never really talked again.

Later that night, he jumped out of a second-floor window and crushed both of his heels. You know how as a child, you'd wish for something—like for your

parents to disappear if you were arguing with them—and then worry: What if it actually happens? It was like that for me. The next morning, when I heard he'd broken his heels jumping out of a window, it felt as if it was my fault.

## DO I NEED TO GO AWAY FROM HOME AND CUT MY TIES IN ORDER TO DEVELOP, TO UNLEARN OR REDEFINE MY ROOTS?

When I dropped out of architecture studies, my grandmother Janja was actually the first member of the family to show support. She called me over and laid out this far-fetched plan that I should apply to the Royal College of Art in London. I mean, the idea appealed to me; I just had no clue whatsoever about how to do this. She had lived for fifteen years in London while married to Lord Robyn, so she must have had some idea about how to get me in. We did start the process, and I frequently went over to spend time with her, ostensibly to work on the application. What we actually ended up doing depended on how far in the day she was in her drinking. In that aspect, she was the classic gin-and-tonic-in-the-morning lady, even though I think red wine was her drug of choice. That and chain smoking.

I enjoyed her immensely, as she shared with me all of her younger aspirations, how she'd longed to be an artist one day. She enjoyed her life to the fullest and found a lost love for art through me. But somehow, she always found a way to hurt someone too, mostly my mother, her daughter. In her presence, my mother would morph back into a neglected five-year-old.

Toward the end of that last year, before I moved to Venice, she asked me to do a month of house-sitting. Me, on my own in her beautiful apartment, packed with the trappings of a proper bohemian and intellectual lifestyle? Bring it on.

It was a magical month. I reembraced my high school heyday and friends. The doors were open to all, and the apartment transformed into a sort of commune crossed with a salon. I would wear a set of Janja's decadent silk robes; I'd paint and draw in all of the rooms and on the balcony, sometimes laying paper or canvas directly on the floor. I'd prance around the apartment, the silk drifting around me as I wove through one painting after another. I made love to my girl, still wearing (or not) that silk robe, literally everywhere, including on those huge drawings. I did my best work of that period in that apartment. It was a dream month, a prelude to what was coming.

Officially, I was still applying to the Ljubljana academy for the second time, following very clear instructions about what I needed to provide in order to get

in. In actuality, I couldn't have cared less. When I finally brought in a new folder of drawings and showed it to the bald, short, screaming professor, he took one look and recognized that I was spitting in his face. The drawings were my own preferred style and looked nothing like what he had "instructed" me to do in order to get in. This was my middle finger.

My father accompanied me to the floating city for a week of admission exams. We rented a room, walked to the Accademia every morning, then he waited for me on Campo Santo Stefano, where we would go for our beloved *spaghetti con le vongole* at a local place that I would come back to, years later, with him and the family during the opening week of Biennale, when I participated, representing Slovenia in 2015. At that time, I didn't know, couldn't imagine that would become my reality. How could I? I had to pass the exams.

## HOW CAN I REGROUP AND FIND A NEW EQUILIBRIUM WHEN EVERYTHING SEEMS TO BE MOVING TOO QUICKLY?

When you live in a reality of parallel and braided paths that eventually define you as an artist, it is sometimes hard to decipher the moment where it can all shift in the most unexpected direction. But tragedies can be a strong wake-up call for those who stick around to rethink and redefine how to carry on, those who rebound from them.

At the opening of that workshop's final show, Marko came in in a wheelchair. Same old Marko, smiling and energetic, but in a goddamn wheelchair. That hit home to me. Overnight, I said no to everything that had been planned. It was the start of summer. I packed up everything and went, with my new girlfriend at the time, to spend the summer on a Croatian island. I felt that I needed to get away. The fights, the booze, the late nights, the passions, the unknown girls I would wake up next to, the total exhaustion . . . I started feeling the bite of this proper rock-and-roll rhythm of life. Something clicked and I had to go away. I registered for entrance exams at both the Ljubljana academy and the Accademia in Venice (and maybe even the Royal Academy; who knows if Janja ever got that sorted for me—I sure don't), and I had to wait. I would swim, cook, make love, and paint. It was a scene out of a movie. My girlfriend's family had a tiny house on a tiny island. I would fish with the locals for lunch. It was time that allowed me to digest everything I'd been learning. I felt I was in control again.

As much as Marko took me in, as my ambition grew, I better understood the power of his position and that my path was different from his and what he envisioned for me. I wanted to manifest a different art and way of life. This

is where I sensed his volcanic presence as a threat, and I got the vibe that he sensed it in reverse, too. We had a running joke that whoever wanted Marko's position had to wait. There was no way that we could usurp him (because he would always work more than we could), but we joked that he would eventually kill himself. His lifestyle seemed unsustainable, so we just had to wait for him to burn out.

Marko was preparing some giant canvases for a big show that summer. He would talk about them, but he never showed them to us. He was working on something that would firmly establish himself as the big fish in town. We were ostensibly friends, but we all feared him; we were scared of how good the works he showed would be. The show opened and it was an instant success in the Ljubljana scene. During the opening, a friend later told me, Marko was the calmest version of himself. He'd only had one beer. The paintings were of incredible quality and monumental ambition (though still dicks and pussies, of course). Almost everyone from the scene was there at the opening (I was still on the island), but they felt that the opening was so amazing, it was enough. Only a few closest friends went out drinking after. So when he climbed out of the moving car later that night between parties, he climbed out on his own. He didn't try to convince anyone else to climb up with him. It was his moment, his triumph. And that was the night he fell off the roof of the moving car. He hit the pavement, was in a coma for a week, and died.

He had been the glue that brought together some thirty young Slovenian artists, working, partying, fucking, drinking, living as if every day were our last. But without him, we disintegrated. For me, his death was the last signal that I had to go, to embrace a completely new reality. What I learned in this time would keep me afloat in the years to come. When we were younger, we looked to Arthur Rimbaud and thought about the "21 Club" (I was nineteen at the time), the great artists who burned bright and died young. But as you approach twenty-one thinking, "I've only got a year left. Is this really my fantasy?" things change. Can you save yourself from this daydream once you've pushed yourself off on this path? Marko pushed me to ask myself these questions. I allowed myself to find peace with my decisions.

I stopped fighting with him in my mind. Art ceased to be about tomorrow. It became about now. That was when I really felt that I was an artist, not striving to become one. But at the same moment I realized this: I'm not yet doing the art I want.

It was when I came back from the Croatian island, the news of Marko's death completely disintegrating the scene I'd become part of, that my acceptance at the Venice Accademia hit me: This was my new reality.

My mom, my beautifully difficult and crazy mom, threw me the party of a lifetime. All of my friends came, and we broke all the records of empty champagne bottles by the time we collapsed. At some point my mom and my girlfriend were pretending to swim as they slid across the living room floor.

The following days felt like floating right into a rainbow. I hovered above the streets of my hometown, talking to my friends and family in a state of continuous high. So many things were happening or had just happened, so many things were ending or had just ended. Anything and everything was possible. The only thing, or the most important thing, the thing that anchored me, is what this whole period gave me: a day-to-day relationship with what I wanted most, my art.

The creative process, for what it stands for and where it can take you, is like boxing with a bear. The bear might be wearing a tutu, but at any moment while you are entertaining alongside the bear, it can turn on you and quite literally eat you up. Nothing will be left. At any point in your career, honesty is the only thing that can get you anywhere in this relationship with your work. Your work becomes your lover, your wife, your husband, your children, your parents, all wrapped up in a single entity. When I say honesty, I mean the fact that you're the only judge. Nobody is looking and nobody will know but you. How you deal with the limitations, trials, conflicts in the studio is up to you. There's no way to fake it. The shortcuts you need to take to fulfill your daily ambition? Up to you. How much of a bullshitter you become to fake your way through? Up to you—until you meet the right teacher. In my experience there are only a handful of teachers—let me correct that: There are too many teachers who can recognize your weak spots or catch you in your moment of creative crisis. Who will extend to you the hand of God and pull you out of the mud pit in which you wrestle with yourself? Who will stop you and help you understand what's really happening?

The creative process is a tricky beast. Engaging with it requires various contrasting experiences, highs and lows, and emotional investment. Taming it requires a cocktail of skills, concepts, and approaches.

## WHAT ART SHOULD I BE SURE TO SEE FOR INSPIRATION AND TO LEARN AS MUCH AS POSSIBLE?

Every day the art that you should see first, the one you look to for inspiration, should be whatever you're working on in your own studio. That should be your legitimate secret that draws a hidden smile to your face while you're sipping an

overpriced prosecco in the midst of the biggest of openings. Attend any bigger venue that has a curatorial professional premise—and these days there are a lot. Festivals, biennials. Avoid art fairs. Go to one, to see what they're like. The trend is to emphasize art fairs above all. But they are so marketing driven and overhyped. Museum shows are incredible showcases of quality and professional art production. Add to that the hotshot big galleries that compete, in scale of shows, with the museums (as they often have more money to spend than the museums). These days there's a high-end competition in quality, production, and scale—this is to the benefit of art lovers. To a young, aspiring, unknown artist, this can feel suffocating. Dive into the big venues and hotshot galleries, but balance that with "alternative" low-key project spaces with experimental, younger, lower-budget productions. Seek out the "garage sound." In garage productions, when you don't have the money, you have to compensate with audacity. When money is the only filter of the quality of production, this can be an extremely blinding aspect. Seek out student projects done in homes, in basements, in attics, in abandoned spaces. Seek out projects done by more than just one artist, actual art groups that came together for a project. Fresh and raw energy is what you want to tune in to, because it's closer to your reality. Big productions can give you the false idea that this is possible for you tomorrow, but it's probably going to take much longer, and you can do so much more in the meantime.

The best places to study art are the places with a lot of great art available to see. These tend to be big cities with clutches of major museums. A breadth of art is always best, especially when one is trying to cope with the multilayered complexity of art.

Let's isolate painting for now. Let's focus on the classical knowledge of how to paint, what it means to become a skillful draftsman, to learn the basic techniques that allow you to learn your métier. How do you prepare a canvas on your own, what brushes do you buy, how do you manipulate colors?—all the technical elements before you actually get creative. Add to that the hundred-plus years of the development of painting as we know it. In my experience, if you honestly want to do anything original, you need to go through all of this in some shape or form. The basic techniques, the history, the styles, the movements—you need to walk with the giants, be humbled by their greatness, but then challenge them every night when you get your courage back in your studio, and, if nothing else, pull on their toes while they're sleeping.

That is why my time came to pack up my stuff, to make peace with my demons, and to sing with the angels. The two years in between gave me unimaginable strength and the stamina to face my vision on my own, one of those moments of standing on the edge of the abyss, knowing a step forward would

likely result in a fall. But you know what? No. It will be an incredible flight. I will board my own cloud of dreams and sail far. I made sure that everyone was coming with me, in spirit and in lessons, though not in body. Every piece of the puzzle that was me, up to that day, every magnificent (or less so) person who defined me, would come along. I owed it to them and to myself. Right there, somewhere in the crowded room of my mind, where we harbor those dear to us, Marko was still laughing and shouting from the top of his wine-lubed lips, "Fuck this drama! Create some contrast. Use yellow and shout about it!"

I was determined to become a different artist than the one I was at the time. I wanted light. I wanted colors. The old into the new. I wanted to find my way into contemporary art outside of my hometown. So what better option than the floating city? A place rife with history, packed with museums and the Biennale. A place that functioned like a living museum while remaining on the fringe of the art scene: that magical place called Venice.

# 3

## AT THE ACADEMY

### How Early on Do I Need to Find My Style?

The first time I crossed the bridge in front of Ferrovia, the main train station in Venice, was after I'd spent eight long hours on a train from Ljubljana. Did I mention that it only takes three hours to get to Venice? I did—but that's if you have a car and a driver's license (one of those things I managed *not* to get while becoming an artist). The train back then, the Ljubljana-Venice connection, was something out of the olden days, the border of the "free" capitalist world and the dangerous world of the "commies." The train had to stop at the border, and I don't know what the hell they were doing, but it took them ages: changing tracks, wagons, maybe even replacing the windows; an endless stream of police checks and my first close encounter with the Carabinieri, Italy's military police. Whenever I see one of those uniforms, with its oversized hat with the huge metal emblem emblazoned upon it, along with the famous red stripe on the trousers, my hair stands on end.

I walked to the station in the middle of the night, incredibly happy I was on my way. I must have been still drunk, too. The night before we'd held the ultimate farewell beer with friends. But the day before that, we'd rocked out my official "Jaša fuck off to Venice" party—Roman-style.

When I came back to my family apartment to pick up some stuff and get a couple hours of sleep (by then, I had made sure to interrupt all of my romantic relationships and turned my room back into my home base, as I'd subleased

my studio to my punk friends), my mother was there, in the kitchen, where she had waited for me on so many nights over the past years to get some basic coordinates about her son.

She was still grappling with the divorce process, so the fact that I was about to definitively leave the nest brought out all of her colors. She was good at packing moments with intensity. I was leaving, sure, but she would throw in more bolts of lightning to anything emotional, giving it the potential to become a shitstorm. At the same time, she embraced emotionally complex moments, diving in fully one time and then shrugging it off the next, as if nothing had happened. So there were tears of joy from her—her son fulfilling his and also his mother's abandoned dream of becoming an artist and setting forth—and on my side, mostly a hangover.

Now, you might think I was totally on top of things, an alpha primed to sail away and conquer new territories. If only. I was nervous, particularly at that moment, there in the kitchen, where the final separation from home and from Mom was palpable. At the same time, there was something grand in the air, so when she crowned the moment with, "My dear Jaško"—the older I got, the more often she would call me using this diminutive—"it's time to go. So go, and become what I always knew you would become," I took my shit and split.

## WHAT SHOULD I PACK WHEN I SET OUT FROM HOME?

I boarded an early morning train, so early that it was a night train, around 3:00 a.m., with everything I thought I needed at the time and armed with no clear idea as to where I'd live in the coming period. I'd spent the last week frantically going through my stuff, trying to understand what objects contained my identity and what my identity contained, ending up with a mountain of belongings. By the end, reality and luggage space pushed me to pack only the bare necessities, along with a wagon of memories, feelings, and expectations.

Two days before, I was looking for a pair of trousers—one pair that would stick to my butt for most of the coming year. I am a tough cookie when it comes to pants, or any clothes. I like to have a single pair that suits my swagger of the moment and that I don't have to think twice about slipping on. Jim Morrison was never seen without his leather trousers, so maybe there's something to it? You know the stories of people who can make any kind of creative decision that consequently determines the outcome of, let's say, a work of art, or the feel of an event, but who cannot choose between two pairs of socks in the morning? Well, that was me, even back then.

The last stop was a shop where I found a pair of pants. A girl worked there whom I knew from the high school. I knew she liked me. I bluntly invited her to my farewell, which was a dual-themed party, unifying the late Roman Empire with the barbarians. I was Caesar and my buddy Bobo was king of the Visigoths.

We didn't just take art seriously. If we were to throw a period-themed party, we would get it right, down to the last detail. We cooked ancient-Roman-style meat and trimmings with honey, spices, and lots of wine. We sacked out with cushions and pillows, all of us on the floor in nothing but our homemade togas. She came in one, too. She looked like a goddess.

When we'd devoured everything and drank the impossible, we all ended up in different parts of my friend's huge house. When she and I were finally alone, I was so wasted that my toga got stuck around my neck when I was hastily trying to get naked. We laughed; we rolled on the floor, ending up completely naked . . . eventually. Warm skin against warm skin, my face immersed in her beautiful breasts. Still, it was not my Olympic night. I'd had so much to drink that there was no way I could get it up. But it didn't bother me, actually. I was happy where I was, in this general haze of goodness, caressing every part of her naked body. She probably was a bit disappointed, and fell asleep while I did a Woody Allen impression, with my eyes and hands wide open, soaking in as much as possible until morning lit the room.

Walking toward the Accademia in Venice one day later, I still had her smell on me. It was more than just daydreaming. It was a stroll through paradise. I was walking toward my new life. It must have been the light, the way it breaks on the tiny waves in the canals, the voices, the feel, the never-ending song of pleasure, meeting me at every corner, the taste of freedom that each breeze would bring to my lips.

Leaving my hometown had been a long period of goodbyes, mostly invigorating, some heartbreaking. But nothing was as legendary as my farewell Roman-style party and that gave extra wind beneath my wings.

As I was standing in front of the entrance to the Accademia di Belle Arti in Venice, it was still the historical entrance to the Renaissance edifice, an entrance that so many artists, going back half a millennium, had walked through. Let me share a secret: I was so scared at the time, and so in shock, that I couldn't even muster the courage to visit the Biennale that year. I felt like such a tiny bird in the grand forest of Venice. The moment I entered the Accademia, it became clear to me that this was an institution that had seen thousands of inspiring and aspiring young artists. It was as far as possible from what I'd known in my hometown. It looked like a classical monument, but it felt like I was entering some futuristic film.

CHAPTER 3

That was the Accademia. You could see a conceptual artist "sculpting" out of air next to a Michelangelo-inspired traditional sculptor carving a block of marble. It was like walking into an encyclopedia of art history embodied by actual living, breathing young artists. Every style and technique, from Renaissance to Cubism to Futurism to Abstraction up to the flavors of the moment, video art and performance. It was all there and alive and aspiring.

It was intimidating, to say the least. With every step I took inside, I felt smaller and smaller. The exams were done, but now I was there, with my set of tools and skills, just twenty years old. I didn't have a place to stay in Venice yet. I didn't speak any Italian yet—I relied on everyone speaking English, of course. It was like I'd come from a different dimension, and now I had entered a new one in which I had to prove my worth, prove even the relevance of my existence. I was fired up, supercharged, but did not even know where to take a leak.

In the Accademia, depending on your medium, you were assigned to a professor and his or her studio. There were four painting studios, two for sculpture, and two for decorative arts (which covered all media in contemporary art beyond painting and sculpture). If you wanted to change from the studio to which you were automatically assigned as your home base, you had to convince another professor to take you on. And all the students, from all years, worked together in the same space—giant open studios—ateliers, where you'd work alongside polished older students who were finishing their studies. We had a week to either accept the assignment or switch to another studio and, therefore, a new supervising professor. The first studio, I could tell from the start, wasn't for me. I quickly heard that Professor Carlo di Raco was the shit.

Entering his studio for the first time was one of the most beautiful moments. It consisted of two big, old-school studio spaces with very high ceilings, and there were two big shots there. They each had recently finished huge paintings. I learned afterward that they were rivals in the studio and competed over who would do the bigger, more ambitious paintings. One ended up with a $14 \times 5$ meter painting, beating in size the other's $8 \times 3$ canvas, but both were, to all of our eyes, incredible works, intimidating in quality and audacity, not just scale. I knew right away that this was the studio for me, where I wanted to grow. The studio teemed with creativity, ideas, devotion to art, which breathed what I wanted most—nowness. And in the midst, I saw this Woody Allenesque character, complete with orange hair: Carlo di Raco. He would change the course of my life.

If I'd felt small when I entered the Accademia, then I was the size of a bean by the time I got to talk to him. My Italian was nonexistent and he didn't speak English, or at least he joked that he didn't. He spoke so quietly. I would later learn that this was one of his tactics, part of his exquisitely conceptually con-

structed persona. He was a devoted full-time professor, not a practicing artist. He was also the youngest professor of painting in Italy to have his own studio at that time. When he talked, you had to literally shut down your own thoughts in order to hear him. The air itself would freeze when he began to speak in his studio. But this was not the cliché authoritarian professor who makes your blood freeze. His style of authority was so different from what I was used to: the macho, alpha, Ruskie, manly, straight-out-of-the-woods-chopping-firewood-and-hunting-game-while-downing-Schnapps type of my homeland, whose primary goal seemed to be to ruin young talents. No way. Di Raco gave off the aura of someone who had studied and dissected what it meant to be a classical professor type, then reconstructed it, painted it pink (or any color with character, actually), and sewed it back up together in a form that summoned authority with neither alpha actions nor machismo.

It took me a week to get an interview with him, but when I finally did, Di Raco liked what I showed him. He pointed to a one-square-meter wedge of floor space in the studio. This was where I could start.

Over the next month or so, I struck up a friendship with Simone Settimo, a painter from Padua who was one year ahead of me in the same studio. Simone seemed like a character from a film the title of which I couldn't recall, but I could vividly remember its jazz soundtrack. In the first week, the two of us ended up at Caffe Rosso in Piazza Santa Margherita, talking about painting. Simone barely spoke English and I did not yet speak Italian, but somehow we managed to share ideas. We spent some three hours together that first day, "talking" mostly through gestures and sketches on napkins. Yet we managed to convey what we felt passionate about when it came to art. We bonded as artists without a common language, or rather, we embodied the truism that the visual language is universal. It would develop into one of the most beautiful and fruitful friendships of my life, personally and professionally.

Two months later, after a proper, hardcore night in Padua at his studio with his friends and colleagues, smoking more hashish than I'd seen in my life (an almost professional sport in Padua at the time), Simone woke me gently with jazz music and coffee. I was still out of it, smoked up. For the past two months since I'd been in Venice, I'd felt like I was living in a black hole, surrounded by the Italian language I could barely understand and couldn't speak. But I'd been soaking up the sounds, more so than I realized. That morning, before I was fully conscious, I remember seeing Simone's face, and I was *talking* to him. Simone was giving me a weird look. I was still all hazy. Then Simone said, "Jaša, you're speaking Italian." And that was it. I was in the ocean of the new language and I'd started swimming.

My beginnings as an art student were similar. I just started swimming. I realized fairly quickly that I was already more experienced, with more bases covered, than most of my fellow first-years. The hours I'd put in back in Ljubljana had produced an effect. I had developed an autonomous rhythm, I had some basics, and I was used to harsh criticism. I could work every day without assignments. And now that I had all the legitimate time in the world to put in all the extra hours, I wanted to spread out as much as possible. There were so many hours I needed to put in, just painting, changing, not stopping at one "discovery" and saying, "This is me now."

The first year was one of utter and complete discovery. Who can I become? I felt that I'd embraced some solutions to what I wanted to do in art early on, and I was almost overly eager to have those solutions define me as an artist too early. I wanted to be recognized, established, as soon as possible. And at the age of barely twenty, there was a danger that I would pick an approach only out of stress and impatience and decide it was mine and stick with it for my whole career. What saved me was how I felt, as an artist—I felt old. And it is a strange thing to feel old at twenty. It can be reassuring for a while to embrace and learn from dead artists, from books and museums, but it is something else to jump into the whirlpool of contemporaneity. That's what I wanted.

## HOW QUICKLY MUST I FIND MY SIGNATURE STYLE?

Being surrounded by some 150 other young, dynamic, passionate, talented artists at the Accademia encouraged me to expand and explode. It was key that I was no longer alone in my studio. From an early stage I could not decide which way to go, or I had multiple interests at the same time pulling me in different directions. Until my move to Venice, this felt like my default limitation. After the move, not only did I see and understand what was possible, I could see that this multiplicity of interests could become my advantage.

So, what is your style?

My approach was not to have a style. Or better, I never wanted to call it by one name. I didn't want to be "the artist who's into apples" and then all I make are apples. Being as conceptual as you like, if you are into one thing and one thing alone, it can indeed help get you recognized sooner. It's easier packaging. But it can remain just that—a package. I never wanted to become a sort of packaged one-liner. I would often get asked the same old question by peers and professors now and journalists and critics later on: "Can you tell me, in one sentence, what your art is about?" "Oh, fuck off, *again*?" would be my unuttered response. I

felt like a beast in a cage when presented with this question. The difference now is that I allow myself to play with the question, whereas it used to just annoy me. But it took me years to allow myself to do that. I never knew if I was just too stubborn to accept that most people, especially nonartists, approach artists and want to categorize them, sum them up. It might be "Keith Haring? Oh, he's the one who paints stick figures," or, "John Currin? He's a contemporary painter in a Surrealist, Mannerist, nonpainterly, figurative style." I thought, there's no way you can describe art like that. But not to describe your art meant that you were not fully out there, I was always told, even at this early stage.

So I pushed myself to come up with witty statements to describe my art. That helped me distill my thoughts, but mostly it reinforced that I really didn't want to be defined. I managed to define myself in a slippery way. Then my slippery definition became *the* definition; I later wanted to go against that, so I actually invented a critic, Crish Feelting, and wrote about my own work in his name. A journalist much later asked me where this critic's article on me had appeared, so I explained my invention. Defining your work is as much a process as creating your work. If you're able to define your work as early as possible—perhaps with an essay, perhaps with one word or one sentence—go ahead. Just don't turn it into your trademark, as it will stop your process. You'll become a one-trick pony, and that trick might be popular and you can make a living with it for a while, but it can suck the creativity out of art. It can make you repetitive, overly comfortable. Question it, hate it—like a hit song. If a style or definition grips for a moment, makes you comfortable for a period, ride it. But the moment it gnaws at you, change it. How you present your work should go hand in hand with whatever you're doing at the moment, even at such an early stage. So if someone asks you, and you really don't know what you're doing at the moment, it's okay to say as much. "I do not know" is still one of the most beautiful openers to a potentially inspiring conversation.

Then again, if you do not zig-zag your options and adapt to the option of change at this point in your career, you probably never will.

## IS IT GOOD TO WORK IN OVERCROWDED STUDIOS, OR SHOULD I SEEK ISOLATION INSTEAD?

There are a lot of stereotypes about nations, some good, some bad, some true, some less so. The one about Italians talking a lot? True . . . and good. Back in Ljubljana it was the opposite. People were reticent. In Italy, from the morning espresso to the nightcap, the talking, the joy, the social dynamic was so bois-

terous that it felt like an assault on my senses at first, and in contrast to what I was used to. So many *buongiornos* and *com'e stais*. It was a cultural shock, and I struggled with it at first. But, okay, so that's fine outside, at cafés and in the street. But, man, it was the same *inside* the studio. People talked while painting! This part I could, never, ever understand. In time it pushed me to develop something remarkable that enabled my flexibility when it comes to where and how I could work. We can all be amazing at whining and complaining about how we would have been incredible, if only we could've had the ideal conditions to do so. Instead, I learned that you can bring the studio with you wherever you go. It's in your head, and this attitude toward space around you can bend to fit anything that enables you to do something great.

Over the years, I became notorious for being an avid promoter of *shush*ing while working in the atelier beside others. Without telling people to shut the hell up, I made it clear that I would prefer to work with less chatter. At one point, it became so terribly obnoxious that I wrote on the back of my working T-shirt: *Ciao, com'e stai? Mi fa piacere, anche io.* ("Hey, how are you doing? Great, me too.")

So this is the danger time, when you search for your signature style that will make you explode overnight. But, as I mentioned, hold back the reins a bit. Be open to all, to the new, to discomfort, to learning, to changing. This is when you establish your autonomy, but also where you learn how to collaborate. Putting yourself in a place of discomfort is beneficial. It's like being a foreign-language student who learns the most by plunking down in a foreign country, where everyone speaks a different language. You struggle at first, panic a bit, and then suddenly start floating and flowing and you learn infinitely more, and more quickly, than you can in your familiar home-language environment or from books to cereal boxes to street signs to proper courses. I managed to do this with art and with the language at the same time, so I can vouch for the analogy being an appropriate one. You establish a dynamic with peers, but also a transgenerational dialogue is hugely beneficial. Teaching art is one of the most difficult and perverse things, especially nowadays, where it is hard to distinguish what is the "scientific" part, the base of skills within the craft, and where the concept and expression kick in, and where any of that can be objective.

Di Raco didn't talk much to me for the first half year or so. This is how he pushed me. Within my studio space, I worked as hard as I could. That meant trial and error, with lots of canvases finished, half-finished, set aside. Each new week meant a new approach. I finally had all the legitimate time to do that: I was an art student.

Soon enough I learned the dynamics of the studio. I could see that there were different groups within it. The main group were those who worked after

hours and were the first in the studio. They usually made the best works, too. I learned to read Di Raco's interaction with different students and therefore take in as much as possible. His quiet voice pushed through when he began to speak, and the noisy, talkative studio would go oddly quiet when he talked to someone, as we all strained to hear what he was saying. One of his brilliant strategies was to push students beyond their capabilities, fears, and ambitions, no matter what they were doing. I also learned that the time I thought he wasn't paying attention to me was a false wall—he was aware of every brushstroke I made. He knew where every student was in their processes, every day. He would drift from space to space, then stop and talk to one student for a while. He taught how to be attentive when you were not the center of attention. He would put on the spot anyone who faked working seriously, those who tried to cover up slacking off with bullshit concepts and excuses.

The more time you spent working, the more you were in contact with your own art and drawing inspiration from the options around you, the more he approved. In one studio, I could see twenty, thirty, or more different styles in the making. Because you are so self-absorbed naturally at this age and stage in a career, you don't necessarily acknowledge them, but you're soaking it all in nevertheless. The best thing that can happen at this stage—or any, really—is being exposed to the art of others and seeing their process of making it.

## HOW SELF-SUFFICIENT MUST I BE, AND HOW MUCH CAN I RELY ON OTHERS?

Gregor, alas, turned out to be an asshole. Within the walls of the Accademia, I very quickly found my way. Beyond them, in that great city of Venice, unable to speak Italian, it was a different ball game. I needed a friend to help me find a cheap place to live.

We had grown apart back in Ljubljana, mostly over the hierarchy in Marko's cult, but we were both headed to the Accademia and neither of us had a place to stay lined up in Venice. I was sure that I was setting out on this grand new adventure with a friend by my side. Two artists, two friends. What I neglected to see, or simply did not want to see, was that something had snapped inside Gregor and he grew jealous.

As soon as we got to Venice, he showed his true colors. He handed me a list of phone numbers at the phone booth and said, "Here are some people renting apartments; be sure to call them; I'm going for a coffee."

"But I don't speak Italian," I said, frustrated.

"You should start," he replied, and off he went.

He figured that he couldn't beat me in the art department, so he would get some passive-aggressive satisfaction in making my life outside of the art studio a shitshow. He even later managed to switch into Di Raco's studio, following me there. But he did not make a splash when he was there.

There's a difference between jealousy and rivalry. Jealousy is the negative side of the coin. It's born of a feeling of inferiority on one person's part. Rivalry can have a jealousy component, but it has also historically been beneficial to the development of art. Rivals can be confident, strong artists who compete with one another and try to surpass the other, but not necessarily by playing dirty, more by elevating their game. I was yet to meet my peer artists (and rivals) who would actually become my life companions.

When the Accademia closed that day, we had already maxed out our possible sleepover couch-surfing locations. We literally did not have a place to go. We ended up in a bar that was a student favorite, offering thickly stuffed, cheap tramezzini sandwiches and Aperol spritz, the cocktail of choice. I was there, by then drowning in my own sweat, feeling like I was coming down with something, while Gregor would just not stop: "We are true artists! We will drink until they close the bars, meet somebody with a flat, fuck them or just stay up until dawn! This is the juice of life; a true artist is homeless!" He would rant and fire out his mind farts and half-baked visions, all utter and total crap, about what art is and should be, and how he was, more than ever, in tune with himself. I could have killed the guy, seriously. But I wasn't feeling well, and I could barely move from stress, late nights, and little sleep.

But then it happened.

The doors to the bar opened, and there she was—the strangest and most beautiful image. Yeah, that's the thing. That moment was so unreal that it felt like what I was seeing must be a mirage. It was not exactly a moment of classical, romantic, lovestruck beauty. It wasn't, "That's it, I love her." It was sublime, like the recognition of some greater power that exists and moves things for you, in your direction, to extend a hand as you flail in the waves. Something happened, everything changed, but it was as if I had nothing to do with it: a single gesture of somebody walking through a door.

The idiot would keep on talking, but his voice dissipated into nothingness, his whole threatening persona melted away into the surroundings. In a matter of minutes, she, Meta Grgurevič, was at our table. "I hear you guys study at the Accademia; is that right?"

That was it. She was there with another Slovenian art student, Jasmina Cibic. Meta was staying at Jasmina's place, a house full of students on the Lido, a sec-

tion of Venice known for its public beach and 1950s dolce vita glamor, long faded. Jasmina was one year ahead of us and already the talk of the Accademia.

"Do you guys have any plans for later on? We are cooking, so if you want to join in you are more than welcome." Jasmina invited us along with the elegance of a veteran. And that, right there, was my lifeboat.

In a couple of hours, we were all in this beautiful house, full of students, all girls, with my fever (yeah, it really was a fever) going unstoppably up, in an incline parallel to Gregor's narcissistic parade. At one point, when Jasmina could clearly see that I was about to collapse and that Gregor was getting more and more drunk, she offered her bed for me to lay down.

When I opened my sore eyes in the morning, I realized I had been stricken by a proper flu and that the best thing would be to get my ass back to Ljubljana and lay low, since I did not see any option for rest and recuperation in Venice. I also realized that I'd slept in between Jasmina on the left and Meta on the right, a situation that would soon enough become my reality for a month. But that morning, I could still hear Gregor's obnoxious, self-indulgent laughter in the next room. Jasmina gave me a full play-by-play of how the night went down: how he had gotten completely drunk, started a fight, wanted to go out again and set up an artistic revolution. I decided to share with Jasmina the story of our friendship and of his leaving me to flop like a landed fish, and she understood it right away. "It was clear from the start; he's a complete bullshitter," she confirmed. "You can stay here, if you want, for a while, given the severity of the situation."

What beautiful words. Me, in a house full of students, sleeping between two girls, while figuring out the plan of studies with a hotshot student like Jasmina? Hmmm, let me think about it . . .

I stepped outside, where Gregor waited for me, pale, lighting up a cigarette. We were supposed to see an apartment. We walked in silence to the first corner, where I turned the opposite way. I slowed my pace, to check which way he intended to go. I stopped briefly and said, "I am going this way. Without you."

I never turned back. I don't remember how I dragged my ass all the way back to Ljubljana on that horrible, extra-long train ride. I literally collapsed when my mother opened the door at home. She did one of her voodoo healing things that night on me: rubbed my shivering body with chestnut schnapps and covered me with blankets. I hallucinated for a night, sweated the living dead out of me. I had two days to get better so I could get back to Venice, to my studies and to the start of a new week. I was set to get into Di Raco's studio and I could camp at Jasmina's for a while.

Monday morning I was back, with this hurdle cleared. Now it was time to get to work for real.

It was an incredible, intense period: drawing constantly, first thing in the morning and last thing before collapsing at night, drinking cheap wine. I would daydream about making a 14 × 5 meter painting, but I didn't feel close to that yet. I fantasized about turning into an abstract painter, but I didn't know what it would take.

Then I figured out how to shift from figurative painting to abstraction. It was one of the most liberating moments of my life. I saw a door I simply had to walk through. Especially at the end of the year, I produced some works that still, to this day, surprise me when I stumble across them, as many are displayed at the homes of friends. It was the first period during which I managed to discover and maintain a deeper state of mind, where I would create an ever-closer relationship with what I was doing, when my own works would mesmerize me. I would be working and enter a magic zone where my thoughts would fly faster than they ever had.

Once, Meta and I spent a whole night talking about art together, at first just as flatmates. The conversation was greased with our complaints and tactics about how to deal with frustrations. We both felt not just humbled but crushed by what we were facing. It was as if we were frantically calling out for lifeboats in a choppy sea, fragments of our past identity, while understanding that we need to embrace the sea. We knew that we needed a strategy to do so, or we'd lose our ways and our identities as we'd so laboriously developed them to date.

I expressed some of these ideas to Meta. As I described to her how I imagined I could go further, she looked at me and said, "You already have." She made me realize that I had cracked *how to do it* conceptually, and so it was just a matter of *doing it* with this in mind.

My conversation with Meta and her support was the push over the edge—for my art and for our relationship. That was when we got together. It was the first relationship I'd had with someone who did not feel threatened by my achievements and ambitions. Other friends and lovers had stopped me, subconsciously or otherwise, out of fear or jealousy or a mutual lack of understanding. She was also the first artist with whom I fell in love.

I went to the studio that day, after our all-nighter, and opted for a new direction. Poof! And it was beautiful. Something unpredictable started pouring out of me. It took about five minutes for Di Raco to show up beside me. The resulting conversation helped me to establish cornerstones of my own creative process. I learned to keep on boxing the bear until I ended up dancing with it. Every time you succeed, the dance lasts only briefly before another crisis hits, and the boxing resumes. But each bout is an opportunity to grow and develop, to evolve.

Di Raco allowed me to find my own structure within his studio before he came along and started really working with me, commenting. I'm still grateful for it, for him. I saw the achievements of the older students. I was literally painting in their shadows. Di Raco helped the students develop their own destinations. The visible jump in quality within the same studio space, first years versus fourth years, was a testament to the quality of the professor. We all had our moments of despair, disillusion, exhaustion, of feeling lost in the wilderness of options. You start with a blank canvas, literally, with infinite possibility. That's when you are closest to what we call freedom: absolute freedom of choice and expression. Then what? Then you make your first move, and that pushes you into the field of choice. From there on it's either a struggle or a dance. At this early stage, it was mostly a struggle for me, particularly recognizing the gap between what I wanted to do, what I could do (when looking at the work of others and seeing what they've done), and what I actually could pull off given my experience and skill set. But Di Raco managed to find you in those moments, clear the smoke from your vision, and help you focus. He never did it with a palpable solution. He just pointed out the problem. That made you not sleep for a week, but the solution you came up with was yours, your cracking of the code. And so it stayed with you.

I exploded—in a good way. That spring I did everything I'd dreamed of to date. I made bigger canvases, I splashed my expression. I shed my fear.

By the end of the year, Simone and I would invent brushes that were big enough to cover canvases in one stroke after dipping them in buckets of paint. It finally felt like with these brushes I could bring an emotion and ambition, but instead of the usual drama that manifests through dark, mostly brown or red shades, I would splash pink and baby blue. This felt good, as it felt like I was adding complexity to the form and content simultaneously. I finally could paint something that conveyed, for example, strawberry-ness, without actually painting a strawberry. This was a breakthrough, a liberating time for me, when pleasure and ambition began to walk hand in hand. And it seems that when you achieve an artistic breakthrough, other things in life seem to follow suit.

Before it did, life got so dramatically complicated that I thought I would have to interrupt it all. Finding an affordable apartment in Venice, one that was not rat-infested and had at least a moment of daylight, was a nightmare. Art students the world over will sympathize, especially those studying in big cities. Finding decent, budget-acceptable housing is a big headache, as is finding flatmates who will not drive you nuts. I bounced from one apartment to the next, dodging disastrous flatmates. Winner of the most disastrous flatmate award goes to a guy

who was a reserve cop, working two days a week, and otherwise engaged full-time in watching TV and smoking pot from plastic bags that he brought home from work. He once found me staring into the void in the middle of the night in the kitchen, and he said, "Jaša, what the fuck are you doing?"

"I'm drawing," I replied, "planning for tomorrow's work." I was referring to me "drawing" lines in my mind.

"I knew you were shooting heroin!" he shouted. It took a good deal of diplomacy to convince him that this didn't warrant further investigation.

In the last part of that first year, mostly due to the overpriced rent, we were so poor it hurt. But we managed to work and party like crazy. We survived on pasta and cheap red wine. Our circumstances led us to some shameless shenanigans. Once Simone pretended to be sick next to a vegetable vendor boat, in order to create a diversion while the girls stuffed as much greens as they could into their bags. We ran off with celery sticking out of every pocket. I came up with every recipe I could think of that included celery. When I collected enough coins to buy us eggs and a thin slice of pancetta, it felt like Christmas. Such is the life of most art students: young, poor, and sexy.

At some point I called my father and fed endless coins (good old Italian lire) into a phone booth. I was at one of my lowest points and needed a pep talk. He told me, "The thing is that you only know you are out of the worst when you look back and you don't recognize the person that was you. Due to the extremity of the situation, you slide into a survival mode personality and you literally shut out half of what is happening around you, because if you did not, it could completely derail you."

I was talking about the overcrowded studio, the constant chatter of the other students, and the terrible living situations, the combination of which had pushed me to the edge. I felt like I might snap. I dreamed of better conditions, of situations that would enable me to fully bloom.

"We can all dream of better, perfect conditions," he continued, "that would enable us to be the perfect version of ourselves. The danger is that reality never lives up to these dreams, so we can risk never fully developing our potential if we rely on them. I remember when I started my studies, I became somebody else, whatever the given situation required, good or bad, so I could survive and nevertheless create options for the real me and seize any opportunities. I found out that I started training my own flexibility, rather than losing energy in whining and complaining. In extremely terrible conditions, with roommates shouting and mocking me when I had to study, I cut out a silent room in my own head. From there on, any place where I can bring my own coffee cup and place it on a desk becomes my space, my dream condition, a place where I do whatever I want."

From that day on I resolved that wherever I go, I'll take my favorite coffee mug so that in the morning, in that cold unknown place, I can go to where things are most familiar, dipping into my creative process, and just start working. Virginia Woolf said that everyone needs a room of one's own. Since I couldn't afford that, I'll go with my father's low-budget alternative: Everyone needs a coffee mug of one's own.

## HOW CAN I MAKE MY FIRST PROPER SALE?

Early on for us artists, selling equals success. This is as hard as starting a career. I'm not saying this to scare you off. On the contrary, I'm telling you this so you can get ready for the kind of bumps that will inevitably rock your ride. I will always remember my first proper sale, back in 1999. The buyer was a big-shot lawyer and an acquaintance of my mother. I'd finished my first year at the Accademia in extremely high spirits after a dark and intense winter.

One summer morning, this big guy rang at the door and came blasting into my Ljubljana studio, saying, "I hear you are a good young painter, and I'm looking for a good, big painting." He liked what he saw and commissioned me. He paid a quarter in advance, and we settled on a price that I remembered deeming "super cool" at the time. I painted like a madman, riding this amazingly positive vibe. I cracked the painting in an extremely short time. It felt dynamic and fresh and, as ordered, it was big. I knew I had to wrap up the process or I would destroy the momentum, so I called him. He came charging in, as he had the first time, stating, "So are you done? Where is it? *Aha!* Fuck yeah, I love it!" And that was it; he left.

I was on such a high, it seemed surreal. I asked a friend for help, and we moved the painting into the patron's apartment. We hung it, and it looked so freaking good that I felt like a star. He was there, got a whole leg of prosciutto out, started slicing it and opening bottles of wine. In an hour, I was so drunk that I started to wonder how I'd make it out of there, but that buzz fueled my high. He gave me a fat envelope once we'd drunk all the wine and he had to go to dinner. In a few seconds, bum-bam-bim, it was done. I was so happy that I even cried in his stairwell.

If only it always went so smoothly, right?

Soon after, this fear leaped upon me: What now? Now that I've gotten a taste of it, what next? How could I get more such sales? How could I keep this flow, well, flowing? The best thing I could do was to get right back to work. Though, to be fair, I did invest some of the sale price in some proper

joie de vivre, too. I tried to use that energy as a wave to ride past the doubts that inevitably started kicking in.

When in doubt, keep on working. If you don't, then once the high subsides, you might find yourself waiting for another "chance" opportunity. It was luck or fortune that sent that big patron into my studio, and it's no good waiting for it to strike again. In time, you get to learn how to generate other business opportunities, too. But when fate sends you a wave, ride it as long as you can, man, and remember the feeling during the down moments. Your first sale is, most often, down to chance: The right person happens to come across your work, loves it, and buys it.

The first time you land a solo show in New York City, get a big interview in an important newspaper, or get into a major museum show—these are the touchstones that can make you feel like you've made it. Each time a box is checked, it feels bigger and therefore more frightening. You feel like the ground starts shaking. And the danger is that the highs can be so high that you don't know what to do when you're brought back down to earth. That first big sale, coupled with the approval of Di Raco, made me feel like I had made it. Round one down, the points were mine, but the bout of boxing with the bear continued. The beast even took time to put lipstick on.

You know that when you've been focusing on the mountain you want to climb, the moment you reach the summit, besides feeling satisfaction and a sense of achievement, when you look out, you see other peaks. That probably sounds like I read it in a fortune cookie, but it's true. What I saw and realized at that moment was that I was not the only one who had climbed the mountain, and not the only one feeling that triumph mixed with "What's next? bring it on!" I had become the number one student in my year, and I'd done it without exhibiting. I intentionally participated in no exhibits during that time. Now I could lift my head from my four square meters and reengage with the outside world. And my outside world was Venice, the Biennale, the Guggenheim, Palazzo Grassi. I was no longer in a local scene but in a milieu with the big shots. I had fulfilled my goals in the process of creating my work. It was time to step outside again. It was time to invite another huge beast back into the ring: the process of exhibiting your work. Unlike many of my peers in the studio, I was experienced in this.

But to do that, to swivel externally, to put myself out there, I wanted a fucking band.

# 4

# FIRST SHOWS AND ENTERING THE ART SCENE

## How Early, and How Should I Show My Work?

Everybody is a rebel at dawn. Once you have your group of people and you've cracked everything in your local bars, clubs, and living rooms, it's time to get out and do all that publicly. Probably no one will want to show you at this point. That was the case for me. But I didn't let a little thing like that stop me. It spurred me on, made me angry, and that's the recipe I'd recommend to any young artist when they feel ready to show.

### HOW EARLY SHOULD I TRY TO SHOW MY WORK?

After my year on hiatus, when I decided I was ready to show again, I thought back upon how I pulled it off in my hometown. I realized that I'd been able to do it because I'd done it with others. The shows were collective efforts. Coming together with others was a good way to surmount this latest obstacle of mine, too: how to show in Venice. It also meant emptying my pockets and putting all the options on the table.

Venues can be the trickiest, especially with a limited or nonexistent budget. You may find collaborators who have the skills, access, or other attributes you lack. Audacity is always an asset. Your studio, a friend's garage, your local bar, an abandoned shop, your own living room where you lay down the foundations for an early morning revolution over coffee and a rolled cigarette—any of these

can become a public platform for others to see what you are planning. When you do that, be as cunning as possible, as playful, as provocative as you can. Do not put on your "grown-up suit." If you're crazy at five in the morning, don't become all polished at five in the afternoon. Keep the raw energy; don't adjust to what you think the public wants.

The sooner you learn to process and show your work at the same time, the better. Not (a) process then (b) I will show. Anything else (galleries, etc.) might push you into formalizing, becoming too uniform, too early. Your work on its own, at this point, is probably not that unique yet. It definitely is raw—or at least I say it should be. Then the combination of you and your environment mixed into the work can make it even more interesting and unique. The transplanting of your work alone into a standard white cube gallery might kill the other elements, remove what makes it interesting. Or it might simply kill your experimentation. Moving directly into the standard gallery format can erase a valuable period of experimenting with off-spaces, foundations that will allow you to develop a unique style. It's unwise, at this stage, to fantasize about those famous white cube galleries (for example, White Cube Gallery in London or Gagosian in New York—anything of that super-high level), because they are impossible to reach, at least for the foreseeable future when viewed from the vantage point of the question: When should I start showing? So focus on the accessible, the feasible, the stretches, not the chasm leaps. You'll need to crawl before you can sprint. Dream away, if you like, but don't lose time planning attacks against the impenetrable fortresses.

To be honest, a few among you readers *will* "make it" in the sense of your likely fantasies of fame and fortune. The exceptions to the rule make it harder for me to argue that this shouldn't be your target, because it's unrealistic for 99+ percent of you (I should say, of *us*). Out of every reader of this book, one or two will "make it" in the cliché stardom sense, the sense that I'm trying very hard to shift you away from targeting. It is excruciating to limit the idea of having "made it" onto a single, glossy celebrity version of the term. My emphasis is to show you the value of the significant percentage who can "make it" in the sense of becoming working, full-time artists, with or without celebrity. That should be the aim—living off your art with no compromise. There is so much more than just the obvious celebrity system, and that system blinds us to the value of other definitions of success. The goal should be to be an artist, full stop, to live by making art that you love. Stardom is nearly impossible and largely vacuous and irrelevant, a time-wasting, soulless target. Your time is hugely valuable. You can never have it back. So use it to focus on the feasible. We are in this to create a nation of artists, not just a few.

When choosing which of your works to show, consider your one-on-one relationship with your work and how you discuss it with others. The perfect combination would be friends, rivals, and a mentor. All of their feedback is useful. Consider the feedback of all three before deciding which pieces to show. And make sure you feel that your choice is risky, audacious. What is safe will recede into the depths. Ask what makes your heart pulse and grind over the gears of your own audacity. The answer is the right direction. If you ask five people and all point to the same painting of yours, something strange might happen. You might start hating that work. In art, as in good music, you're not writing ten songs to come up with one hit, but you're writing ten songs because you're making an album. So if you manage to come up with a hit, after it has made you famous, it's okay to hate it. Healthy, even. Don't be afraid of last-minute snap decisions because something just won't leave you alone. If there's a calling in your head, even if it is deviant and strange, try to follow it, I would say.

In the Accademia, there were stories of students climbing into exhibition spaces at night before an opening to change, overpaint, or slash what was already set up for display. Part of this was definitely stage fright. That's not what we're talking about. But switching out for something unexpected, something that resonates with you better, is good. But we'll get to it, step by step.

At that point, with a successful first year under my belt and all fired up for the next, I felt ready to get back out there, but to do that, to swing externally, to put myself out there, I needed teammates.

## WHAT HAPPENS IF I FEEL INTIMIDATED BY THE ART AROUND ME?

I confess that I could not bring myself to visit the Biennale that first year. I could not face my fears. I was terrified that the art I would encounter would make what I was doing, what I was capable of doing, feel insignificant. It would shred to pieces my capabilities and self-identification as an artist. I came from a situation where I had to fight like a lion to get a chance to make art. I felt like the Biennale would burn my feathers and I would no longer be able to fly.

But I was so surrounded by chatter about the art at the Biennale that I started to develop strong opinions about works on display that I hadn't actually seen but had just absorbed information about through the conversations of others. I was ashamed about not being brave enough to go, so I never let on. I never went that first year. I became so good at debating works I'd not seen but heard so much about that no one knew.

Intimidation is normal, especially if you are young and confronted by "grown-up" artists. It's all about how you react. If we create a safe zone for ourselves by refusing, going against, blocking out, making excuses to do less work, that's not helpful, and you are damaging yourself. If intimidation pushes you into isolation to get more work done, then it can be positive.

If you can debate your dilemmas, convictions, upbringing, and influences with other artists of your own age, you can propel yourself and each other forward. This is how Crash in Progress came about.

By the end of the first year, my friendship with Simone was based on our working side by side, testing, trying, channeling to find what we really wanted to do. From my experience showing with others back in Ljubljana, through Marko, I realized it would be more interesting, efficient, and fun if I found a group to show with. Simone was the obvious choice, and we debated who else we should invite. We settled on Peter Furlan and Giorgio Andreotta Calò.

Giorgio was a good-looking young artist who floated through life with a cloud of mysticism surrounding him. But he worked hard; he was a sculptor and a rare student at the Accademia who was actually born in Venice. There was a WAGSWDSS (Weird Anonymous Group Show We Did Somewhere with Somebody) to which we three were invited: Simone, Giorgio, and me. Installing that show, I remember that just the three of us were actually installing into the night—the others just sort of dumped their work and left. Out of more than twenty participants, we were the only three who seemed to be similarly obsessive, ambitious, detail-oriented, and ready to work hard if needed.

Giorgio always wore the same pair of shabby jeans that he'd not changed in years, with a similar jacket and hat. On the second day of the installation of that early group show, he invited Simone and me over to his place for pasta. We emulated his swagger as he strolled down Venetian alleys, leading us to one of the biggest palaces overlooking the Grand Canal. By swagger, I mean there's a way that Venetians walk and especially traverse the hundreds of tiny bridges that connect the hundreds of tiny islands that comprise the city. There are no cars in Venice, so you can't show your style, strut your stuff, with a cool or expensive car—that's how "mainlanders" might do it. So instead, the way you walk can distinguish you, point to you as a mover and shaker. The preferred "I'm important" method was to cross bridges with fast-paced, short steps with a jumpy spring to them, cutting down on the real estate covered, switching down alleys and using shortcuts down little-known paths. Giorgio's approach was different, what you might call a laid-back ride: wider steps, smoothly shifting weight from one to the next with an evident use of the hips, creating a sound that went something like "*sthak*-pause-*sthak*," with a bit more length in his left

leg; arms at his sides, slowly swinging his way along, full of intensity of gaze and observation, but a slow mosey approach. To make it even more vagabond *assassino*, he would always chew on a half-length Toscanello *cigarillo*. That was Giorgio Swagger 101.

We were all students living in dark, sometimes rat-infested student cave rooms that never saw daylight—all we could afford in Venice. By his appearance, Giorgio looked cut from similar cloth. But then we entered this palace, walked up to the Piano Nobile, and were greeted by an Indian butler. He asked to take my jacket. I didn't know what to make of it and was a bit embarrassed. Giorgio was the first proper Venetian I'd met, my first encounter with ancien régime nobility. Giorgio was trying to rebel against his heritage with his clothing and manner, but this would eventually help him.

Simone and I talked to Giorgio about our idea, over that first plate of pasta we shared at his *palazzo*, about doing an exhibition: a project as a group, but as an independent group. We saw how this early group exhibit didn't do things as we would have liked, and how we, on our own, could do better. We realized that we needed an additional member who was already out there. Peter seemed to be the answer. He was a rock-n-roll young painter already involved in organizing projects, events, exhibits, and presentations at a level we hadn't dreamed of. He was a year ahead of me, from Trieste. He was always with his girlfriend, Martina, and they were functioning as one. There was something so extremely sexy but uncanny about them. They seemed both so self-sufficient, especially Martina, but yet so open-minded and ready to take on the world. At the time, all I knew of them was their work. I admired Peter's ability to fire off almost a painting a day. All around him was so utterly and naturally punkish, but he would spin a brush instead of a guitar or mic. I just loved that raw, audacious, all-out I-don't-give-a-fuck attitude in how he treated pretty much everything on or around his large canvases. He would be the first to start painting but also the first to stop and wrap up, turning on his heels, flashing a smile to whoever might be watching, and adding, "Fuck it, that's it from my side for today, time to smoke and drink!" If I wanted anyone on the team, it fucking had to be him! So we decided to approach him, assuming that he would be up for it, too. He accepted, and it was time for the first organizational dinner.

The first year, when it came to housing, had been a complete fucking nightmare. Then, we were looking for anything possible, anything we could afford short of a rat-infested, cave-black, this-is-what-you-get humidor.

During the summer, we finally got lucky and moved into a dreamlike apartment. It was just behind Teatro Fenice, one in a goddamn million. This meant high ceilings, beautiful tall windows, large rooms overlooking the canal, and a

proper stone atrium, which, in the coming years, became our spring and summer party place. It was full of stairs and weird passages, larger apartments sliced into smaller ones (with extremely thin walls, so you could hear *everything*), and packed with students of all ages.

A year later, Meta came up with her all-female group. We would have to come up with a schedule for our various group meetings. A healthy rivalry rose up between us. Before we even established what we would do, what our name would be, we would have dinner parties and fight over our varying visions of what art should or could be, about what our convictions were, about what art should be. Peter was the most progressive, the most fearless, the best able to embrace contemporary art for what it stood for at the time. The rest of us felt, conceptually, that we were struggling enough with what needed to be done in the studio to bother so much with the big questions and ideas. On the one hand, you ask yourself, "How do I make art?" On the other, you can graduate to, "How should I present this to the public?" For us, the name we chose, Crash in Progress, was about how we would always disagree about how something should be done because each of us wanted to push through our own vision or idea. But I had experienced, back in my grunge days, that when you find expression and original "sound," it was because of chemistry. Chemistry rises when you stop fighting based on egos and use that hyper-charge to merge dissonant ideas into a better collective solution. The blood treaty we signed verbally was that fighting was okay as long as we all knew that we were making progress, working toward the best solution. It didn't matter whose idea won or if it was a merger of several ideas; as long as we knew that the solution was the best possible one, then the fighting had been productive, and we could concentrate on how to turn ideas into realities.

When it came to brainstorming, Peter was a machine. You could hate him for how great he was at pushing limits, but man, was he good. His whole thing was about always taking the wrong turn. If the rest of us thought, "Fuck video art man, let's do something else!" He would go, "No, video art is the next shit; we need to invest in that!" His whole persona was: "I know what I like; I know where I come from. Okay, let's fucking focus on stuff I do not know. Let's cut the roots; let's shake the foundations. If everyone else hates performance art, then I will learn to love it!"

Giorgio and I would feel frustrated because Peter didn't want to jump into the material as quickly as we did—he wanted to continue conceptualizing. But those differences made for a more powerful whole. And we had to put the ideas and plans we batted around over dinners in the evening into action the following morning. Peter allowed me to start digging into my own roots, too,

to actively abandon what I'd learned, to broaden my horizon, to face the fear of the unknown and learn to love it! In the coming years, we became inseparable. We became this incredibly well-oiled machine, constantly pushing each other.

This all started in Venice, which had no galleries or exhibition spaces for up-and-coming artists. So we had to invent places we might show, what we wanted to show, how we wanted to show it, what we wanted to call it. How could we get funds to cover expenses? We had so many questions and no answers at the start. We would push our plans through heated Friday dinners. Come Monday, we would compete to see who was the first in the studio to get to work, who was the first with solutions to the problems thumbed over during the weekend, and who would present the best solution during the first coffee break. It was a mutually supportive competition for everyone's benefit.

This was my second year. I was a nobody outside of Ljubljana. I had no useful connections. But what I'd learned from Marko was that when he wanted to do something, he didn't think vertically. He spread out horizontally for solutions. Marko would come up with an idea in a bar and would turn to others at the bar and start hitting them up for funds or spaces or solutions. He was shameless and chaotic in this approach, but it was admirable that he tried. I decided to borrow his technique: Let's use our connections and bring them all on the same table—Giorgio from Venice, Simone from Padua, Peter from Trieste, and I from Ljubljana. Through a fat stack of rejections, of doors opening and closing, of endless noes, we never gave up. We found a space. We found a sponsor. We found a launch date. Every community has its own ways to pry open doors. To explain what we did is not really relevant unless you are in Venice twenty years ago, but each community has some departments linked to culture, state-run or local or private. There are funds available and spaces to be used.

Venice is full of smaller, dark spaces. Big, spacious, light spaces there are expensive and hard to find. We decided we would have to find a virgin space, nothing gallery-like, and harness it, make it bend to our wishes. For every artist starting somewhere new, working on a show with peers in a nongallery space is a great experience. It helps you understand how things get done when you have to do them yourself. Actually accomplishing what you set out to do is so powerful for your self-identity. We craved the opportunity to prove our worth, to be art warriors, to go to urban battle and emerge as Artists.

Could we really make our oversized installation? Could we make the quality of video art we planned? Could we print our own invitations and actually get people to come? Could we plan an opening that would involve prosecco and food? In the city of Biennale, the expectation was that art openings should be big. Everyone in the Accademia knew we were up to something. We generated

curiosity and hype built on promises we don't know if we could fulfill. We were audacious in offering a lot more than we had or were capable of delivering at that moment, but we put in the hours and the sweat. Not enough time, not enough money. We started to realize that every aspect of a show is part of the story. The invitation isn't just a conveyance of information but can be a work of art itself. The opening ceremony is not just drinks and snacks but could be an event unto itself. The way people move through the space could be a work of art.

## SHOULD I ASK THE OPINIONS OF MY PEERS ABOUT MY WORK AND INSTALLATIONS? AND WILL I GET A STRAIGHT ANSWER?

Crash in Progress saw each of us working on our own artworks, maintaining our autonomy, so we were not creating works together but creating exhibitions together. That's an important distinction.

This might seem strange, as we considered the exhibitions themselves to be artworks. That's why we joined forces; we all understood so well how many fields you need to cover in order to make every detail of an exhibit fit your vision. The way your work relates to the space around you, whatever the medium, is difficult to predict and, in my experience, is never ideal. To the contrary, usually your work feels like it shrinks, becoming a pale version of what it was back in your studio. This situation triggers that hot-cold drop of sweat breaking down your neck and spine, where you elbow the person closest to you: "What do you think? Is it okay?" And inevitably they say: "Yeah, it's amazing," even if it isn't. And so you decide to ignore the shivers and go out for a cigarette, deciding the installation must be okay. This approach means less work for all involved, and an earlier *aperitivo*. It's nice to pre-celebrate, rather than obsess and try to fix your work or the exhibit space in the last days before showtime.

But if the person you elbow is realistic and senses your doubt, they should reply accordingly. If it is your peer (not your friend) and this is a group show, the thought will be: "Okay, this one here is not even getting basic lightning, so one less to worry about, one less competitor." So, the peer will say, "Yeah, it's amazing!" And after you leave, the peer will work on creating some better conditions for their own work. If you ask the question of a mentor, their likelihood of an honest and helpful response depends on many things, above all how many relevant exhibition experiences the mentor in question has. I have seen amazing art tutors who were inspiring mentors but not that inspiring when it came to their own work or how they showed it.

The question of how you show your work is as complex as how or why you make your work. It's sufficiently complicated that some might simply shy away from such a demanding task and question. Asked, "Is this okay?" any reply other than, "Yeah, this is amazing!" will get complicated and strung-out, involve sweat and nerves and ego . . . a potentially messy situation that you probably do not feel fit to face. When it comes to whoever is supposed to be there to cover your ass—a curator, a gallerist, a technician—there are so many reasons to fake it. It is simply demanding of work and thought and energy, which is likely in short supply shortly before an opening. Something or everything feels "off." Peers are more likely to see you as competition than as a teammate. If this fact is still fresh to you, you might naively think that we are all in the art business together, and making and showing art makes a better world, right?

Bollocks, I'm afraid. It takes time to realize this. It can be a hard fall, the emotional equivalent of broken ribs. It's disillusioning, but that's capitalism for you. Survival of the fittest. There are only so many patrons out there, only so much in the art acquisition fund, only so much space in the newspaper column—and if one person gets in there, it means someone else, a lot of someone elses, are left out. So erase your illusions, or at least scale them back. The sooner you are aware of the shark tank that is the "community" of artists, the better. You can start to single out the bullshitters, and frankly, they vastly outnumber the "good" folks. So if, in a moment of doubt, you turn your eyes toward somebody who is supposedly there for you, try to read the situation first before blindly throwing your question, often a desperate cry for positive feedback to restore your shaky ego, in somebody else's direction and seeking approval. This may be how it is now, but I am optimistic that things will improve.

Meanwhile, I've developed some tricks to share about how to navigate the current waters. It's shit the way it is, if you ask me, and many have tried to convince me that this is just the way it is and that I'd better accept it and swim downstream. But I'm a proponent of moving away from selfish asshole behavior and toward a definition of "making it" that allows for camaraderie among artists, even if the current environment seems bent on forcing artists into a Darwinian gladiatorial arena.

When we met to install our work, Giorgio, Simone, and I all stayed late, fixing what we could in that early WAGSWDSS, before we became an official group and when we followed Giorgio's swagger back to his palazzo for the first time. We stayed and stayed and adjusted and adjusted, because the shivers would not cease. The overall situation was complete shit and we were trying to work through it. We tried everything we could in a far-from-ideal situation. Later on, in other group shows, already as a team, we would end up helping

each other when we had nothing but purely resolvable technical problems. Do not imagine that it is all about utopian altruism. In my opinion we, as a society, can truly function only through small gestures of camaraderie, and when you can detect a defect and your role within it—and help to fix it—this can make the world a better place. It also helps if your work is in a show that has a general professional level to it, and you are not surrounded with hobbyist approaches toward the basic how-to of making and exhibiting a work of art.

Over the course of a long night preparing for the show, we would discuss all the possible flaws, traps, and easy ways out. We would discuss all the mistakes one can usually make and not only how to avoid them, but how to turn them to our advantage and make them part of our art. This is why and how we all started working together, because of that question: "Is it okay?" For Peter, Giorgio, Simone, and me, that became a challenge. When Giorgio approached me at that first WAGSWDSS show, asking me the question, my answer was: "No, it is simply not working."

"Why?" was his reply.

"Because everything around the work is off. I mean, I love the sculpture, but the spot is wrong, the lighting is shit, and it just does not work."

But here's the key. I didn't stop there and walk away with a secret fraudster grin on my face, thinking I had just scored some advantage points. I continued and did my best to help, saying, "In my opinion you could try this . . ." And this was it, this is how we hit the "progress" part of the oath. We proactively and consciously decided to always ask each other these questions and to answer them honestly, to not slack off and go with the easy route, to not view each other *only* as competition that should be impeded so that we might advance. That may sound normal and civil to you now, but it was radical and against the grain then, and it still is in most art community contexts. My father always called this "healthy competition." He said, "Embrace things that kick your ass, let them push you forward. But don't become an asshole." When he taught this to me, it was in the context of my early competitive sporting life, but many of the same dynamics were evident to me in the studio and in these early group shows. There is a small but important distinction: In sport you know you're competing due to dripping sweat and kicks in the thighs, and this is not glossed over or sugarcoated. In art communities, the competition is there but beneath the surface, and it is made up with a lipstick of faux friendship and team spirit, the idea that we're making art to make a better world.

The first show was eponymous: *Crash in Progress*. As we approached the opening, we were all preoccupied by our own work. We never came up with a proper hierarchy of roles, and perhaps we should have spelled that out. It makes

it easier to have each person know their role ahead of time, even to have it written out. But the opening happened, and it was a huge success.

I need to qualify "huge success." Venice doesn't have private galleries, so we were not selling works and finding representation. That was never an option. It was a success because it was packed. Everyone we hoped or imagined would come to the opening came. Loads of people drove over from Ljubljana, Padua, Trieste—our hometowns—which I did not expect. That made each of our spheres of contact expand many times, all in one go. If you can create an atmosphere of sincere celebration, not just among your friends but sending out the vibe, "Man, these guys have really pulled it off," then the sound of the prosecco corks popping really pops. Overnight, we became the stars of the Accademia. That was all we could hope for within the context of Venice in our second year as students. We had set out to be autonomous, to learn from doing it ourselves. It had been all on us. And it had worked.

We exhibited that first show, *Crash in Progress*, in 2001, at an old, deconsecrated, gutted church at the end of Via Garibaldi, the street behind the Giardini where everyone goes during the Biennale these days. Back when we were there, it was still a bit of a hidden spot. Even through the Biennale had external events, there was no way we could slip into it; this was a close as we could get, geographically, and we ran the show when Biennale was on, so we audaciously hoped to get some spillover from Biennale visitors.

But just before we started installing the show, we got a call from the chief of the youth culture department in Venice, who completely supported our cause—she liked us and our enthusiasm and ambition—and allowed us to have that amazing space. "Good morning boys," she said. "One thing before we forget, as you start installing soon. Absolutely no nails in the walls. Not even a scratch. These walls, as with most of the walls in Venice, are of historical value and have culturally protected status. That aside, I wish you all the luck in the world."

"Not a fucking nail?! How the fuck are we supposed to install a goddamned show of large-scale paintings and shit?!" was, if I recall, our articulate and measured response. But, yeah, that was it: no nails, and just two weeks before showtime. And honestly, this was yet another problem to add to the mountain of issues we faced. It completely sank us. How do you stick something heavy onto a wall when you can't make any holes in it or stick any bits of metal into it? We had to come up with something brilliant and very much outside the box.

The video, in the following years, became our unwritten manifesto, our treaty, our promise, to each other and each self. It showed a skinny, muscular guy trying to catch an elevator (as we felt we would be, doing an ambitious show and heading straight to the top)—but he misses it, lingers, then frantically opts

to run up the stairs and catch the elevator on a higher floor. Once he starts opening the doors, he goes through unimaginable spaces that become unforeseen obstacles and challenges: a stairway door leads him to an open field, to turn behind the tree, a street corner, jumping into water and coming out of a bathtub, and so on. While passing through these obstacles, his determination only grows, even as scars and bruises start piling up from hits, bumps, and falls, including a car crash. Eventually, he manages to get to the next floor, before the elevator doors close. He gets in, relieved, rises two floors with the lift and, just as we think that this is it, he continues to run. While hoping, seeking for an easier, shorter path, what he finds out is that he is in it for the love of running.

At one of our dinner parties, with me cooking frantically and us all consuming far too much terrible, cheap Venetian red wine, we invited over the team from the German Pavilion, including artist Gregor Schneider, who would win the Gold Lion that year. We ended up in a push-up contest. He won by a mile. Mihael Stab was the technical director of the German Pavilion that year, and he and I struck up a friendship. In the opening week of the Biennale, everyone is everywhere, and you just stumble across people at various parties and events. He wound up asking me about some logistics in Venice, as I looked like a local artist, and I was able to help with some advice. This piece of good fortune was a way for us to slip into the milieu of the Biennale uninvited. Another night we wound up getting naked and covering ourselves with acrylic paint, which (after partying all night) seemed like a good idea until the paint hardened on our skin. We were scrubbing, vigorously, in all the "nooks and crannies," as you might imagine. This was our first contact with a major artist and the team behind him.

Buddying up with the German team and the Golden Lion winner was a special experience, more valuable than reading a pile of books and learning theory. And that was the first time I actually managed to see the Biennale. It blew my mind.

I was happy and proud of what we had achieved, but by diving into the works on display, especially Schneider's installation *Totes haus u r* (2001), I was inspired and frustrated. The work was an immense installation that Schneider had secretly conceived of over fourteen years. He was alone in his family house, and he spent all that time developing, altering, adding to his own house, creating a surrealist series of rooms and spaces, with additional walls, stairs, doors, windows of varying size and shape where you would never expect them. And then he brought his own house in pieces to Venice and reconstructed it there. It was monumental and breathtaking in scope. I felt I'd done as much as I was capable of at that age and in those circumstances, but I wanted much more. I wanted to throw myself into another gear. We all wanted that, and Schneider's

work showed us a potential direction. *Totes haus u r* summed up a theme we'd been discussing: What would it feel like to literally walk into an artwork—not into an exhibit, not to look at an artwork, but to move within it?

On one of our last drunken nights together, Mihael Stab said to me, "At your age, what determines a young artist is that you keep on working. Too many stop."

With Crash in Progress, we felt like we were rushing forward. But it would be a continuous rush over a period of five years. Even though we worked together for just that five-year period, we established our road maps for our careers: the pace, the passion, the hard work, the ambition that still continues in our individual careers. Our lifestyle was to work our asses off. What we did in the studio continued in evenings and weekends. The talking between artists over espresso and wine became constant debates, brainstorming which way we would voyage together. Peter was the most progressive. I was actually the most conservative of the bunch at the time, and that helped me crack my eggshell more than anything.

Within the context of socialist Yugoslavia and the milieu of my family, we were bourgeois hippie intellectuals, in touch with the zeitgeist of the 1970s and early 1980s, talking about books, music, and art. When it came to visual art, my liberal family had become more conservative by the time I was creating. My main hurdle remained my mother. She wanted her son to become an architect, and when I turned my back on that field, it was a terrible shock to her. It was a dramatic, filmic scene, complete with hysteria, throwing of books and maga-zines, kicking, and screaming. It was really traumatic at the time for both of us. Then, when she made peace with my shift away from architecture, she wanted me to be a more traditional painter. But now I did not want to be a traditional painter. I was in the heart of the avant-garde trends of contemporary art. Think of the Biennale: It is the oldest, most powerful and relevant showcase for the hottest artists of the moment. As a student in Venice, the Biennale was, logically, the be-all and end-all. Venice is a smaller-scale location—in terms of big art cen-ters like New York, London, Paris, and Milan—but Venice has the best of the best, though only for a period of a few months every two years. It is otherwise a quieter place with little art market and buzz. That makes it a perfect incubator. After getting your ass kicked, you have time to figure something out in the suit-ably brooding humidity of the Venetian fog. We joked that the Biennale was a "space shuttle": It came every other year, occupied the city for six months, and then flew off. Venice still has no relevant gallery system and no dedicated exhibi-tion spaces for young artists, so there are no points of contemporary influence outside of the Biennale.

# CHAPTER 4

* * *

Our next step was to embark on a series of smaller projects that helped guide us to where we wanted to go, artistically. As a painter, I was feverishly approaching polystylism, a term borrowed from music (led by the Russian composer Alfred Schnittke). The idea was first to embrace what had been done before, sampling from the past and from all potential influences, before arriving at our own conclusion. But while we are sampling, it should be referred to as polystylism, acknowledging that you are at the borrowing, all-embracing, gathering phase. This influenced our idea that an exhibit was a whole, a *Gesamtkunstwerk* that utilizes all aspects of a viewer's experience of a space: architecture, painting, sculpture, sounds; even scents, movement in spaces, videos, and performance.

Everything that happened after *Crash in Progress* had prepared us for our next big achievement. Meta's group, Passaporta, was like an all-female counterbalance to our Crash in Progress. While we were trying to guerilla build our way to success, Passaporta actually went for the real golden ticket to stardom of the moment: the Biennale of Young Artists of the Mediterranean. This was an official festival: Regions sent out an open call, artists applied, and those selected were sent to the main show representing a city, region, or country. Passaporta put in to represent Venice and won. This was the biggest official show possible at the time, with an exhibit in Athens, Greece. In one fell swoop, they'd kicked our asses. And I was sharing a bed with one of them, so it was a constant, if delightful, reminder. This was a wake-up call for us, as it had not really occurred to us to apply for it. It was a completely different procedure from the approach we were used to. Passaporta's example showed us how, by being selected, you can be handed an important international showcase and finances overnight.

We abandoned all the small things in development and decided that whatever we did next, it had to be a very big bang. We imagined it would all go smoothly, given our achievements to date. It did not. We started applying for all open calls available, and we got nothing. It was a difficult, frustrating process, and we simply couldn't understand why we weren't getting accepted; there was no class to teach us how to do this.

Because of what we did, we felt so punk rock; it was all about guerilla autonomy, doing it all on our own. Open calls needed a different approach. It required sitting down, studying the rules, and applying your vision (or even coming up with one that would fit the context). We just did not yet know how to apply to an institutional call.

We created opportunities where there were simply none. By doing so we projected an image of self-sufficiency. This was our survival mode, but became

our identity, too. By opening up to other viable options, we understood (later on) that the image of self-sufficiency could be understood as a disadvantage rather than an advantage. We simply had not cracked the code at that point.

Giorgio was the first to start applying to open calls on his own, once he recognized that it was a code that needed cracking. He was accepted as a solo artist. The rest of the group—Simone, Peter, and me—felt betrayed to some extent. I remember feeling that this was selfish and exclusionary. He hadn't told us about it; he just invited us to the opening when he had been accepted. Something was changing between us, but we did not know what at the time.

The rejections and disappointments pushed us on. Peter and I felt we'd lost out on everything, so we resorted to grandiose plans to climb back up, spending nights developing the craziest plan we could possibly think of. And we were crazy enough to believe we could actually make it happen. We created a fever state, and we knew very well that once we in the tumble of it, we could make amazing things happen. More and more, the video we made became analogous to our reality. We all hoped that by doing one amazing thing, we would get into the elevator and arrive at the plateau where everything is possible and everything is so much simpler.

Needless to say, it did not go like that. The video proved portentous, but not in the way we'd hoped. The more you achieve, the harder it is to cope with the fact that every new cycle means everything starts again, almost as if you have done nothing before. The runner was our manifesto; it became our lives. We realized that one huge exhibition or one ambitious video was not enough to ride the elevator up—that the running was constant, endless. Even when you'd catch a ride up one floor, you had to sprint to reach the next. Slowly it started seeping in that we were in it for the love of running, so we'd better embrace that and turn it into something magical. It was best to stop thinking how unrighteous it is, looking for the elevator all the way to the top that never comes our way. We needed to take the bull by the horns. Sure, we'd scratched the surface and made some sound. But that wasn't enough to make it last forever. We were in it for the love of the process, so we jumped up, heads down, all in, this is it, all or nothing. With this next one, we fly or we die.

In a way we did both. We simply could not know what was out there waiting for us, with all the rawness of a woken grizzly in the spring. We started kicking the grizzly in the balls.

We started with shipping containers in a public space in Venice. We worked with a young group of architects and came up with this far-out plan: We would put six shipping containers, one atop the other, so it looked like an autonomous sculpture. But inside would be a walk-in installation. It would be called *Dafne*.

# 5

# YOUNG AND BOLD

## How Do I Survive Building the Impossible (and the Aftermath)?

"Whatever you do, don't cross this part," Giorgio said to me a couple of times when we passed behind Thetis in his boat, indicating a stretch of the lagoon where the water was less than a meter deep. "It's really dangerous, as you can bust the motor and barely pull it out because of the suction from the mud." *Quit trying to father me the wrong way,* I thought to myself; I said, "Sure, Giorgio, I got it."

\* \* \*

"What if we lure in the public with the image of a cute, lovely little girl? But once they take the bait, we hit them with all the emotional weight of our work?" That was our concept. In our outreach to the public, we used a five-year-old girl as the face of the art project campaign, and we called both her and the project Dafne. At that time, in our eyes, shows were promoted either with a picture of one of the works in an exhibit or with just with the name of the artist. Choosing a different tactic, Dafne became the lure, a third-party option beyond our faces and names or a photograph of one of our works. We wanted a broader public. That was the start of our biggest adventure to date.

We decided to turn around the dynamics of who chooses who or who invites who as our response to the open call procedures we endured. We wanted to call the shots. Our ambition included bringing in more collaborators. What

we ended up with felt like a generational all-star team of active players and a transgenerational super-support team. All of this was done on a wave of pure enthusiasm. No one earned a dime. We were in it for the glory, all of us.

## CAN I WORK ON AND DEVELOP A COLOSSAL SHOW IF I DO NOT EVEN HAVE THE SPACE OR THE MONEY TO DO IT YET?

We had not yet secured the public space we would need, so all this was pre-hype, a promise without a guarantee. It's such a balancing act, as you need to charm people into following your craziness, when all you've got is your belief in a vision. In art, you are not selling a concept that brings practical benefits, you are creating and generating hype around a possibility. It is the strongest thing we can offer as artists, but it is extremely fragile, as it can evaporate the moment somebody looks at you and says, "So, I give you money, just like that, but what do *I* get out of it, financially?" The only answer is: "Well, actually nothing, per se." You can always offer your art, but at an early stage, that can turn counterproductive, as you want to protect your idea from exposure to any "How much is it worth *really*" conversations. People like to be associated with something fresh and wild—untamable energy. That's appealing, the fire in the eyes of the one defending the practically unnecessary but beautiful for what it stands for. But to convince the other, you need somebody who already speaks that language. We kept knocking on endless doors, one disappointment after another, until we found an opportunity within the space of Thetis, on the far side of Arsenale.

These days there are some external pavilions of the Biennale there, linked to those in Arsenale, but this was long before that time. Thetis is a research firm that owns huge hangars. The firm had someone who worked on relationships with possible artistic collaborations to promote the goodwill of the company. She gave us the chance to use the space. It was a huge naval hangar that had been renovated, with half turned into sleek, contemporary glass-and-steel offices. The other part was a colossal empty space walled in brick, in total some sixty meters long, ten meters high, and twenty meters wide. We had carte blanche. We had hit the jackpot.

By this time, we'd gathered a circle of more than thirty people involved or collaborating in the exhibit. We wanted to make it a proper walk-in sculpture, the next level of *Gesamtkunstwerk*, with the space itself already a work of art: You see the monumental sculpture, then you walk in and the voyage continues. We worked with a young group of architects, Plan 9 from Trieste,

to develop our own construction system. This meant we needed money for the materials, and we were not even close to having the amount necessary. But we set our opening date six months ahead. Now we had the team, the space, the idea, the launch date—but no funding, just gigantic balls. It's the sort of audacity you can feel in your twenties when you don't realize the scope of the consequences, because knowing the consequences can prevent you from doing something incredible.

Knowing what follows can suck the air from your lungs before you've taken your first step. But you've promised yourself, tattooed on your bones, that you'll never become the sort of person who rationalizes, "I could do it all, if I only had the means," which is just a bullshit excuse at the end of the day. Bullheaded is better than bullshit (if we're going to pick our ends of the bull), and so we took every "No," every "There's no way you guys can pull this off," as fuel for our fire. Our search for funds was just to cover costs to create the project. It didn't cross our minds at the time that there could be income for us. We needed to recoup expenses and have enough left over to live off. But those modest expectations were cut by the fact that we were looking at expenses for our build of over €40,000.

I managed to get an interview with the Franci Zavrl, head of the leading advertising bureau in Ljubljana. It was a meeting that changed the course of my life, enabling the craziness I aimed for, uncompromised. He was looking for an artist to support. This sort of thing—an old-fashioned patronage—just doesn't happen anymore. He had helped the previous generation's leading artist group, IRWIN, and now he was looking for a younger artist to champion. This was during Slovenia's independent capitalistic boom. Some people were making a whole lot of money and, emerging from socialism, were examining ways to spend that money in beneficial ways. He had first heard of me through my father, but the rest was on me.

## DOES THE ALTERING OF THE INITIAL IDEA DUE TO FINANCIAL REALITIES MEAN THAT I AM COMPROMISING OR PROGRESSING?

The project with the shipping containers, just on paper, would have cost around €150,000 (without all the unforeseen and additional costs that end up inflating all projects). As my later collaborator, Rosa Lux (who would become head of production on my biggest projects), would say, "When Jaša presents an idea with a cost, I double it, so it becomes realistic." This part, this lesson, on

my side was the hardest, the one that made me bleed a lot over the years. I guess it has to do with my upbringing and it stood in sharp contrast to Giorgio's—he was a merciless machine with everything under control on the financial front, down to the last cent. I just needed to know we could start the process and then I figured we'd manage as we went. This is not the way. As cold a shower as it might be to pin down a high-flying idea, to risk losing the drive and momentum, you need to *pin it*, pull it back down to earth. It will save your ass from a slow bleed to death along the way, or a quick, bloody end of the process.

The best lessons on how to deal with anything ambitious came to me from Zavrl. He was not to be messed with in the business world. Luckily, I was an artist and he loved artists. He would become not only my patron, but my mentor and my friend. He loved the idea of getting the most batshit crazy ideas to the wider public.

Meetings with him were usually twenty minutes each, as a rule. He didn't need to give you more of his time to know if he wanted to give you more of his time. So I pitched our idea for this second concept. Going into meeting with him at that time reminded me of my competitive basketball days, when the coach would keep me warm on the bench just to catch my breath and shoot me back into the fire of the game, where I'd have about five minutes to show my worth. No pressure, right? Just a few minutes to demonstrate that you're worth more. I would get ready, breathe deeply, and enter the fray all pumped up. You can't just show up all nonchalant, especially in meetings with potential backers! They are looking to see your passion, not your *sprezzatura* laid-back coolness. They want you to show that you need them and that you can make amazing things happen, but only with their help. That feeds the ego of the patron, and that's good for you, as an artist in need of patronage.

This was it. Boom—the doors to his office closed behind me, and I think I must have made one of those crazy happy dances, because the secretary sent me an approving smile. It was as if the coach had sent me in and I'd landed a three-pointer in the final seconds.

When this patronage was secured, other attempts we were making to cover smaller expenses, in amounts running from a few hundred to the low thousands, started to fall into place, as usually happens when the main donation is in. We had our funds, but there was no breathing space and we had only enough for the materials—nothing else. One of the hardest moments for Peter and me came when a double-length trailer truck arrived and unloaded seven tons of wood and three tons of iron for us to work with to make the custom structure. It was dumped at Tronchetto, the part of town where materials are unloaded for

delivery to Venice, and we didn't have the money to get the materials from the unloading dock to the installation site. Oops.

We'd had an idea to hire a professional team to build the forty meter-long, six meter-high, two-meter-wide structure that would be the focal point of the *Dafne* exhibit. But we didn't have the funds to hire anyone. Our first contingency plan was required. We just decided not to give a fuck. We redid the budget: It was there, clean and crisp on the paper. Just enough to cover the expenses, which included the requisite of the Comune di Venezia sending us a cargo ship to move the raw materials, but nothing for anything else.

We didn't even have enough money to prepare the hundreds of raw wooden beams for installation. They needed to be drilled and prepped to fit the iron joints that would link them together. We didn't have the tools or the construction knowledge to do it ourselves.

A sympathetic lady at the Comune di Venezia finagled us a place to store the material. It was an extra freebie on Certosa, a tiny island close to the section of Venice where Thetis was located, which was actually like a prison halfway house. It was run by ex-prisoners on their way to freedom but who were not quite ready for normal society, a half-probation. They could not leave, or "escape" the island, but it was their first taste of freedom and nature without proactive police supervision.

I will never forget Giorgio's face when he got off the phone, breaking the news to us: "So, this is what they can offer. We can bring the material there to the island, work on it and live there while working on it with . . . uh, well, sort of ex-cons."

He paused, looked at Simone, Peter, and me. We kept on looking at each other, thinking, "Is this really happening? Like, right now?"

"So, it's us, with ten tons of material, on a tiny island that is like a prison, but isn't, run by ex-cons?" I asked.

"Yup," was Giorgio's reply.

We exploded into a fit of laughter.

## IS THERE ANYONE ELSE I CAN RELY ON WHILE TURNING MY DREAMS, MY VISION, INTO REALITY, OR IS IT REALLY JUST MONEY THAT CAN WIN ME FRIENDS AND HELPERS?

The four of us moved ten tons of materials from the dock at Certosa into a hangar there. Let me repeat that, because you're probably thinking, *Hang on, really?*

*The four of you? Ten tons?* Yep. But let me walk you through this odyssey. When it came to the docking part, we had zero money for the crane. Peter and I went over to the guy in charge. It must have been clear that we did not have the slightest idea how to move ten tons of material from the truck onto the ships. As this was the only docking site for all of Venice, he wanted us out of the way as quickly as possible and did us a huge favor. Bam—the material was on the ships. Our possibly charming, possibly annoying naivete had benefited us again.

Seated on the cargo ships driving over to Certosa, we both knew that from here on, we were on our own. We didn't care. We'd just overcome one huge hurdle and were ecstatic. "We'll figure the next out, too," we screamed into the early summer sky and salty breeze as the ship cut through the lagoon.

Once we made it to the island of Certosa, we first had to unload the material. This time it was just us: no magical cranes, no army of assistants. A huge, creepy guy pointed to where we could store it all. "There," was the extent of his conversation: a hangar at least 250 meters from where we docked. Since the boat had been sent from the Comune di Venezia, our supporter, the taximeter was off. The clock was not ticking money away. So we started, moving ten tons, piece by piece.

I will never forget how Peter came, dressed as he always was, for a rock concert, sporting a new pair of flashy sunglasses, the Strokes vibe, and still moving ten tons of material by hand. As was Martina, the fifth member of Crash in Progress, who was either rarely present in this process or worked as Peter's satellite. We would have to move them several more times to other hangars on the island. I started adding marks to some of them, the beams, or the wooden sheets, or the iron bits, as we touched them, moved them, worked them so many times since that truck came to Tronchetto.

## SHOULD I ASK FOR HELP WHEN THINGS GO WRONG, OR SHOULD IT BE ALL ON ME?

We were warming up to the ex-felons, and they helped us move the materials by boat into an abandoned fisherman's house on the far side of the island. We recruited friends to help out and spent the summer hard at work in construction. But we had to invest all our pocket money into tools. We bought a machine to help us thin the ends of the beams. I rigged a support to hold the drill above the beams so we could drill holes in them to put the iron connectors through. We spent two months living on this island in the lagoon. Simone and Giorgio would thin the beams, and I would drill them. We slept in a nearby hangar with sleeping bags. The resident convicts lent us a tiny kitchen. One night I arrived

in the kitchen and there was a huge machete resting on the table. A guy three times my size, with a scar across his face, was hunched over in the kitchen. I was supposed to make us dinner there. Machete Man moved to make space for me, but his bulk blacked out the existing light from a tiny bulb hanging on a raw electrical cable over the wooden table. The kitchen was small, and now it shrunk further. I was terrified, but then Simone and Giorgio walked in. They must've met the guy already, as they started chatting about what we would eat, casually. My gaze remained fixedly on that huge machete.

Another guy, a quiet little one, would sneak out each night by flashlight to fish for cuttlefish. He turned out to be the creepiest. He was half my size, but his presence was chilling. He was shifty and quick, flipping his head constantly in alarm at any sound. His flashlight was there, dancing in the darkness by the lagoon every night. He gave us half of his hunted treasure once, perhaps a peace offering. I can't remember if we ever learned their names or just nicknamed them, as we did everyone else we worked with or around.

The game changer was when the boys put me behind the pots. We would take Giorgio's boat and jump to the nearest supermarket in Venice. Our filter was, as always in that time, budget or lack thereof. Usually we were starving when we went over to the market, so by the time we were there, browsing our options, we always opted for the price-performance meal: What would maximally fill our bellies for the lowest price and still be tasty? Our default was *spaghetti con salsiccia*. Every time we knew we had someone to thank, either because they kicked in with some extra hands at work for a day or two or simply to win over some ex-felons to support our cause, it was *spaghetti con salsiccia* time.

That night and many others, with the ex-felons—or new friends, once you've shared a meal together—we killed god knows how many bottles of wine, as well as the obligatory grappa that was the big guy's tipple of choice. We talked, we ate, we listened to music.

We won the ex-felons over with our spaghetti and sausage that night, and then with our hard work. They became our fan club. The more we started feeling the tooth of the process, the more they kicked in with extra support. Machete Man? He became our mother figure, all worried when one of us came in with a bleeding wound or simply exhausted at the end of the day. He would sit us down in that tiny kitchen, beside his resting pet machete (he kept it there to ward off uninvited guests and to cut herbs for dinner, pour a shot of grappa and pop an ice cold beer from the fridge. "It is important, what you guys are doing," he said. "Working hard in the name of art." The ex-felons saved our assess multiple times before it was all completed, with the most honest and heartfelt support we got along the way, both psychologically and physically.

By midsummer the material was ready, but we had to get it from the fisherman's house first back to the hangar on the other side of Certosa and then all of it, again piece by piece, to Thetis. When things got tough, we divided the roles; Peter took off for his native Trieste, where he could be on top of all the design elements. We were blessed that a lot of friends came to help out in the summertime, all in the name of art, but it was the ex-felons who really made the difference that day. They kicked in full force to help us move the material. It was like cavalry coming to the tea party. The material flew to the cargo boat, and by the time we were on it, I would swear that Machete Man was holding back tears. One incredible part of the mission was accomplished on the island of Certosa, now it was Thetis time. It was time to build *Dafne*.

* * *

Finally, back at the hangar, we started building a forty-meter-long wall, which meant noise and a construction site. The Thetis people were not happy with the incursion. We were already late, working nonstop but somehow always meeting our deadline, when we were called in by the once-friendly Thetis lady. She said that we had to stop our activities, president's orders. She had given us the green light and the company liked supporting artists in principle, but the extent and nature of the work had not been made clear, she said, the construction zone that would be a precursor to the final exhibit. At that point we learned that even though she'd sat with us in all the meetings, presentations, and dealings, she did not have a clue as to what we were actually building, the scope and the necessities of the process. The mistake on our side was that we weren't aware of that. What we were up to was of no particular interest to her. We thought that her disinterest gave us freedom. But the company did not like working around a pop-up building site.

I was the designated shmoozer. For the first few days, we spent a great deal of time trying to sweet-talk this woman and try to get her to lobby on our behalf, which meant double work. Remember, most of the time it was just Simone, Giorgio, and me, with occasional help from friends. Now we needed one of us to be free all the time to drink coffees and talk for hours with the lady. She wanted attention. I was not well-balanced at that moment. In one meeting, when her constant denying and ignorance rubbed me the wrong way, I started being honest (and firm) with her: How could she commit to the project, commit us to all that work, without grasping what she had committed to? Being honest was the right thing here, as it always is, but my mistake was being too emotional about it. It didn't help that I was the only non-Italian in the group, so I was an "exotic"

accessory. After this fallout, I was the black sheep. Exoticism is charming when all goes well, but it makes you the scapegoat when it does not.

She used my flipping out as a reason to stop the whole installation process. We were in a terrible place already, with two months of nonstop work on our shoulders. The building of the massive installation was not going as planned, as we encountered one problem after another. On top of that, summer vacations were close, so everyone but us started with other preoccupations. At that moment, everything stopped.

Our next move was to send Giorgio in to negotiate, since he was the only Venetian in the group. If he spoke, Venetian to Venetian (in dialect), we might continue. I knew that in order to pull this off, he would throw me under the bus. This seemed the only way forward at the time, but when our group later disintegrated, it would come back to bite me. I was stigmatized as the "crazy outsider" (in a very negative way). Giorgio came in and positioned himself as the mannered, educated member of our group, but above all as the Local. Even someone from Padua (Simone) or Trieste (Peter and Martina), each an hour away, was Other.

Thetis agreed to let us finish, but on their terms. The hotshots at Thetis made us stop for three days and then come back, and they would tell us their conditions to continue. We imagined they would give us a Sisyphean task, but the terms were excruciatingly easy: We could work from 6:00 p.m. until 6:00 a.m., but we had to clean up every piece of evidence of our presence before we left and we had to be long gone by the time the first worker arrived with his coffee and croissant.

This actually turned out to be good for us. We could work without interruptions, without schmoozing and deathly stares from all the people trying to work around us. This was a blessing in disguise, as it helped us find a rhythm. But working nights was logistically tricky, to say the least. In time it became extremely physically exhausting, draining. The only two machines that worked in the complex were for coffee and popsicles, so our diet was not exactly primo. In the morning, we would catch the first vaporetto home, eat, drink a couple of beers or inhale a necessary spliff to anaesthetize our sore bodies, sleep for three hours at best, and then wake up and do it all over again.

It was the waking up part that was the biggest challenge.

\* \* \*

Somewhere in the middle of all this I had to run to Ljubljana, where we shot the video and prepped all the images. I got a call the night before from the mother of

the little girl we had cast as Dafne. The mother was a childhood friend of mine. She said, "Jaša, I do not know how to break this to you, but we had an accident. Our girl was attacked by a dog and bitten in the face!" Oh shit! I honestly did know what to make out of it. "She's okay," she continued, "but all bruised up and she even got some stitches above her eyebrow. She's still very excited about the whole thing, but I do not know what that means for you."

My first reaction was concern for the girl, followed by the idea that this was some bad omen for our project. We later decided that it could be an omen of a different sort, and that we should use it, embrace it, as long as the girl was okay and able to move forward.

We made a video invitation with our model five-year-old, in which we invited guests to a secret spot where the show would begin. They would arrive at a location in San Marco and be picked up by a vaporetto that the Passaporta group had turned into a magical installation, covered in grass. That grass was one of the many tons of ingredients we moved—a whole truck full of grass, as grass in Venice is hard to come by. All this for one magical night, but it was worth it to concoct a floating lawn installation that shuttled guests to the exhibit site.

Prior to that, the public was invited through a specially designed web page, where videos of a dancing and laughing Dafne floated in a blank virtual space. The last thing they received was a secret map that indicated only the time and the spot for the pickup in the grass vaporetto. Once on the floating lawn, everyone got a special package (all meticulously designed by the girls) containing custom-made glass etched with the picture of an invented friend of Dafne, sweets, and a green apple. The little girl, Dafne, was there in person.

Stepping off the vaporetto, guests were led to a beautiful garden in front of the hangar, where our massive installation presided. In the garden stood the additional individual installations by each of us. We opened the hangar so guests could approach the installation from various angles (we had to, as the number of people who came far exceeded our expectations). The conceptual *percorso* was to approach the installation from a smaller entrance that led the public directly into a dark forty-meter-long corridor that we wanted them to pass through before stepping out into the expanse of the hangar itself. The corridor ended with a hidden room, like an abandoned child's room, decked out in black-and-white pictures of us. The luring in ended here, as we got the public ready to face each of our individual works. But before that, guests had to go up the stairs that lead to an additional floor we built—a second story in the hangar—dedicated to our previous projects, which we distilled into new sculptures. The enormous wall we'd built was the main focal point on which we exhibited our individual works, and we decided to balance the second story on storage containers that

happened to be inside the hangar. We had to come up with a makeshift staircase to access the second story atop the storage containers, which would either be a lot of work or a lot of money. We had to opt for a lot of work. We also made autonomous spaces for us each to show our own work. You'd think one or more of us would've said, "Enough already"—and we did have those conversations, but they were more for show. Our attitude was "Go big or go home," with more being preferable and somehow always feasible.

\* \* \*

In Campo Santa Margherita, there's a house in the middle of the market that is owned by the Comune di Venezia. It's got a great name, Casa del Boia, the Executioner's House. We dreamed of using a facade of this house to display an advertising banner featuring Dafne on a swing. In the various images, the bruises she suffered from the dog bite could either barely be seen or were hidden, but this image was so large that her injuries were really highlighted, as this was a photograph and digital painting, four by three meters in size. We immersed her photograph in a sea of 3D computer-generated butterflies. With Peter we envisioned this high-saccharine, all-out euphoric image, a big leap on the swing into the unimaginable.

We asked the Comune for permission and, believe it or not, they said yes. These are the same people who had said yes to letting us use the space on Certosa. They'd seen that we'd made each step they had offered us work, so they were on board. We convinced them that this banner was also an art piece, not only a promotion (which it was). From that point on, this facade became a spot used to advertise for all subsequent Biennales. We invested all the money we had into printing it, and we had to transport it and fix it to the facade ourselves— without drilling into the historic brick building. How could we hang a banner on a facade without drilling?

## AT WHAT POINT DOES THE IMPOSSIBLE SHIFT FROM AN IMPOSSIBLE DREAM THAT I'LL MANAGE TO ACHIEVE TO BEING, IN ACTUALITY, IMPOSSIBLE?

Ah, hurdles! This was nothing but another impossible technical and logistical challenge on top of everything else. In any process of coming up with something incredible, by the time you are done, you have developed a list of complications as long as the Bible—but the moment it is done, the ache fades away. This

blessed forgetfulness is probably the only reason you start another masochistic process the next time. By the time the installation of the banner was approved, we were still feverishly building the forty-meter-long, six-meter-high, two-meter-wide structure, with an extra floor on top of the two containers, and five additional individual installations, which we called "storerooms." All of this was done working overnight and organizing during the day and full-on over the weekends. This time we had no ex-cons to fly in and rarely did anyone join us during the graveyard shift—it was just too hard-core.

It was one challenge after another, at least a challenge per day. Now we needed to bring the poster from Trieste and did not have the money for proper transport. So we brought it as regular passengers on the train, then on a water bus—doing whatever we had to do to convince the ticket guys that the enormous roll should qualify as normal luggage—all the way to Thetis. While on a high induced by too much coffee and ice cream, we came up with the support structure overnight, made of wood, on which we could hang the banner, bring it back to the water bus in the morning, and get it to Campo Santa Margherita.

Now we had to climb on air somehow to get to the sufficient height to install the banner—impossibility #47 of the day to overcome. We managed to rig the wooden structure and use ropes to lift the banner; exactly how is still a complete blur to me. It involved a far-too-small ladder (all we could bring with us) and our jellied brains. Miraculously, we managed to lift it and all was going well until it transformed into a sail, buffeting in the wind. So we turned covert operatives and used screws to penetrate the historic brick at four points to anchor the banner. We did it in plain sight and no one complained.

I was even luckier a few nights later. I was using a big circular saw and had just one pair of gloves. They became like my second skin, almost attached to me. There's a story told by Vasari that Michelangelo lived in a pair of dogskin boots, even slept with them, and they got stuck to his skin. That was me and those gloves. One night I think I was falling asleep while at the saw, and I heard a voice. I turned around just as I felt the pressure of the blade on my fingers. I snapped out of it and turned to my hand to see that the glove had started to slide off my fingers; the tips of the glove had been sliced off, but my fingertips were fine. In another century, this would have been attributed to divine intervention and I'd have set up a shrine to the patron saint of construction equipment.

We were behind in practically everything, but these signs of impending disaster made me insist we take a couple of days off. The next day, August 22, was my birthday, and I would turn twenty-five. We went to Padua, to Simone's place, where I collapsed in his bathtub. My body hurt so much I could not talk or move. A bathtub and a spliff and Simone's signature ice cold mojito pro-

pelled me back to life. The fact was that, complain though we would, we fucking loved this whole process. It was the best time of our lives and we were living it, fully, all in—as every fiber of our mind and body was invested.

## IF I GET A BUNCH OF SMALL DETAILS WRONG, WILL IT FUCK EVERYTHING UP?

On the day of the opening, some three hours before the big moment, I got an emergency call from the Passaporta girls. They needed some equipment for an urgent last-minute fix on the grass-covered vaporetto before they picked up the first load of passengers. When they called in panic, I dropped everything and ran off to help them.

I felt responsible for coordinating all the moving pieces of this multifaceted opening. I had a sense that the others were melting away with fatigue into their own work only. When the girls called, I was wrapping up my sculpture (another last-minute thing I had to do). Simultaneously, a colleague came running in with an additional fifty meters of electrical cable we needed to light up the outdoor installations. I was driven by everything that still needed an extra touch, a turn of the screw, to be moved a centimeter to the side. I was overcome with this feeling that, fuck, we need one more day that we do not have! And this was just as all the catering came in.

Two companies sponsored our opening by donating food and drinks and a team of professional waiters. We had a film team on-site to get footage for a planned documentary. All of it needed directing. Everyone did. And everyone arrived at once. And there I was, about to pass out, feeling the need to coordinate everything. Smoke was coming out of my ears. And now Passaporta needed equipment. I shouted out instructions to the various moving parts that had arrived—some of them were wrong, which gnawed at me for months to come. And then off I sprinted, like a headless chicken, to Giorgio's boat, two hours before the opening.

"I can do it; fuck, I *have* to!"—and off I went.

In extreme moments you sometimes surprise yourself with the lucidity or efficiency you can achieve against the odds. And once you discover these stages of your own creativity, you push on—until you cannot. Other times . . . well, discretion would've been the better part of valor. If there's any lesson here, it's get your ducks lined up and coordinated *way* in advance, to save all this sort of drama. But you live and learn, you can't always plan so far in advance, and shit always happens.

I was in the boat, I had delivered the rescue supplies, and I was in a hurry to get back, so I took a shortcut—directly through that part of the lagoon that Giorgio had said, repeatedly, "Whatever you do, don't cross here." The boat got stuck in the shallow water and the propeller was lodged in the mud, the motor choked some thirty meters offshore.

I was still in my work suit, a T-shirt and shorts, or what was left of it, as I jumped out of the boat and started manually trying to pull the motor free. It wouldn't move, not an inch. The suction of the mud swallowed my feet and held the motor locked into place. I freaked out. "The opening is about to hit off in five freaking minutes!" screamed my inner voice. "Come on Jaša, just one last push!" They say that adrenaline can give you preternatural strength. But by the time I was standing in this mud, we'd each lost over ten kilos, working overnight, not sleeping, and subsisting on coffee and popsicles. Warm tears of despair came running down my face as I thought that this would be it. I'd miss the opening, I'd miss the event, and I'd be the asshole stuck waving at the guests as they arrived, still stuck in the mud thirty meters from shore.

Ready to resign and slink away into the mud of the lagoon, I gave it one more push.

I have no idea how I managed, but I did. I pulled the motor out as my tears of sorrow became ecstatic tears of joy. Shaking, I cleaned the mud from the propeller and got it running again.

By the time I got the motor out of the mud and running, Passaporta had already transported four loads of passengers. We never knew how many people attended, but it was way more than we planned or expected. In any other circumstances, this would be the time to pop champagne and celebrate—an utter triumph. But for me, covered in mud, exhausted, not even having finished everything I wanted on the art side of the equation, I was out of time. The boat incident burned my last chance to be fully ready. This was not how I pictured the grand opening after all those months of preparation. It never is, but only experience shows you that. But on a level like this—we had no experience to call upon. So it all came as a shock, the sort that comes swiftly and cuts the ground out from under you.

I came in running from one of the back entrances, dripping from smelly Venetian mud. In the cold worker showers at Thetis, I washed out the mud. I remembered my father's words: "If you do not take five minutes to fully realize what you have done, the minimum to let the reality of your own vision slip in, you better not go out there. You'll be off beat, out of tune, bouncing from one bravo to another, while all compliments will slide off you like from a Teflon pan. Nobody can make peace with your ongoing process but you." He's always right.

I entered the main space of Thetis, where the focal point of our installation was displayed and spotlighted. It was so big, monumental, unearthly, gargantuan. So oversized for our age and experience. The crowd was in a state of sincere, positive shock at what we had created. But in my state of mind, it felt not like a dream come true but a high-stress nightmare complete with a checklist of mistakes that I'd made. Exhaustion really is a bitch. It can completely distort the reality within you, smearing it all up with toxic self-doubt and endless questioning. Then again, this was only the beginning of a process I managed to control over the years. At the time, we all floated from one person to the next, from situation to situation. We all felt like the bruised face of Dafne, bitten by the raw reality of our own dreams, our own vision.

Scores of guests wanted to speak with us, and I hardly had my head attached. People were pouring in from all sides. The drinks and food ran out in record time. When the river of guests climbed the staircase we had installed in the hangar to lead from the ground floor to the upper story, all I could focus on was a loose screw that was clanging under the weight. We had faked some of the permission papers for the stairs and the upper story. If it had collapsed . . . I don't even want to think about it. We built it super strong, whale-proof. We just could not afford the papers. I saw, out of the corner of my eye, one of the architects who had helped us as he slinked over to the staircase and undid the telltale screw, slipping it into his pocket. He winked at me.

Think that was it? Get this: that night, there was a serious blackout that wound up affecting much of Italy. It struck just when our opening ended, as we were walking from Thetis back toward the center of Venice. All of a sudden, the world went completely dark. It was such a black cherry on the top of the whole surreal situation. We had to walk all the way back to our apartment, which was miles, in pitch darkness.

A lot of people had come from Ljubljana to be there for me, and they hadn't made reservations—they were all going to stay in our apartment. We had more than fifty people crash out there, all over the floor, on chairs, on the table, under the table, in the bathroom, in the bathtub, after we'd wrapped a huge party. Somewhere along the way I passed out in a corner of my own bed. It was a miracle I could even find a free corner.

If this were a movie, the credits would roll now. But it doesn't work like that. The end isn't the end. We were all in debt because of the project, and we'd have to pay that off, so our work was ongoing. There was more: We'd pulled in a professional film crew to record the event with four pro cameras. At some point, the team had left the film equipment in a corner and joined the party. By the end of the night, the equipment was gone. Not only did we have to reimburse the

team for the stolen equipment, but worse, the footage was gone, so the entire grand enterprise of *Dafne* was lost, save for a few snippets of the event. You have to understand that this was a time just before social media, when phones did not have integrated cameras. These days gallery openings are documented whether the artists want it or not. But this was before that was possible. If you didn't have cameras (or if someone stole them) then an event like this could go almost undocumented.

It was a victory with losses. This was the impression from the inside, mostly due to fatigue. Exhaustion pulls a dark filter over your eyes. But from the external standpoint, we had totally made it. We'd fucking nailed it.

## HOW IMPORTANT IS THE CITY, THE LOCATION WHERE I SHOW MY ART? DOES IT HELP MY CAREER ONLY IF IT IS IN A GIANT ART METROPOLIS? AND HOW DO I "READ" THE EFFECT MY WORK HAS HAD?

What does it mean to be famous in Venice? It's not New York famous, and it's not social media famous. We were gods in the Accademia. You either worship gods or you hate them—that's how it goes. There was also this odd side effect that people seemed to think we'd also suddenly gotten rich. It was just the opposite. In the small town that Venice remains outside of the Biennale, those sharing the city with us who were aware of the arts saw us more as a threat than anything else. Jealousy at our success, I suppose, but that is inevitable. You cannot find success without others envying that success. It comes with the territory. Only failure does not breed jealousy.

So now, in the aftermath of the impossible, we did what we always did. We sat around and talked. Now we'd come to the plateau we'd wanted, and there was no turning back. And this is where the first dissonant ideas appeared, the ones that would eventually pull us apart. We tried to overcome what bugged us, what troubled us, what depressed us. Above all, it was the debt. We responded to that, as we always did, creatively. I said: "Guys, fuck this! Let's come up with a new show, one that will pay the old debts!" By creating a new cycle of enthusiasm, we did exactly that—we bowed to the army of numerous collaborators, lured in new sponsors, and did a show of a scale we could easily control after the scale of *Dafne*. We called it *Dafne Revisited*.

What had changed was that we had experience under our belts and knew that we had to take care of each other on our own terms. We also learned that the pipe dream of so many young artists—that by doing something incredible,

somebody would just come along and take away all your burdens and all the negative stuff, that all future projects would be easy and lucrative—well, it does not happen like this. The one in a million stories of overnight success make the headlines and skew the impression of how things work. The stories we knew, the Young British Artists or tidbits from the 1980s boom in New York were real, they did happen, but it makes no sense to chase happenstance. Should you aim for the miracle, or should you hedge your bets and plan on something feasible for a good chunk of artists who find a way to make it?

We took up the reins: a new injection of optimism running along the border of a lack of realism. At the time, we didn't realize that everything we had hoped for to that point had actually happened. Chasing the pipe dream that you do an art exhibit and *then* good things come is understandable, but what I want to underscore is that the art exhibit should *be* the pipe dream. *Dafne* was the dream. It's important to consider the success of the art as the pinnacle.

*Dafne* was, for me, the strongest drug I'd ever taken. Finishing a painting lifts you up onto a cloud of euphoria. But it's a pale imitation of launching your own entire show on that scale; one that you built by hand and delivered, uncompromised, brings you to highs unimaginable. The aftermath can be a bummer. It's one in a million that the world responds, giving you feedback at a level mirroring the energy and passion you put in. You need tools to survive this discrepancy, but above all to understand the process of making it. What changed with *Dafne* was the scale of medium we embraced: site-specific installation.

The fact that we ran out of money and we could not follow our initial ideas—that we'd hire others to build for us, for example—forced us to lean into this kind of work, the process and the medium, and so we grew as artists. We learned that despite all the preparations, you need to plan for contingencies. The so-called god's-eye view is crucial to coming up with a general plan and structure that holds the *Gesamtkunstwerk* together. But once you are within the role of a spectator, and if you come with a sensibility for details, surfaces, materials, volumes, paths, then things will change during the process. It's one thing to change something on a canvas that's 1.5 by 2 meters across. It's another thing to change the aspect of an installation that stretches over 40 meters. Inevitably, you'll run out of time, money, or energy, but somehow you can always pull it off. And if the process demands something, if what you planned in reality is not yet embedded in the material the way it should be, then you need to push forward. The question is, will you realize that you can push and make it happen, or will you give up before the bridge is approached? Once you cross it, will you recognize, through the veil of stress and fatigue, that you managed to pull it off?

Technical things, especially, inevitably go wrong. Years later I noted that prior to any site-specific installation process, event, performance, or opening of any kind, form, or scope, my mind would start predicting all of the possible negative scenarios, almost obsessively, usually during sleepless nights. I would still miss quite a few—mainly those that involved people turning into assholes—but I was as prepared as I could be.

Launching art is like playing chess. You have to think moves and counter-moves ahead. Thinking of a negative outcome, while feverishly working on an absolute vision, makes the reality, when it hits, less traumatic—it just becomes what it is, another technical problem to overcome, instead of the floor being swept out from under you. That's why I'm taking the time to tell you all of this, in a level of detail that probably has you thinking, *Okay, we got it already*. This isn't about any of my projects. It's using my project to help prepare you for your projects.

## DO I NEED MY OWN *DAFNE* TO PROVE MY WORTH, TO MYSELF OR TO THE PUBLIC (OR BOTH)?

Too often we have access only to the icing on the cake of great, monumental, and successful art projects. The truth is that we are all so obsessed with project-ing the image of our own success that we forget what the whole thing is about: art, layering accumulated knowledge, and doing it not only among those from whom you can benefit, but with a wide range of people. Why? It's human, it's dignified. It's what can make us truly great and relevant in retrospect, far from the "Oh, I want to drink champagne alone on Mount Everest!"

So create your own *Dafne* and make it ten times better than ours was, and please tell me about it. I would love to listen, as I definitely never want to drink champagne (or even a beer) on Mount Everest *alone*.

## MY ART GROUP FOUND SUCCESS. HOW DO YOU KEEP IT TOGETHER? OR IS DISINTEGRATION INEVITABLE?

So you put it all in and the world goes, "Oh, yeah, okay"—or worse, just shrugs and moves on. You're the toast of the town for a week or a night or not at all. Overnight success does not sweep from the heavens and shower you with lovin'. How do you deal with that? I did not have the tools at the time. *Dafne* allowed us to reach a platform that it had been our goal to scale. We

had loudly and ambitiously stated, "WE ARE HERE." And we did it with confidence and self-sufficiency, and on our own terms, at least in little Venice. What we hadn't figured out is how the heck we could maintain this rhythm and not burn out tomorrow.

We pulled in different directions. I started planning my biggest, most ambitious painting to date, a complex approach to a big painting that was composed of thirty-six individual canvases, each 100 x 70 cm, featuring thirty-six variations in style or concept, but all about my childhood house.

The idea that the public walks *into* an artwork became my driving force, my love, my obsession. I wanted more. We all wanted more. *Dafne* had meant complete immersion into a whole new process, multifaceted, and using all sorts of media and art forms, beyond pigment and canvas. I saw myself continuing to embrace the wholeness, the complexity of every aspect of an art project, as an event, from site-specific installation and all necessary details. I'd also learned what it means to direct an art installation, creating it in space and time. You'd think that because the aftermath kicked my ass, I would've had enough. In fact, I fell in love with it. What I understood, too, is how quickly you can burn out and how important it is to find your own point of balance. I still keep losing balance and teaching myself how to regain it. If I ever stopped, my art would grow stale.

Money is what is most likely to disintegrate groups, from rock bands to art collectives. It would end Crash in Progress, too. How do you maintain both your artistic autonomy and the integrity of the group? How you survive the dark times, the in-betweens, will determine whether you stay together. Like all partnerships, success is based on dialogue. You have to talk things out, you have to know how the others are feeling, and everyone needs to feel that their opinions are valid and valued. We had that for a while after *Dafne*. Our process hadn't stopped, so we kept on running. We wanted our life to be more of what *Dafne* had shown us. But we knew Accademia wouldn't be forever. What should we do afterward? This is when it got tricky. Someone wanted to move to Berlin, another to London, another wanted to go home for a while. Our success wasn't a financial one—whatever we earned went back into other projects. We had no savings and no life to speak of beyond the art. We couldn't afford to up and move to a bigger venue and try to do *Dafne 2.0* in a major art city. We did, however, start planning for when we could.

We made a string of great shows together after *Dafne*. None were of the same scale, but if they felt relatively easy, then we had a tendency to add complications, as they say in the watch business, elevating the conceptual and aesthetic complexity. We stayed together for two more years. Our varying personal routes led us apart. Peter and Simone graduated a year ahead of Giorgio and

me. Peter and Martina moved back to Trieste. As the first ones facing the outside world, they were the first to crash into reality. Outside of the Accademia, Peter had to figure out how to earn a living. To this point we'd all survived on some sort of scholarship or student stipend, with support from families here and there. We could get money for projects, but we were not earning money: no monthly payments, few sales of works. Peter needed a solution quickly to cover rent and groceries, so a different kind of pressure influenced our plans. There was an idea to get more money for projects and divide it equally among us. This would come from group activities or contributions from our solo work. We were dreaming a socialist dream in an extremely capitalist world.

But late at night, each of us still dreamed that a hot gallerist would pick us up and represent us, that one or more patrons would fall in love with our work and start buying it up, that we would find (or be handed) a studio or coverage in the most desirable international media venues. All of this was the trap we'd worked so hard to avoid: to simply follow the rules of what it means to be successful out there in the big bright world.

There may be times and opportunities when the glittery art world cracks its door open and appears to invite you in. If this has always been your secret dream, then in order to test it out and see if it is really what you imagine and want, you may need to step inside, even if only briefly. We are all empirically inclined believers, so to truly understand the traps that lay all around—in the glittery room of the few, the "successful" and beyond it—we may need to experience it ourselves, to skinny dip within its gilded waters.

Your dream of the glittery room is the trap.

Finally it happened. A prince on a horse arrived. It seemed too good to be true. We just did not expect the prince to come in ripped jeans, with a huge hole around his balls. An influential curator showed up and said, "You guys rock; I'm going to take you to Milan. You'll meet amazing gallerists, and I'll make you part of this ace new show that is coming soon. You'll be the hottest young artists there."

In retrospect, this was a clichéd trick: flashing the lollipop in front of the craving kids that we were. It was also a cliché that we bit it. But at the time, half-expecting, pipe-dreaming of something like this, our reaction was a mindless and grateful, "Finally." The jackpot had arrived. But we were too hopeful because we were too hopeless. We'd succeeded. We'd built the impossible. We had *made* it. But we could not see it for what it was—or rather we did see it, but as individuals, not as a collective.

# 6

## MONEY, ART, SEX

### How Do I Navigate the Triumphs and Pitfalls?

Graduation, which came right after *Dafne*, felt like being pushed off a cliff. During our super-fancy graduation lunch outside of Venice, my mom looked at me and said, "So, since things are looking good for you; I do not see any problem with you going completely solo"—as in, financially. My father agreed—they'd been long separated, by now both in new relationships, but they formed a united front. During my student years, I'd obtained financial support here and there from scholarships, developing the artist/patron relationship with Zavrl, occasional awards, and some funds from Crash in Progress projects. But still, the monthly support that came from my family allowed me to breathe easier.

I knew the financial axe would fall one day. I just didn't know it would happen on my graduation day.

I did something weird. I set down my glass and I looked at her, saying, "Of course. Excuse me just a moment." Then I ran. As in, I stood up from the nice restaurant table and sprinted outside. I was not running away in tears. I just ran, as if something had shot me out of my seat. My thoughts outran my legs. I had no fucking idea how I would survive. I just knew I had to find a way. It was perhaps less than ideal timing for my parents to break this news. There I was, graduating with flying colors, with those who I most respected and admired at the Accademia praising me for what I'd achieved. But the bubble of school life is one thing. The real fight is out there, out there where we were breaking ground

with Crash in Progress, like proper pioneers, like the crazy kids that we were, like fucking rock stars. Still, my heart fell right down into my pants, and I just ran. As a kid, when my parents asked me to get some milk and bread or anything, I would run to the nearest shop. I just wanted this chore to be over and done with as soon as possible. For a while, I was known among our neighbors as the kid who always runs. My peers would giggle when I ran past them. That day, theoretically now an adult, I did something similar. I just ran, probably wanting to jump the process ahead of me and just get from point A to point B as soon as possible, hurdling over the little question of my finances. I kept on running outside the restaurant. I did come back after a while and the celebration went on late into the night.

## I'M IN A HURRY TO BECOME SUCCESSFUL. ARE THERE WAYS I CAN SKIP THE QUEUE?

A friend once told me, "I really do not care about this [local] show; my movies are made for Cannes." We were showing in a smaller venue then, but it was an important project for all of us. He was a good filmmaker, but he never finished the movie he had set out to do. He never made it to Cannes. He never finished a proper film project. I'm not sure he really ever even started one. Aiming for the pinnacle, he hoped to—*expected to*—skip all the warm-ups and necessary exertions along the uphill path.

Every band that made it big once played its share of gigs in nasty places, with three occasional drunks swaying to their groundbreaking music. It takes a lot of work, a lot of not-quites and wish-I-hads and did-we-really-just-do-thats to move up to the next level, much less up to the top. There are simply steps you need to take, and not all of them are star movie material, not all glitter and applause. Even the so-called overnight success stories may have made the leap from anonymous to name with a single action, but extensive practice and toil away from the limelight led up to that overnight sensation. You improve over years, not hours. Sometimes good things can come out of seemingly bad gigs, and bad things can come out of seemingly perfect situations. It is how you swim through these waters that makes the difference. It is how you walk that wire, constantly seeking balance. We are all wire walkers, day after day. It just never stops. So no, you cannot skip the queue if it's relevance you're after. The steps in between being a student and being a professional out on my own in life were probably the hardest, the longest of jumps. Not only was life at the Accademia coming to an end, but all of Crash in Progress was, too. In those strange months,

we all tried various desperate things in order to move forward as smoothly as possible. But rarely are transitions smooth.

We'd anticipated the end of our student years and were preparing ourselves for it. We did try to find a way to keep the band together.

## DOES THE INVITATION OF SEX FOR ADVANCEMENT EVER LEAD TO A HAPPY ENDING?

*You are the special one. You do not belong here. You need to come to Paris with me and meet this amazing gallerist, who will love your work just the way I do. Come with me.*

I remember her smell. It was a mixture that was bugging me all the time, the words and the smell, and then that twist of her head, moving her hair, something she'd probably done as a teenager. Something was off, but I couldn't quite place it. And at that point in my life, before I had a career, at the start of the Accademia, I very much wanted to believe it was all true.

It is so strange, that surreal haze that kidnaps your ego and throws it onto a rollercoaster. Booze, drugs, the finest foods, all thrown at you only because you have "talent." Or so they say. And then it all goes sour, out of the blue. Inevitably. Because somehow you decided to believe in your work, and out there are a handful of desperate older men and women who correctly understand the cravings of a young aspiring artist, the naivete. How easy it is to make an ambitious talent fall for you, if you offer them the promise of igniting their career. It is a game, but those in power use it to their advantage, and it can be devastating. It can ruin your trust as a young artist. It can destroy your career if you blindly fall for the promise or allow other attributes, that young body of yours, to determine the outcome.

With the passing of time, I understand more the envy of youth and what it can do to an unsatisfied soul. As a teacher and mentor of young artists at the same academy where I once studied and beyond, I can see the underlying complexity of the sexual game clearly, how and why it was such a frightening beast back then. But then again, is it not one of the responsibilities of the transgenerational exchange of truths and experience that you look out for those less experienced?

In your art, you invest your whole self, sometimes literally. Sexuality is a constant underlying energy and can be a tool of power. I will never forget the suffering faces of older professors when their female students would bring rather unoriginal self-portraits in the form of classical nudes (preferably as photography). They would administer high grades, and others using less "effective" methods were furious. Yes, sexuality can be a millstone that has its

purpose, grinding to produce something desirable, but it can also become a millstone around one's neck.

It is a game as old as humanity. We want to be seen and we want to be liked; we want to be adored. But there is an extremely fine line on which hangs dignity and self-respect, and this line can snap in a moment if it is pulled too hard by someone for whom your sexuality is their only goal. Be forewarned. I'll let my mind be the weapon of endurance and not necessarily my youth.

When the so-called gallerist pointed me out at my early stage, I looked up from the corner of the studio space at the Accademia, where I hovered over my work. She walked toward me, all smiles and pearl necklaces, and singled me out, or rather my work, I assumed. It all started with the first drink, which became dinners, which evolved quickly into how she knows famous dealers in Italy, and one in Paris, of course. She wanted to introduce me to him. She could set up several shows for me. I met her kid. And then she suggested that I accompany her to Paris for a weekend. I could stay at her flat, in fact. All of that in a matter of days. Yeah, right.

At first, I thought I'd hit the jackpot. It is only when some of my colleagues pointed out a few reasons to be wary that my disposition changed. Yet I still wanted to believe that it was the real deal. Everyone wants to be discovered. Every young artist wants to have their work singled out. It was not unusual to have a studio visit from a dealer or curator or gallerist on the hunt for new talent. You'd hear of a young artist who was discovered and, a matter of months later, selling works and making a living and having media coverage and solo exhibitions and living the dream and blah blah blah.

So I declined the invitation, politely saying that I had Accademia assignments and did not think I could make it. The door closed and the contact ceased. I later learned that this same woman had taken works by a fellow student at the Accademia, with the promise that she would show them to a famous dealer, and the student had never gotten the works back. She was a fraud—or rather, not quite *entirely* a fraud, but a certain type of character who is, unfortunately, prevalent within the world of the art trade.

I remember several occasions as a young student or later on in my mid-twenties and even early thirties, when I was propositioned, either directly or by implication, by a man or a woman in exchange for the promise of a leg up. The thing is that most of the cases might not even be that obvious. Some were.

One was from the pearl-necklace-bedecked gallerist I just mentioned. The second was from a gentleman of a certain age who was one of the movers and shakers of the art scene in Venice.

This second instance was one with which many of my colleagues could sympathize, for they'd endured something parallel. In Venice, he was a renowned curator who could indeed make a career if he wanted to, well-connected as he was throughout the art world. He was also renowned for having an incubus interest in young men. Despite knowing this reputation, there was a great gravitational pull, knowing that this was one of the most influential people in the art world, with indisputable charisma. He was important not only in Venice but throughout Italy, which was the world for us at the time. He drew into his orbit those young artists upon whom he scattered attention. I say "scattered" intentionally, because it was as if he would throw out breadcrumbs of attention to many, then wait to see who took the bait or simply responded.

There was also an immediate precedent: A colleague of mine from the Accademia had gone from an unknown student to a significant figure, selling works regularly and with solo exhibitions, once he'd allowed himself to be taken under this curator's wing. It was said that the price he paid was becoming the curator's lover, an open secret that—in theory at least, and from a reasonable distance—might have seemed like an acceptable dance with the devil. When this colleague later disappeared for a while and then emerged in Spain a year later, word was that he felt he had to make a complete and clean break from his home and success in Italy to start anew. He felt that his success had been compromised, that he'd been trapped in a golden cage in terms of his art. This was the most obvious endgame: that the curator had encouraged a specific conceptual approach to painting and had found my colleague buyers for these paintings. He spent days working on paintings that he would eventually slash into shreds that he enclosed in plastic that he'd affix to wooden stretchers. He'd won a big competition with a work like this, and it seemed ingenious . . . but then, with the curator's encouragement, he spent the year or so producing the exact same concept, over and over, with nothing different or new.

Despite knowing this, it was difficult not to look for what appeared to be an opportunity in this curator's advances. There was a gnawing echo of hope in the back of my mind that maybe it really was my work that was so impressive to this curator, that I was the exception to the cliché. *Dafne* was the reason he pointed us out, but we felt that this was the golden ticket for probably just one of us. Each one of us secretly hoped that the curator's interests were about the art. He scattered his breadcrumbs toward all of us, and each member of our group fantasized that it was their personal creations that set them apart from others, that they were the one to be discovered and to make it on the back of their art alone. That was how I felt, even though the rational side of my brain argued otherwise.

This curator was particularly skillful at manipulating potential targets. He would invite us, the Crash in Progress gang, to his luxurious, art-filled apartment in Venice, pouring the prosecco with a heavy hand and playing one of us against the others. One moment he'd be giving me all his attention and ignoring the others until they felt a sense of jealousy and tried to compete for his attention, at which point he would single out someone else. It was a game, a dance. There was a joke in our group, because this curator had a special pair of trousers that had an "air conditioning system" built in, so that by moving his leg aside, the curator would reveal more than any of us wanted to see. This was choreographed and the curator would carefully gauge the reactions of each of his guests. Those of us who continued to show some interest and did not recoil, or even flirted back to some extent, received extra attention.

At one point I decided to test the theory and shifted from being as neutral as possible to showing a modicum of interest in the curator's advances. I immediately saw the result in his flashing eyes. Without saying it in so many words, the curator made clear that if the door I had opened were opened fully, then he would open all sorts of doors for me in exchange. I gently closed the door, and from that point on, it was entirely clear that there would be no engagement of any sort, professional or otherwise, with this curator, and with so many others.

Sadly, these sorts of stories are all too common in the world of young artists and art students. It matters little the gender of predator and prey. The power differential is great, and the potential for a single influential member of the art trade to make the career of someone who, at this point, has no career at all but who is full of ambition and the desire for self-actualization (and perhaps not as full of honest self-confidence) means that manipulation is prevalent.

The situations were in fact numerous, both for me and for others I knew or heard about. One came during this big opening where I was supposed to meet a hotshot curator. I had to send in my portfolio prior to the meeting, and man, I sweated over it. As I've mentioned, I was bad at this portfolio thing, condensing my art into short descriptions. I hated it. I sent it in, and my contact said I should meet him during an opening. It was a situation designed to make me feel the power gap: I was trailing this big shot for hours at the opening, waiting for him to give me his valuable attention. Once I was presented to him, he looked deep into my eyes and said, "Not now, but stay close." I endured hours of uncertainty, forcing endless rubbery smiles while lingering around, thinking about what his reaction would be to my work, going through the material I'd sent in my head, over and over again, constantly picking the words that would conceptually embrace my practice in a satisfying way. The big shot left me hanging until the opening was practically over, then came by and said, "Well, you want to know what I think?"

"Um, yeah," I replied, getting ready for a proper mind-bending take on what he saw.

"That you are so fucking hot!"

Completely annoyed and disillusioned, I left the big opening shortly after. Just before I did, I saw his tongue deep down somebody else's throat. I knew the other guy; he was my age and had been "staying close" to the big shot all night, too. When I passed them, I felt played and stupid, as I honestly thought the promised "evaluation" was supposed to be about the intellectual value and the relevance of my work. I was looking for a dialogue, not an affair.

If such a situation arises and you are comfortable, then no problem. But for other less clear and symbiotic dynamics, if you feel a sort of knot in your stomach at any moment that's telling you "This isn't right," stop right there.

There are some "testing points" I can recommend that can be used to gauge whether the interest of an older, influential member of the art trade is really about the art or about the artist's physical person. As soon as you detect interest and are not sure it's wholly about the art, you should immediately start asking numerous technical questions: "You would like to set up an exhibition for me? That's great, where exactly would it be? How will it be promoted? Is this something I will earn money from? How many works will be included? How will we get my work to the venue? Who will cover the expenses? Who will cover your fee?" All of these are legitimate and need to be discussed if some sort of collaboration is real. But they also work as a litmus test. If they are brought up early on, and if the interest in the art is strong enough, then they will not be considered annoying or probing, but rather a legitimate and adult response to the proposition. If, however, the interest is merely a ruse to get intimate with you, to flex some muscle in a power dynamic in which you owe them something, then such questions will quickly repel the predator when it becomes clear that this artist is serious and thoughtful and not ripe for manipulation.

The last thing I want you to think is that I was some sort of prudish monk being preyed upon by naughty art folk. I was always as sexually active as you might expect an artistic gentleman to be. There was a time when a close friend warned me, "For fuck's sake, Jaša, can you once keep your pants on?" He was really mad and had my best interests at heart, because sometimes my promiscuity sabotaged his romantic and professional options, too. Our generation were fucking like bunnies, up, down, left, right, and center. We were decidedly not celibate. To be honest, I was a little tamer than my peers. When you put a bunch of artists in the same room with lots of booze and occasional drugs, then late night celebrations can finish in flagrante delicto, but you would still see me talking rather than partaking. If all parties are willing, aware, and—most

importantly—entirely comfortable with the goings-on, then no problem. What I'm talking about is the intergenerational dynamic. Out of the safety net we can create for each other, there are those who prey and the power play of those in power (curators, gallerists, established older artists) who can take advantage of younger, less experienced artists, in positions of need and therefore weakness, and that's what I'm flagging. It's lame and simply wrong.

*   *   *

The variety of aforementioned issues were the last nails in Crash in Progress's coffin. We just fell apart. It didn't happen overnight. It was a disintegration process that lasted more than a year. We all tried, in our best (or our only feasible) way, to stitch ourselves back together. We even did what would be called these days a team-building retreat. We came to Ljubljana and stayed in an apartment together, where we lived, ate, drank, quarreled, loved, you name it, for four straight days. What we struggled, and unfortunately failed, to achieve was a visionary survival system. We sought to come up with a sustainable, economical system through which we could continue working under the umbrella of Crash in Progress while progressively developing our own individual paths. I called it a "confederation." That was our idea. Could we develop it, map it out, and make it happen?

The main problem at that moment was that we were not swimming in cash. This was all theoretical, pooling financial resources that we really didn't have. Peter's impatience grew and boiled and eventually sabotaged the experiment. None of us blame him at all. He's still one of my dearest friends and one of the most talented artists I had the privilege to work and grow up with. In my eyes, what happened to him was nothing but textbook burnout syndrome due to our last five years, during which we worked like idiots and he never paused.

Peter and Martina packed up and, overnight, moved to Barcelona. For a year he was untraceable. I couldn't let go of the idea, even though reality stared me down. Meta and I were still living in Venice, while reality drifted to pieces.

Things started to change for good when it became obvious that each of us was now laying the foundation for our next chapter in life. Simone got a beautiful studio in Padova, Giorgio in Venice, while I still had a spot at Accademia as I continued to work with Di Raco. Meta had a similar situation with Passaporta: Everyone was leaving Venice. So out of the blue, we felt that we needed to do something about it, fast. I feverishly started to look for a studio. Berlin was the target, but an incredible option came about where I least expected it—Ljubljana. A newly built studio-plus apartment complex had been built by the city specifically for young artists. It was great space, in a great location, and it was

subsidized. But we had to decide overnight. Going back home was never an option, for various reasons. So we decided we would do it only if it meant going forward. We packed and left to start living in this new space.

"If you do move, I will open a gallery in less than a year." That was Primož Nemec, and I knew he was for real.

"Will this new gallery," I replied, "be based on what we have been doing with Crash in Progress and the girls with Passaporta?"

"Oh, yes. Precisely that," Primož confirmed. "We'll start with the Venetian gang and add some other groundbreakers from around here. It will be a generational gig. We have a hole to fill."

## HOW DO YOU MOVE ONWARD (AND UPWARD) AFTER A SUCCESSFUL PERIOD?

If you've got that throb inside you to do it up big, then you try to build it up to the moon. This excitement, however, is cut by the fact that the higher you build up expectations, the farther it has to fall on its face. That's when the nasty voice deep inside you can whisper dark words, trying to undercut your confidence. You've got to shout it down with optimism, which can come in short supply.

After a run of five years working like crazy, coming up with one ambitious project after another, it felt like it was time for me to do more of the same, but this time solo. That's when Primož came back into the picture. I'd met him even before I'd moved to Venice. One night I was looking for a buddy to accompany me out on the town on an all-nighter. I was supposed to sleep over at my girl-friend's, but her parents had made up the couch for me in the living room. That was an unacceptable alternative. And so I set off for the night, refusing to sleep unless I was sleeping with my girl. Primož and I eventually ended up going for a swim at 6:00 a.m. in a small lake near Gorizia.

The son of a sculptor, Primož had ambitions in the art world, but not as an artist. When we met, it was early days for me, before I studied at the Accademia in Venice. That morning, with the sunrise bursting above the water as we waded in, a glory of purples and reds, I looked at him and said, "I have big dreams, but I already know that I cannot make it on my own. I need a brother to push me along." And he said, matter-of-factly, "I know. That's why you met me."

I lost track of Primož while I was studying, but I always had a sense that good connections are lasting, even if they lurk beneath the surface. Years later Primož did pop up, and that was at a time when he had established himself. He offered to make me a show in Ljubljana. It would be my first solo show.

It didn't take me long to return his call. "Let's do it," I said, "and we'll call it *The Big Show*." He laughed and loved the title. We spent ages looking for the right venue, until we came up with this fantastic space in Ljubljana Castle. The medieval edifice had been renovated in the twentieth century and a newer restoration was still underway. This meant that it was not being used, it was not open to the public, and some of the vaulted ground-floor spaces were like vast sheets of blank paper waiting to be filled in. But while we were deciding which of the primary spaces to choose, we passed through a variety of underground passages that connected them. The more we walked, the clearer it became to me: Why should we choose one, when we could use them all as a ready-made?

We wound up building everything that was missing, which included putting up some walls to subdivide the cavernous spaces and to provide a surface onto which we could actually hang paintings.

## HOW DO YOU DETERMINE SUCCESS IF YOUR WORK GARNERS MIXED REACTIONS?

With *The Big Show*, I managed to fulfill the dream that bloomed while working on *Dafne*. When you achieve something that others see as incredible, monumental (within whatever context: local, national, or international), a love-hate relationship is cracked open. I can't overstate how much I enjoyed the process of *The Big Show*. Maybe the title sums it up best: the scale. The old-school folks in Ljubljana saw this show as too big for my age. That thinking can sound obnoxious or encouraging, depending on your perspective, and it certainly prompted both extremes of reaction among audiences, friends, and even family.

Still *The Big Show* was a huge success for me. For five years with Crash in Progress, I was working simultaneously on various media: site-specific installation, performance, and video, and started directing them in space and time. I wanted so badly to spread my wings and experiment with more media. I started treating individual elements as characters in an overarching story that I wished to tell. In *The Big Show*, I did that through the dialogue of the three different spaces I used and the characters of the colossal paintings. Still, it was a farewell to what I had done up to that moment. After years of a complicated relationship with architecture, I saw that architecture was in my blood. I embraced it through *Dafne* (taking a huge empty space and designing and building structures within it), *The Big Show*, and beyond. If *The Big Show* was a conclusion of my early days, it was also the first seed (though I was not fully

aware of it yet) of what I wanted to become, which I would actualize ten years later, with *Utter* at the Biennale.

I don't know how to describe this feeling. You're building your dream show, a painting show, but the smallest piece in it, this cardboard architectural mockup-like sculpture that isn't really the focus of the show at all, is the piece that vibrates, shakes, pulsates for you more than everything else that you're creating. Don't get me wrong, showing the big works was a dream come true, and they determined the whole show. But already while working on it, I envisioned new works, and above all, I saw a completely new direction entwining all the elements I was working on up to the moment.

The moment I realized this, I started "running." Remember the runner from my first video artwork? I started to accelerate the rhythm of my work, which seemed impossible since I'd been working to exhaustion with Crash in Progress. But with a group, the tasks were divided among us. Now it was only me. I had to cover everything. I loved that challenge. Beneath all of that there was another calling that I'd experimented with during the Crash in Progress period: performance. My first brush with performance was back in the 1990s, which meant dicks, tits, blood, and piss. (If you know the history of performance, you'll know what I mean.) Most of the performance art of that period made me nauseated: It was a movement built around nudity and bodily fluids, a threshold I didn't intend to cross. But with a Crash in Progress project called *Le Signorine*, for which we hired a person of diminutive stature to perform, I discovered the potential energy of live presence within the show and the power of ephemeral. I saw incredible potential for creating situations that could bend and generate reality. But in order to get the knowledge and know-how, I needed to experiment with "interventions into reality."

This is how my first big performance project was born: a performance not in a gallery, but out there, in the streets, without any announcement. I scripted a concept that I did not press on others before I managed to live through it. In my eyes, that was the major distinction and, consequently, the relevance of the content: just me, in a pink bodysuit, on the streets of Sarajevo. But man, I may have been dressed in pink, but I was as green as anyone could be.

## WILL MY ART CHANGE ME?

Imagine postwar Sarajevo, still as broken, physically and mentally, as could be. And there I am, dressed as a character I called Mr. Tiger, an antisuperhero in a

flashy pink Lycra costume with funny rabbit ears, an open unmasked face, and sleeves designed far too long so you could imagine the sleeves tied together in a knot, straitjacket style. Mr. Tiger had one power: He was there to talk, but mostly to listen. I threw myself into a concept that, at the time, I had no idea how to push through. It was extremely challenging, as I'd had no experience with this. It was midwinter in a city packed with shattered people. I had nothing but good intentions. My goal was to understand better what the aftermath of the conflict meant, not to impose myself in any way. I just wanted to talk to people. This process did what I thought it would: It changed me.

Change is a huge word, and never in my life was change a cakewalk. It was always a hydra. I wanted to change as an artist. I felt that I'd been scratching at surfaces, moving in the right direction but not penetrating deeply, meaningfully. *Mr. Tiger* was a punch in the stomach, one of the strongest brushes with reality we could create for one another.

Sarajevo still looked like a war zone. A city of rubble, crumbled buildings, bullet-ridden walls. The locals called them "flowers": remnants of explosions, shrapnel, bombs, rockets, bullets throughout the city. I chose a pink suit to bring a dot of color to the grisaille cityscape. My silly look was meant to provoke smiles in a city that had been woefully short on them. I wanted to discover why and how a conflict occurs within yourself and how that manifests. When I moved back to Slovenia, in 2006, it was a striving, thriving new independent country, fully embracing capitalism and with an extraordinarily booming economy. And this at a time when the rest of the country I'd been born into, the now-disintegrated Yugoslavia, was dragging itself along, its legs cut out from under.

How do you swiftly reply to what reality does to you as an artist? Everything is possible but it's all on you, all the weight and consequence and parameters are yours to make and work within. This led to my complete U-turn manifested in *Let's Put an End to All the Disasters*, my first solo show at Primož's new gallery.

## HOW CAN I INCORPORATE REALITY INTO MY WORK (AND SHOULD I)?

How did a performance in Sarajevo work as a show in a gallery? For the site-specific installation, I covered the whole gallery space with brightly colored pages from free catalogues and magazines riddled with just publicity that would come in the post. I collected them, cut out aspects of them, and used whole pages overlapped into a paper quilt all across the floor. It was a cacophony of capitalism. Buy this, buy that, in candy colors. I put a bright orange spray-

painted face of Che Guevara inside the white bowl of the two toilets in the gallery, so the acidic piss would erode the image. Every good idea had suddenly become marketable. It was overnight capitalism at home while our brothers, our neighbors, were picking up bullet casings from the ruins of their apartments. I did one performance in Ljubljana, too. I was in the pink costume, but I'd covered myself in writing with the phrase, "For the people in my heart." I stripped off the costume on a bridge over the Ljubljanica River and leapt into the water, jumping straight into the reflection in the water's surface of a neon sign I'd affixed to the underside of the bridge. The sign was written backwards, so it could be read in the reflection in the river: "Love over everything."

*Mr. Tiger* was extremely well received. It was my first solo show and also the first at Primož's new gallery. The first show of all was a group show of our generation of contemporary artists, mostly emerging from Venice—Jasmina, Meta, Giorgio, and Simone, among others—called *Bad Girls & Bad Boys*. That made waves, a big cannonball into the art scene. Our attitude was all about "We're here to kick you all in the balls." This group show stitched up what we'd managed to achieve in Venice. It brought us, as individual artists, together in one show and in a fresh, new, audacious gallery. It felt like a huge step toward being grown-ups. By grown-ups, I mean doing what, from our perspective, adults were doing: living the high life while working our asses off. We managed to transplant and transform the energy we'd created in Venice and bring it to Ljubljana and a new period, with some of the known characters but incorporating other young(ish) artists. We kicked off a new chapter in which I jumped into the life of a successful(ish) young artist post-Accademia. I learned not only that I wanted to have control over what it meant and still means, to be an artist, but I *had* control. I was in charge of my life and work completely. I was part of a gallery and I helped to run it with my best buddy at the time, working with my soon-to-be wife, Meta. We were living together and had started talking about having a child. My coming home was not a quiet return but one of kicking up dust and banging trash cans.

## CAN I EVER GO TOO FAR PURSUING MY IDEAS?

When I was a kid, my parents would go to almost every opening that was happening in Ljubljana or close by. My mother loved the whole social dancing at them: the talks, the euphoria, the feeling of "We are important; something is happening." From an early stage, I hated it, this theater of the grown-ups: the schmoozing, the over-laughing and continuous nodding, and the inevitable

comment, "Oh, you are so grown up now." The place to show art at the time was Equrna Gallery, owned by this legendary gallerist Taja Brejc, with her famous raspy voice and laughter. Her openings were famous for the quantity of food and drinks that would fuel the guaranteed party at any given opening to the degree that it almost felt as though whoever might be exhibiting was not particularly important. Party first, art later.

Primož found the space for what became Ganes Pratt Gallery near Equrna. But it was a smaller space, and I needed a bigger one. So I suggested we propose a project for Equrna. Taja knew me and gave us a meeting. She knew my work and saw good sales potential in it. But I had a different plan, so I merely mentioned that I might show something else besides my paintings. She approved, as long as there were enough paintings to sell. My cunning plan was to use the fantastic space, which was the right context to do something unexpected. Right after we started installing she knew I was up to something but decided to go with it.

The gallerist was *the* legend of the Ljubljana art scene. She had made the whole postmodern 1980s painting wave in Ljubljana, and she and her artists had made a lot of money. She was extremely good at selling, tough as a professional boxer. She was known for regular drinking, but I did not know how heavy it was. It usually started in the morning with coffee mugs filled with beer. Later in the day, when one of her older artists would come by to mourn, complain, and cry about how the world still did not get his extraordinary art, they'd shift to something stronger. After a couple of days, I figured out her routine. The problem was that she was in the gallery from ten in the morning until late in the evening, every day. I identified windows of opportunity, but I couldn't hide that what I was installing was a site-specific construction that included large-scale sculptures, drawings, an audio piece, and the promised paintings, three huge ones. On a third day, she saw through my plan and said: "You think I do not know what you are up to. This is not a painting show. I have no clue what this is supposed to be. I honestly don't care." My strategy was to win the situation step by step, and I managed to do so by showing her what I was doing in situ. It was a combination of putting in the work and her not having the energy or the heart to tell me to remove it, and also intriguing her with what I installed. I brought in all the more demanding pieces overnight, so in the morning she would have to accept it and go back to drinking.

The opening was coming, and I had a very clear idea of what I wanted to do with it. I gathered a group of performers, including a bodybuilder, an actor, a person of diminutive stature who was also an actor, a DJ, and a band. My plan

was to close the gallery at the official opening and leave everybody outside while the diminutive actor, playing host at the door, insulted the would-be guests ferociously. Inside, the bodybuilder would flex in front of the exhibited works, especially when a guest was trying to look at a painting.

One of the main sculptures was a huge table that was usually used for the famous *aperitivo*, a lavish spread of niblets the gallery offered to guests. Instead of including this traditional nicety, I laid out the table with rotten or plastic food, covered with cigarette butts, dirt, and mold.

I did not tell her of my plans until we started. She thought she had it figured out. The night before, she'd come into the space while I was installing my last bit, an audio sculpture consisting of two black trash bags that would sing, fart, and laugh with and at each other. It was a super-fun piece, very Monty Python, and it gave the whole show the final edge I wanted. She came to me, many sheets to the wind, wielding her finger like a lance, saying, "So, now you tell me, is this, these two plastic bags, this is art now?!" I nodded. She added, "Oh, I see, this is contemporary art, aha! Well, I don't want anything to do with it!" She cursed me and left.

By the time I told her that when the opening started, we would close the gallery, I thought she would hit me. It fell short of fisticuffs, but she freaked out. When the band started slamming and the diminutive actor took over the entrance in a cowboy hat and fluffy scarf, she came yelling and decided to kick me out. At that moment my mother—who was a friend of hers and who strongly disapproved of what I was doing—came in. She, too, wanted her son to be a great painter and not, well, whatever I was doing at Ljubljana's most storied, classiest gallery. They both raised their hands as if to say that this was beyond any repair. They went to Taja's office, where they spent the whole night drinking under her desk.

That was fine by me. I could finally do what we were set to do, undisturbed. For another half hour, everyone was locked outside, as inside the DJ and the band were performing and we were opening champagne. It was surreal, and the tension outside almost provoked the crowd to push through the door. Then we finally let everyone in and the party exploded. It was a blast. Everyone I might've hoped for came. It was beyond my wildest expectations. In the midst of the opening, word got around the city about this far-out crazy art event, so people kept on pouring in. Meanwhile, those of us involved in the happening kept our roles as planned. Primož's smile just kept on expanding—he couldn't believe what I'd pulled off. For me, it was one of the most beautiful nights. It was tough to maintain the pressure, as I knew that keeping the gallerist in the

dark had been my only way to do it. Shortly after the opening, an important article came out entitled "Punk's Not Dead," which was the title of a neon work included in the show. It was a critical success. That enabled me. I felt at one with my style, my position, my attitude, with where I wanted to be, my heart and soul. My message had been received.

The gallerist called me into her office halfway through the show's run. Primož had begun dating her assistant (they'd gotten together at the opening) so the gallerist was friendlier and more understanding. The show was a success, so I felt confident approaching this meeting. My intention was never to humiliate her or prove her wrong. I just knew that she was of a different era and did not feel that she needed to embrace new approaches. I sat across from her and presented her with my proposal, which she accepted based on the idea I would cover the space with paintings, as I had in *The Big Show*.

"Well, Jaša, I need to be honest," she began. "I still do not get shit about what you did here. I mean, singing and farting trash bags? Go figure." She looked at me fiercely. There was no "coffee" mug on her desk, so I knew that this was a serious sit-down. "As said, I don't get it, and I don't even think I want to. But people *loved* it and everyone thinks it is brilliant. So, it is bringing a lot of positive attention to the gallery, which will be great for the sales. But I will not be selling you. You have to know that."

At that point, I was ready for anything. I knew I had it coming and only felt right. I was aware that I had played her in order to do the exact show I'd wanted. I'd needed to do it in that space, I'd needed the seriousness, the regal reputation of the institution as an old-school stalwart in order for the provocation to work. I'd needed that contrast with my Flying Circus opening party. So, for me, her declaration was merely making it even. In any case, it would have been a conflict of interest had she represented me and shopped my work. Primož was representing me. We wanted to poach some of her big buyers, but we knew we had to establish our own scene.

"But," she continued, "nevertheless, I am happy with what you did. It feels like somebody had to open the doors and let some fresh air in, and you did that."

Knowing that she got it in the end was the most calming and reassuring feeling, as I wanted to do my thing, but I did not want to harm anyone or alienate them. We've stayed friends, and she did sell a couple of my works later on, for good money, as she became one of the main supporters of our gallery as well. *Radical Chic* gave me what I wanted: a complete restructuring of what I wanted to be at that stage, and the statement "Punk's Not Dead" still pretty much sums it up.

## ONCE I'VE BEGUN TO SELL WORKS AND HAD SOLO EXHIBITIONS, HOW DO I MAINTAIN MY CAREER?

I have seen many go up so fast and burn so quickly, while I've seen others steadily progressing and barely making it. There can be periods when sales go wild, but then all of a sudden things dry out, or out of the blue a financial crisis hits you on the head, as it did everyone in 2008, or a global pandemic stops the world like the one in 2020. There's always a crisis around the corner that can cut away the fluffy cloud on which you perch.

There is an insane amount of money rolling out there in the contemporary art world—or rather, it attracts insanely wealthy elites who want to be part of the phenomenon called the contemporary art scene and will continue to do so, no matter what. Quite a few living artists get disproportionly loaded. But we are still talking about a small percentage, though they tend to get so much press that they make everyone else assume that being an artist is lucrative (and easy). Every artist wants the finishing glaze on the shiny cake of success, and every collector wants a bite. There have been speculations about the burst of the big balloon that is the art market, but it's still floating. There is one rule: If the market is ruled by those with big bucks, those who have put in big bucks do not want to lose these big bucks. It's a cross between an ouroboros and a catch-22. Collectors who have invested don't want their art to lose value, so they have to keep investing in art to maintain demand for it. Art remains valuable even in a recession, and prices seem to only go up. Rumors of balloons bursting have never proven accurate. But keep in mind that almost all of that money goes to a tiny percentage of artists.

Be careful not to focus too much on achieving exactly what another, super-famous artist has. Don't weigh your own fulfilment based on matching what some star has done. Choose dreams internal to your art and your personal wishes.

## I WANT TO MAKE AS MUCH MONEY AS POSSIBLE AS QUICKLY AS POSSIBLE. WHAT SHOULD I DO?

Okay, first of all, let's take it down a notch. Not only the blue chips are making it. Whatever you do, do not compare yourself with only the top percentage. You *can* make it, sure, but competing with the Hirsts and Koons, who are breaking sales records (they are the two best-selling artists *of all time*), even just in your fantasyland mind, is missing the point and, above all, wasting your time and

energy. To be clear: I don't mock the likes of Hirst and Koons; I scorn those who want to mimic them and anticipate similar success. To achieve that level, to become one of the 1 percent, you need so many factors that are out of your control to fall into place that it really is a one-in-a-million long shot. Trust me, you can still make good money, or at least what you need to keep on working and investing in your art and life, without ascending to such blurry heights.

There is money out there, and there are a lot of people ready to spend on art. Art has always functioned within a sort of a circle of trust, of give and take and then give back again. I am not selling you some cheap karma idea about the flow of the universe. If you are out there and investing your energy, your dedication, doing it with passion and conviction, and if, besides that, you manage to move people emotionally with what you create, people will get it.

In my experience, Europe is different when it comes to art and money, as compared to America or New York, at least. In Europe, you need two separate meetings: one about the content and the other one about the money. What I like in New York is that both elements are on the table simultaneously, and that can make many things way easier.

In this US system, you don't feel like you are playing hide-and-seek. Your upbringing comes into play, too, and colors how you view the system. Where I grew up, in 1980s Yugoslavia, everyone had just enough money. There was a rough equality and very little caste system hierarchy. This meant that money was not at the forefront of people's minds and conversations. Once I started living in Italy, I noticed how romanticized my understanding of money was. For me it was always about "Let's figure out how much we need in order to do something, uncompromised; then let's find a way to get it and, if there's anything left over after our dream is fulfilled, we split the rest—or better, we turn it into a feast." We did live like this for a while, and it was great, but there's a reason utopian socialism has just about never worked, when capitalist profit calls you over and shouts other ideas into your ear from neighboring countries. Humans are inherently greedy. I had to learn that all budget sharing needs to be preorganized, everything written, no spoken promises. Put it all down on paper, sign it. It is a pain in the ass. I hate it, in fact. It makes me feel like I'm playing a Kafka game, an adult in a sea of children, when all I want to do is stay an idealist. But to avoid divisive dramas, it is the only way, especially when (and because) you need to protect yourself.

In the early stages, I trusted people far too much. I still do. People being people, they felt my trust and occasionally took advantage of it. Many times, I knew that this was happening and I tried to look past it, focusing on the art. But then these things add up and you start feeling like an idiot, because even if

you end up with fantastic reviews and articles, with people praising your shows, you can still feel all bruised up from the installation craze, and after performance downhill, you realize that you are as broke as you were before. For a while you shrug it off, but then you want to change the game.

Changing begins with setting your price. This can mean asking an artist's fee when you are invited to participate in a project. It wasn't long ago that you were just happy to be part of a show. You participated for free, just to bulk up your CV. But at some point you can state the costs of your project and the fee you expect for participation. Even if your voice shakes when you name it, you accept the risk for not underselling yourself.

The other case of setting your price is giving value to your work for potential buyers, and perhaps presenting a value that is higher than expected.

## WHAT SORT OF OPPORTUNITIES APPEAR PROMISING BUT ARE BEST AVOIDED OR APPROACHED WITH CAUTION?

Anything that feels off probably has a reason to provoke that feeling. We are all still beasts within, with a faded instinct that lets us sense danger.

A collaborator always said that the combination of his distrust of people and general pessimism when approaching a project, meeting my overwhelming optimism, made us super-effective production partners when it came to transmitting an idea, a vision, into reality. Not everyone is a good judge of character, and that does not necessarily mean that your art is no good. This aspect definitely helps when it comes to the business or management side. In an ideal world, you get to work with people with whom you share ideas, and then you divide up the talents and capabilities. But since ours is an individual and ego-driven society and scene, most of the time you work on your own. A successful New York gallerist once said to me that once you've made it, somehow you will probably continue to mop your own gallery floor before the opening, as you only trust your own ability to do it properly.

Besides that, anything that is based on a flirtatious or sexual energy, or anything that feels like it might go there, will eventually go there. Anything that looks or sounds too good to be true usually is. Cities are built on false promises or projections. Remember, it is a game, a dance. A dance is alluring, sexual, close; it moves, it has a rhythm, and, of course, people and their personalities. So ask questions, doubt, investigate, do allow yourself to play hard to get, but be ready to dive in if it does feel right. If it does not fit your world, do not try to make it fit. If you think it will serve your CV, well, it might, but you will still

have to live through it. Anything you decide to engage with will become a slice of your life. So, my most honest and direct advice is to take in all the information and then take the time to imagine, to visualize, to forecast how it would really feel to be there, to work with that person, to go somewhere and stay and invest your time. Walk through the foreseeable future, step by step, forecasting as best you can, and ask yourself if all of it feels comfortable, reasonable, acceptable, beneficial. It is your life that you are shaping, at the end of the day.

Sometimes you have to go into less-than-ideal situations, as choices seem scarce, and you do it to survive. I did this only when it felt I still could maneuver the outcome onto my own path, in my preferred direction.

## HOW DO I DEAL WITH BAD CHOICES?

Opportunities can go completely sour, even if you have done everything right. It's the others, who did not seem so appalling at first. Given that we are all empirical beings, needing to experience things ourselves to learn from them, there is no way I can give you the right advice as to how you can avoid situations like that. Throughout the years I did many things that required me to forget about all the bad stuff around it, or the people who made it terrible, or the setups that were awful. Or the worst: perfect and promising situations on paper that result in something completely different. What I do remember is the art I managed to make, despite all the imperfect, far-from-ideal, or simply dreadful situations. This is what makes it all worth it. Even if the space or the people behind it do not match your ambition, your capacity, your expectations, even if the context around you simply does not communicate your worth, you can still make the best art you are capable of.

An artist once shared a room with me during a group show in some god-forsaken place at the end of the world. She is a very successful artist now but was up and coming at the time. Her work was all about the margins of society. So there we were, in some really shady conditions, nursing our hurt pride, trying to figure it out. One night we got drunk. Out of desperation, based on the thought that this whole thing is a shitshow, we wondered if we could somehow embrace the shittiness. This is, or should be, our challenge: how to crack it and shift "This is not working for me" into "Well, maybe I need to make it work and adapt the idea to it." We had a great night, talking and drinking a lot, but in the morning she packed and left on the first bus to the airport. I was surprised by her abrupt decision, but I'd seen it coming, too. She talked a good game but had decided that it was just talk. I realized, not for

the first time, that in order to make something happen, I would have to face the music and do something great. Perfect situations rarely emerge. You have to work with what you're offered. Your ability is not down only to how you could work in ideal circumstances, but how you can work within *any* circumstances. In the end, you have to adapt to situations. In this case, I felt that my show turned out better thanks to my rolling with adversity. You won't get far if you refuse to work without your ideal setup. Adversity makes you tough, adaptable, inventive, and, most of all, relevant.

Still, the worst traps are our own projections, things that make us get involved with something that it is not made for us, something that looks great and promising, that better world, that dream of the glittery room. Still, a "wrong turn" can become a decisive factor while shaping your own beliefs that make you as a person and as an artist.

* * *

One morning back in Milan I woke up—or rather, a Thai maid woke me up. My head was sore and my nose was itching. She had gotten up before me, as she usually did, making phone calls through the morning. I liked that. It gave me the feeling of constant rhythm and the freedom to stay longer in bed, nursing the consequences of the glittery decadence that I fully embraced in that period of my life. I have never seen so much champagne, and never had so much cocaine thrown at me almost on a daily basis at all the buzzing events I'd be taken as the "new talent" in town.

After having been served coffee in bed, which I never really got used to. (Every time the maid came in I wanted to get up, but then I remembered I was completely naked, so I just grinned and accepted my morning tray.) The maid was never happy to see me, or her look was more: "Just don't get too comfortable, there were many before you and there will be many more after you." Fair enough; I understood that. Looking back, I laugh at myself, how I pretended to be as busy as she was, staring at my old non-smartphone and thinking who I could call to seem to be working on something urgent and complicated that somehow had to do with my art. Usually, I would call a friend and crack a few jokes about how we'd managed to trash yet another fancy party while getting shitfaced.

An important residency brought me to Milan in 2011. I was on the hunt for new adventure and opportunities. That's when I met Delphine. This was the time when contemporary art became the new black.

Thanks to her, I made one of my most significant shifts as an artist. Living "the dream," I realized one morning when I woke up that I'd survived or

managed to get rid of yet another pipe dream of mine, of "how it should be," the vision of success. It was the usual story: You meet somebody who helps you meet everyone else, and then this somebody offers you what you have been chasing for years, and it's as if everything you have built on your own loses its value in just one breath. For a period I swam through golden flakes and champagne bubbles, high on a cloud of all possible drugs. This was the proper "radikal chic" crowd, and I spoke their language. The cool kids were all mostly "creative" or wannabe artists, dandyish, rock-and-roll, and edgy. In most of the cases, the edge was just the constant boozing and drug abuse.

I was one of the few artists with some status in the crowd, with some actual gigs under my belt. My thing was that I could not just linger around being all cool. I needed action. So I would engage with all sorts of people in all possible situations at all hours and talk, talk, talk. With pounding music, heated bodies, and everything else lubricating the scene, talking longer than two sentences was a rare phenomenon in those wild situations. That I actually wanted to talk inspired people, opening them up and chatting on clouds of the pure enthusiasm and raw energy I had to offer. She took me home, and so it started.

I had, all of a sudden, many doors open, parties thrown in my name, my works sold over spilled champagne, shows were planned, young gallerists and loaded collectors walked into my studio. She threw her weight behind me, and that changed things. But then, out of the blue, the glazed surface cracked.

I was standing in front of a full room, packed with all the cool kids. It was a concluding performance concert of a project of mine, when all of a sudden everything went wrong. Actually, it was just the tip of the iceberg of the feeling that had been mounting inside me. Initially it had been a dream come true, but a feeling grew that the price I would have to pay eventually was not one I was ready for. I had been steadily building a life of my own, built on my terms and to my rhythm. I had always dreamed of what it would be like if something or someone just catapulted me into the orbit of the rich and famous. She was both incredible and unbearable—she was a control freak in all aspects of life. I could tell that staying with her would mean following her lead only, indefinitely. If out there it was all smiles and glitter, it was nothing but gutter and darkness when the effect of everything faded and the doors closed.

For a while, I enjoyed the duel with her aggressive character. But that isn't necessarily a dynamic that is sustainable indefinitely. This was a period when I was seeking that, but not forever. Before I'd left for Milan, I had spoken to a friend and said, "You know what I need now? Somebody who would mentor me through this crazy life. Somebody who would shake me from my comfort." Careful what you wish for. She shook my whole persona.

I became what I wanted: the elusive, unpredictable, wild, punkish, trashy . . . an enfant terrible. But deep inside, I felt that I needed a new direction. I wanted to grow. She saw that and so she pushed me mercilessly. She would bury me with cutting-edge books, documentaries, and magazines in the bruised-up mornings. Days I spent feverishly working on the final residency show and other upcoming projects.

Standing before all those people at my event turned the tide for me. Something happened that night. We had a series of unexpected technical problems with the sound equipment, but it was not just that. It was the underlying discontent that verged on disgust with what my life was becoming. I might have been perceived as a playboy or a bon vivant, or just young and crazy. Sure, but above all, I was and still am an artist. I am a fucking poet. By poet, I mean it not in the literal sense, but as a visual artist à la Rimbaud, a rebel fragile soul who needs only a pencil and a scrap of paper to grasp the existential knot and crush something meaningful and relevant out of it.

The crowd was expecting a raucous musical artistic performance at the mic, something provocative but entertaining. Instead, I picked this moment to break up with that dream of mine. It had been a long time coming, but my decision to do it there and then was spur of the moment. The medium for this fissure was a dark spoken word monologue in lieu of the performance the crowd that evening was expecting. I spoke about things ending, about hopelessness, the void, emptiness. Everyone in the room felt that I was attacking them. And I kept on talking.

Nobody wanted a fucking poet. They wanted an entertainer.

I packed my things and left. It was time to move on.

# 7

## SHIFTING TO A BIGGER STAGE

### How Can I Create Consistency in My Practice While People Come and Go?

This chapter shrinks ten years of shows, projects, and chasing what I wanted to become into a shot glass, a glance through a kaleidoscope refracting various life-changing events, art projects, and life- and art-changing events and projects. It's impossible to put down all the incredible things that happened, all the ambitious projects I developed and realized, or to name all the people who helped me define my work and who I became. So the focus here is on a strategy of how to work with a river of people by keeping some of them partially in the dark without alienating them while also forging long-lasting bonds. It's a complex and multilayered process, which needs iron nerves and will. Looking back on endless shows and projects, there is one underlying thing that pushed me to work like this: the creative process. When you are in the studio, or if all the art that you make is within your studio, then this is where you have all the control. You dance as you please. But if your work involves site-specific interventions, installations, multimedia, performances, and events, collaborating with other artists as your modus operandi, things change because you *have* to work with others. This means you have to share the creative process with others to at least some degree, and this is where it can get tricky. If you work beyond the confines of your studio, you're obliged to work with others, which can force you to change your process. The fruit of this can be beneficial or counterproductive: either way, it must be navigated. Through the years, based on what we developed with Crash in

Progress, I distilled a strategy, an approach, an attitude that would allow me to keep my artistic choices as open as possible for as long as possible. This can be, and usually is, stressful for those who do not inhabit your head.

Now I knew how I wanted to work. I needed to find a way that would enable me to do so.

## HOW DO YOU FIND YOUR OWN PATRON?

It's important to understand that what contemporary artists, especially conceptually driven avant-gardists, are doing is a niche. And that's the best way to pitch it. It's not "Either you, Mr. Collector, buy an Impressionist painting or instead you buy something I've done"; instead, you're offering something edgy from a rare species. In order to attract people to my work and to support me, I emphasized the feeling that those invited had the chance to be part of an exclusive, private club, a circle with a rare chance to buy in to something new, wonderful, developing, speculative.

Primož, Zavrl, and I, with the help of my father, put together a list of potential backers, buyers of my work, in 2007. We needed people with an inclination toward my father or Zavrl (if they didn't yet know me), who had a relationship with art that did not end circa 1900, who had enough money to spend it on art, and who had a personality that would allow a young artist to be their guide into new, exciting waters. It's almost like looking for venture capitalists to buy into a startup of huge potential with the promise of future reward, in terms of interesting art to own and in ploughing new fields.

We made a document based on my ideas that would stretch out far into the future; this was private, exclusively for a group of about a dozen people. Zavrl and my father helped open the door of communication with these people, as I did not know them, but it was up to me to walk through the door and handle the lion's share of communication and pitching to them. The document we prepared included a pitch about who I was, a list of what I'd done to date (which was impressive for an artist of my age), a plan of future projects, and an estimated itemized budget to actualize those projects. For the people in this group, the idea was that they would buy in to my work by investing in me. They would get art in return, as well as the satisfaction of helping a promising career along. We broke down possible investments into three groups—A, B, and C—in terms of investment amount. The interested characters came together in a meeting, sitting around a table together, with an element of competition between them. Then Zavrl would say, at the meeting, "I'm all in for level A, the top level; what about you?" And

the others had some peer pressure to respond that they were also in at that level so their peers wouldn't doubt their financial and cultural chops.

Part of being a successful artist is knowing, at least two years ahead, what you'll be doing. That's what I'd been told, anyway. So I invented future projects based on numerous concepts I had lying around my studio. It is an audacious move to call a concept that you are developing an actual project that will happen. First you have to convince yourself that what you say is, or will be, true. Uncertainty and lack of confidence leak out, and others have a good radar system for spotting them. Not having a space yet to show is perfectly normal. You are asking for support, to be able to develop it through daily practice in your studio until it reaches a stage where you can find a person with a venue to show it.

Out of this, half of my studio work became talking to people, writing to them, making pitches, presenting, making visits for cocktails, coffees, dinners to network, developing my "program" (which included portfolios, artist statements, written concepts), and inviting them to studio visits to present my work. How many people came through? How many faces did I try to impress? How many meetings did I hold, knowing that the vibe had already left the room? Endless. At times the process made me feel like an international door-to-door salesman with a briefcase full of odd objects and concepts.

## HOW DO I DEAL WITH CONSTANT UNCERTAINTY OF INCOME (AND THE FEELINGS OF DEPRESSION THAT CAN ACCOMPANY IT)?

Zavrl taught me to juggle as many balls as possible at once. Each ball is in the air and you're playing each one the best you can. You never know which will go through and when, so distribute risk, mutual fund style. This isn't just advice about finances but about being psychologically prepared. The life of an artist is almost exclusively a world of no thank yous. Know this, expect it, suit up in armor to deflect all the negativity, and revel in the exotic pockets of yes. With so many noes, the danger is that you'll generalize these as a single, collective, personal no, a no not only to your art but to you as a person.

I still struggle with this. You'll almost never receive an explanation for the response—it's usually just an unhelpful no. Those noes may appear objective, but they are not an absolute comment on the quality (or lack thereof) of your work. They are not in the least bit scientific and can give the wrong impression that your work is not of merit. It's all subjective, and it might come down to a jury not liking your work because of the color of their socks that day. This is

something you can understand, but it's easier to shrug and move on in theory than in practice. I still take it personally, and that is normal. A no would knock me off my feet and I'd brood for a day or more, until nights and comforting words from those closest to me helped me reset. You'll inevitably face some sort of loss: emotional, financial, artistic, personal.

This period coincided with my mother's getting cancer and eventually passing away. At the same time, I became a father. My beautiful Bela was born, the girl who would, years later, visit me in the studio, look at me, and say, "Why oh why is the sky so full of blue dogs?" Back then, she was not even two and my mother was fighting her last stage of cancer. I kept on working like mad—it was the only thing that kept me afloat, but eventually stress and extremes tore me apart.

Ever since my school days, I tended toward extremes: the artist cliché of riding high and dropping low. This period was marked with a depression. I was a cocktail of emotions: exhaustion, sadness, joy. Life around me whirled and bubbled and coiled. I started to feel like a fish that had grown too large for a small tank, the glass of which was closing in around me. In retrospect, my main pain was realizing that I'd managed to construct something beautiful, sustainable, and successful, but my feeling was that would not allow me to grow further from that. That this was it: a satisfactory plateau, but I couldn't see how I could move wider or higher. This was my choice and also a symptom of my restlessness.

I started therapy to help cope with these contrasting feelings. My shrink was an old-school, chain-smoking woman who was the psychiatric equivalent of a heavy metal band. A few sessions in I told her I was worried that maybe some of my demons helped me as an artist, and I didn't want therapy to exorcise them to the point where I couldn't create anymore. She said that this was a legitimate concern, that some artists had ironed themselves out emotionally and subsequently flatlined as creatives. Very few great artists in history were happy-go-lucky types. But she assured me that we would follow a systematic therapy, not trying to go deep and uproot the issues but to better understand how I was connected to those around me.

It was 2009, the period of hypermobility. In the 1990s, boarding a plane meant a financial investment. In the 2000s, with discount airlines, it cost less to fly around the world. This changed the art world for good. Horizons expanded, and that coincided with online everywhere-ness.

It was one thing to sustain day-to-day practice, shows, your young family, and spending time with your friends. But now sustaining travels was an important part of being an artist: international presence. In all things, you're successful to a point. Every expansion of that point feels like a victory. Staying in place feels like pedaling in butter.

During my mother's last period, we dreamed of traveling together. Her first love was New York. She wanted the two of us to experience the city together: an experienced architect and a young artist, mother and son. In her own words, "In order to become the artist you want to be, you must be shaped by that city." We never managed to make that trip happen.

Residencies are a great way for artists to expand their geographic horizons with someone else covering their expenses and while being somewhere with a reason—as opposed to the overflying, omnipresent, never actually touching any ground, door-to-door free agent beast that's constantly meeting people and chasing your options around endless art fairs, venues, and openings can turn you into. For me this has always been a balance of two contrasts: the needed solitude of the studio and breaking new ground, making art, and seeking out options to show it. One can eat into the other and it's completely up to your personality how much of any of it you really need—when one or the other voice turns from murmuring to shouting.

When I felt I had to open up my options and horizons, I started applying to numerous open calls, which enabled me in the next period to zigzag Europe with a climax in Williamsburg, Brooklyn, in 2009, which cemented the idea that I wanted to live and work in New York. Residencies let me spread my operational platform and collaborating options.

## IS STANDING OUT A GOOD THING, OR CAN IT RESULT IN "TALL POPPY SYNDROME" TYPES OF PROBLEMS?

Inspired and refreshed by my residencies abroad, I set my eyes on participating in a group show that would place me within the national hierarchy within Slovenia. I had been traveling so much and felt that I needed to make a meaningful impression back at home. There were two ways to move forward: either a gallery with international presence would pick me up and represent me, or I could go through my home nation, which involved a prestigious selection process. I was on the hunt for either or both.

An important group show for contemporary art appears every three years at the Museum of Modern Art in Ljubljana, the most internationally established such institution in this part of Europe. This museum's clique knew perfectly well what I'd been doing, with and through Primož's gallery, the whole Bad Boys & Bad Girls gang. But they just wouldn't let me in. People saw me as an elusive, loud force to be reckoned with. When people create shows and think of artists to include, they think in terms of who they want to work with. My status

at the time was considered "hard to work with" because of my "unpredictable work," but mainly because of the image that I was completely self-sufficient. It was a catch-22. To be able to work, I'd created a system that supported myself. I did that to enter a scene, not just to shout out loud. I wanted to be in the scene in a constructive, creative way. But that self-supporting approach made me seem an outsider. I learned years later, though I had a hunch at the time, that the untamed energy I was cultivating as an artist, aiming for the best, put me on the map but may have resulted in it taking longer for the scene to accept me. Subconsciously, if not overtly, those in power want anyone from our area to come to them for approval. I'd skipped right on past them. Though I felt like we were rocking it on our own, I'm also man enough to admit that I would have liked to have been invited.

So it took the arrival of a foreign curator, Charles Esche, for the Triennale of Slovenian Contemporary Art to recognize my value and include me. I learned that the Triennale selection process had ended long before I thought to apply. But Primož and I insisted until we got a tiny crack opened in the already shut door—enough for me to slip through a project proposal, which Esche loved. He called me just two weeks before the installation started.

## HOW CAN I GET INTO A MUSEUM OF CONTEMPORARY ART THROUGH THE BACK DOOR, TO BECOME PART OF THE MOST IMPORTANT SHOW ON AT THE MOMENT IN MY TOWN AT THE LAST MINUTE, AND EVENTUALLY TAKE OVER THE WHOLE MUSEUM?

I developed the Trojan horse technique with Crash in Progress back in 2003 to get into a bigshot gallery. At that time, the one and only and the most important artistic competition was held every autumn, at the start of the new studying year. We all tried to crack it, and those who won got incredible attention and support. Just getting into the show was amazing, but if you made it among the finalists, you rocked. Usually, those artists exploded overnight into all the shows that mattered in Venice and later, Italy. If you played it smart, the accolades and momentum could last more than a year. Every new winner outshined the ones before. It was the proper cinematic material of urban legends about a young artist who got rich in a year, making show after show, selling like crazy, and partying with the crème de la crème.

The Trojan horse strategy was simple but effective and has worked repeatedly for me, for us, for others, with no sign that anyone is catching on. It is le-

gitimate and legal and uses the weakness of the selectors (their limited attention span) against them. If I may say so, it is pretty ingenious.

We submitted an art video of the sort that we knew the judges would like, but that we were not interested in making as our work properly. Competitions like this ask you to submit the finished work when it comes to classic forms like painting and sculpture. With multimedia, how you install it can be negotiated. That's a fundamental difference. It means that once you are accepted, you have some wiggle room to change your tack and create something different for final display (and judgment as a potential winner). The selection committee for those included in the competition is made up of human beings; that is to say, they will look for shortcuts and grow bored, just like the rest of us.

With this in mind, we prepared a forty-five-minute-long art video, which, at the beginning, was nothing else but a "proper art video" of the moment (some weird effects, dark music, barely noticeable action—and way too long), the type we knew the judges would like and would have the best chance of being accepted. Then, some fifteen minutes in, the content shifted gears and went, well, our way. From minutes sixteen or so until the end, there was nothing in the video but us dicking around: drinking beers, smoking weed, coming up with Monty Pythonesque gags and costumes, anything stupid enough to make us laugh. In short, we buried the actual video and installation that we wanted to present in the competition in the middle of an overly long art video. Had the committee watched all of our submission, they would probably have been baffled about why minutes one through fifteen looked so different from minutes sixteen through forty-five. But they didn't. I'm sure they started watching and, some five minutes in, liked what they saw enough to say yes to our project and stop watching. They also were familiar with *Dafne* and so knew we were capable.

It worked. We competed, and the selection committee could hardly admit to having not approved of what we eventually presented. After all, it was in the submission video. To complain on their part would be to admit that they didn't actually watch the whole video.

In the case of the Esche Triennale in 2010, I went for a similar strategy.

I had one day to hand in a presentation on just a single standard-size piece of paper. To be clear, the first iteration of the Trojan horse, with Crash in Progress, was a sort of harmless con, a trick to get past curators who were a bunch of dicks. Here, that was not the case. Esche was great. The Trojan horse was not about slipping something past him, but about getting a proposal accepted that managed to capture the attitude of the eventual work by offering what I was pretty sure he'd go for, but was vague enough that I could later take it in any number of directions.

It worked. He included me as a last-minute addition to this important show. These selections, the infinite open calls, the shows, the grant applications, and of course, the seemingly endless number of PDF presentations that artists are obliged to submit; this merry-go-round of submissions to be judged by selectors is the language of the art world; millions of documents flying in all directions, sitting on various desks or on a million computers—and I'd wager that some 80 percent never even get looked at, and the ones that do are examined only glancingly. That's not how it should be done, but it happens. Knowing this can offer an advantage to those of us who are obliged to fill out applications, grant requests, and submissions.

My approach changed thanks to a fantastic workshop, mentored by Walid Raad for Fondazione Ratti. He showed me a way to master the medium of the simple A4 document. This is when I started enjoying it: cracking the code, seeing it as just another medium, with all of its technical limitations, demands, and options of expression. A perfect capsule in which to develop a concept.

What I presented on my A4 sheet of paper won over the curator back in 2010 and got me to the next round: an interview. The interview is another medium to master. An artist who is skilled in filling out applications and open calls and who can handle an interview will go far; in terms of opening doors, this skill set can appear to be more important than the art you actually create.

The project started in the basement, next to the toilets. In general, this is a no space in an exhibition. Let people use the toilet uninhibited, is the general rule. My ambition was to meet all the hotshots right before they had to use the restroom. I would stop each of them, say hello, squeeze their hands, and ask them about their work. The situations were hilarious. Most of the artists knew who I was, or at least had heard of my work, but nobody was able to figure out what the hell was I doing down there. Polite questions when someone had "business to take care of" in the facilities made the situation even more bizarre, followed by the even funnier moment when these hotshots emerged from the bathroom and I was still there, and they would look at me, despite their glamor, and wonder, *Did he hear anything?*

My close friend and collaborator, Luka, and I set about working on what became an off-site installation, anchored in the toilets and spread out to two other additional spaces in the basement. It was meant to look odd, out of place, and somehow wrong. Then we mounted a door as an installation: It consisted of nothing but a door set up at a most unexpected and inconvenient place in a basement corridor, just before on the way to the toilets. One had to make an effort to open the door, and it made a lot of noise, as it was rigged to slam shut behind you. It worked as a distraction, as an interruption, an intervention within the tissue of the expected.

For the opening, I invited an amazing performing group, LJUD, with whom we spread out into all the exhibiting spaces. They, too, would be a "surprise" aspect of my now-multifaceted performance-cum-installation. I had one of them, a lady, walk a domesticated pig through the exhibition space; someone dressed as a policeman walked through the show, seemingly interested, who would end up kissing a girl, another member of the group, for an hour. Another dressed as a cleaning lady, still cleaning during the opening and making coffee, and someone else played an elevator attendant who would sing and push drugs to customers in the elevator. I had a guy sing and dance throughout the show, and someone dressed just like the other waiters, but he was naked below the waist. They all came in at first wearing black terrorist masks, observing the show but creating this palpable unease, before going below into the basement, to our operational headquarters, and changing into their roles. My buddies Luka, Junzi, and I formed a band, which we called Leftfinger, so we could add an aspect to the performance of playing on the roof of the museum where the exhibition was held, setting up a proper open-air sound system and four beams of light punctuating the sky. The whole city could see and hear us. And they did.

The performance ended back in the basement, with a hard-core techno party in the toilets, Junzi shaking the very core of the museum with the bass speakers. I concluded it all with a programmed pillow fight, which left white feathers covering the basement floor. The result was this pounding, heated, neon-blinking, feather-flying, champagne-drowning, and all-encompassing pulsating feeling of freedom, of a positive virus that infected everyone that night, a virus that lasted beyond the duration of the show, thanks to its bonding energy. That night, everything was possible, everything was ours, without a shadow of a doubt.

And Esche? He loved it once he got the potential of the project's development, and when he saw that what he liked conceptually was that I was crazy enough to deliver, in a complete and untamed way, he pushed me even more. With the right sparring partner, things start to fly—that's what a curator-artist relationship should look like. Working with him opened a new period for me, now on a bigger stage, with greater risk and evolution.

## HOW DO YOU TURN APPARENT DISADVANTAGES INTO ADVANTAGES?

I came back for the duration of the show almost every day, sliding into various exhibition spaces disguised as one character or another. Observing people of all sorts enabled me to understand how they moved, how much time they spent

engaged with a work, but most of all, what their relationship was, within any given context, with an artwork. This thought process coincided with a renaissance of clubgoing circa 2001 that was never something I was into, grunger that I was. But the music of the era pulled me in and I decided to partake. There were similarities, but one strong discrepancy was apparent to me between consuming art and clubbing. Clubbing takes place throughout the night, amid heated bodies, thumping music, and flowing drinks. It has many similar elements to an art installation, in terms of space, lighting, color, stimulating objects, the human body. The major distinction between clubbing and visiting an art exhibit is time. The elements are similar, but the club is host to an event all night, whereas most people spend less than a minute looking at a given artwork in a gallery and a good deal less than an hour taking in a whole show. This made me wonder how I could lure people into lingering longer at a museum show. What clubbing elements could I borrow and employ in my artwork? And so the experiment began.

I began working closely with a curator at the Museum of Modern Art in Ljubljana on what became my first solo museum show. Little did I know that what began as a monthlong experiment would prove such a success, in very surprising ways, that it lasted almost three full years, from 2011 until 2014.

It began when I was offered a space in the museum when it was freshly renovated. The space available was eventually going to be made into the museum café, but while it had some of the infrastructure, it was far from finished. It was a simple grey-and-white cement cube positioned between the ground and basement levels of the museum, with windows running along the ground floor side. The space felt at once overwhelming with potential and limiting—an odd cocktail. As I stood there within the empty space, I felt it boiling with potential. I could envision the echo of future packed events. I quickly wrote down my concept.

Coming in through the front door of the museum and heading down the stairs wasn't going to cut it. So I arranged to have access via one of the ground floor windows. This gave a surreal and rebellious tinge to the simple act of entering, which required some awkward contortionism.

The saying goes that necessity is the mother of invention. I'd paraphrase it in parallel and say that disadvantage is the motor of invention. The space and museum offered minimal production support, but this is par for the course. Many, if not most, collaborations or options of working with institutions rely on you, the up-and-coming artist, bursting with energy and ambition, being willing to do just about anything just to have a chance to exhibit your work. This is the general rule, and it's definitely not okay. It establishes a dynamic of constantly working on the precipice, barely managing to pull off your vision. It's far too

common in the art world, as many exploit the long line of ambitious newcomers who are willing to accept any terms to be given a venue. So I did what I usually do and started calling people in and knocking on doors. It took me a while to get the necessary equipment, especially when it came to sound systems. The first month was quickly coming to an end, and I needed something. The clock was ticking down to my opening.

I needed an opening event that would show the real potential of the project and encourage the museum to prolong my stay. I organized *The Lovest Days* and invited a series of artists I often worked with at the time to create a dynamic event that consisted of various situations, performing interventions, music, and more. It was a multiperson, multimedia happening. The event lasted for two days and was very well attended, with fantastic energy. The director of the museum, Zdenka Badovinac, came right at the peak and was amazed by how many people came and how long they stayed. She looked at me and said, "Well, I guess there is absolutely no reason to shut down the project now. There is no way we can seriously fund it, but maybe you can find other solutions?"

We invested the week in working on the installation, music, texts, videos, and performances and transforming all of that into a weekly event, Fridays from 6:00 p.m. to 1:00 a.m. Our core team was Luka, Junzi, Fejzo, and Junzi's sister Nina Vidrih, with many others lending a hand (including Meta and my coconspirator on many an artistic adventure, Mark Požlep). It grew gradually, but it grew. People started pouring in. Eventually the "cool kids" of Ljubljana found us and the whole thing exploded. *The Lovest* became the spot to go. How many people in attendance were aware that they were visiting an art installation in the guise of a nightclub was perhaps a reasonable question. But all you can do is lead a horse to water. It felt like a fucking fantastic achievement to have people come to an art show on a Friday night and stick around until closing time.

Over time, *The Lovest* became an instrument of active experimentation in combining individual media into this live wholeness of events that—regardless of the debauchery, happening, concert, dancing, performance, or other raging—always ended with the same words by the gallery doorman: "The museum is closing." And every time he said this, it put a smile on my face, because it reminded everyone who was happily partying that, yes, you are in a museum and you are attending my show, a participatory *Gesamtkunstwerk*.

As I was working on new works and projects, *The Lovest* went on brilliantly for another whole year. At one of the last events, I called all the leading figures who'd worked with me on various occasions to do something special for the public: half-hour DJ sets in front of the museum at the start of the summer. It was a bow to the public who had made the whole project succeed for

years, not just weeks. Somehow it felt incredibly liberating to know that this goodbye meant saying hello to something new. So in the middle of the event, I walked off, with a smile on my face and music in my feet. And I bumped into a smile from a girl who would soon twist my world and make so many things happen: Rosa Lux.

<p style="text-align:center">*   *   *</p>

My telephone rang in the middle of the summer.

"Are you in town?" Primož asked on a hot day when, only by chance, I'd come back to the city to pick up a couple of things.

"Yep, why?" I replied.

"Good, we are meeting a New York gallerist tonight, so you better gear up!"

It was still during *The Lovest* and I came to know that she and her husband had seen it and they'd insisted on seeing me while they were in Ljubljana. Primož knew that my dinner parties were the stuff of local legend. So he convinced Stephanie (the gallerist) and her husband to stay on longer so they could join us. I called every one of my artist gang who was in town, and we threw this crazy dinner in the studio and home I shared with Meta. Every dish contained some kind of alcohol, and the same amount and type of alcohol had to go into the cook.

Stephanie ran a young and successful New York gallery on the Lower East Side. What I learned much later on is the classic duality of New York stories of success: the perceived image and the struggle, the hustle backstage, the immense quantity of money needed to run any kind of freaking business. Any gallery, but a new one especially, with fresh (as yet unestablished) artists, is insane. No wonder most of them give it up, close, or turn to the usual commercial shit. The expenses are ridiculous. So the calculation was simple with me: She loved my work, but I was in Europe. To bring my work and everything it entailed was probably triple the costs, or more, compared to showing any artist living in New York. And that started stalling it all. I was in no position to say, "Eh, no worries, I will cover it all!" So we had to find a way.

A month or so later Stephanie came to Turin for Artissima, a major art fair, and Primož drove there to meet her. I was in the midst of an installation, so again the combination was perfect: The artist is working; the gallerist presents and tries to nail the show. Stephanie said, "Definitely yes," but still could not give us a date. At that time she had to secure some sales to cover her investment into the art fair.

## ARE ART FAIRS A PLACE TO BE FOR AN ARTIST?

Have you ever wondered why gallerists are so obnoxiously tense and snappy at the art fairs? Do you know how much money their booth alone cost? Then add to that the transportation of the works, the travel and living costs of the indispensable support team. At the back you can maybe make some compromises and stay at a friend's place. But when it comes to putting on a show, the face of the gallery, the projection of successful business (which is rarely a reality)—all of this costs a lot of money. And it is still roulette, even a Russian one. You can enter already in debt, and it can happen that you sell not a thing but still need to move on, somehow pretending you are doing great, even if you're on the verge of bankruptcy. And if you are not showing, it is definitely not the place to be an artist.

But an artist's sympathy for gallerists is limited. When your career is on the line, you are understanding only to a point. But the waiting makes you goddamn nervous. I felt like I was waiting in the green room, ready to run out on stage and rock it.

Then an opportunity cracked open. A young gallerist from Milan owed me some money for my works she'd sold. "Let's do it like this," she said. "I'll buy you a ticket to New York and you go there, meet her, and nail the show. So you won't have any more excuses. Deal?" I believe my eloquent reply was, "Fuck yeah!"

In a month's time, I was on 8th Street in Williamsburg, looking for Stephanie's flat. I stayed a week. On the first night in New York, I learned that Stephanie had separated from her husband. Stephanie was still broken, even though she did all she could to hide it. When she laid it all out to me, it became awkward, as my blood started pumping and I could only hear my mind going, "Jaša, do not mess it up this time. Everyone's pants stay on." Especially difficult was the day she finally got off of work and we met after the gallery closed. First we went for an easy dinner, and then she took me to her favorite bar. In the middle of the night, I knew we'd started to feel the effect we had on each other. Somehow we were of the same breed, and words just flew. Listening and smiling occurred naturally, smoothly. But the fact that I wanted to work with her, and that I genuinely felt that this time around would be different, that I'd met a gang like mine, but a New York equivalent, hung over me. I knew that she needed to feel me in order to take me in as an artist. I honestly do not know who turned down who that night, or if it was simply mutual. Pants remained in place.

She finally confirmed my show over breakfast on my last day there. "It is set in stone and we'll do it in June," she said. It was late November, so I had all the

time I needed for what I'd learned during that week: about her gallery, the artists she worked with, her style, the Lower East Side scene, and how New York felt at the time. I'd gotten what I came for, so now I could go back to work.

## WHEN GIVEN THE CHANCE TO STEP OUT ONTO A BIGGER STAGE, DO I PLAY IT SAFE OR GO BOLD?

We artists don't like being told what to do, but it's a risky business in which to be a rebel. You can wind up slamming shut a door that you worked long and hard to open. People don't like taking no for an answer, and the scent in the water of a troublesome artist usually results in potential collaborators fleeing, as I learned painfully. I was smart enough to keep my plans to myself. My plan was to shift my style completely over the course of a year.

As an artist, I'm driven, as most of you are, by a combination of irrational hunches. One could call them visions or inspirations, if you prefer to be Romantic. When I'm in the midst of a flurry of goings-on, a strange feeling rises within me, one of not belonging, like I'm pressed back into a corner of my mind and breath comes short. Then, out of the blue, a phoenix rising feeling emerges and I suddenly am no longer cornered but have it all figured out and can act with heightened capacity. In these moments, I'll get a hunch about where I should take myself and my work that will allow for a long leap forward. This, for me, was one of those moments.

There's also the dance of art and reality. Who triggers who? Does art reflect reality and comment on it, or can art trigger reality? I'm all for the latter: parallel realities, pockets of what is real to viewers who enter a show. This is when I started to see a vision of a man in the air, perhaps like the famous leap photo by Yves Klein. It became a very concrete image.

While Meta was in a residency in Helsinki, Bela and I accompanied her a month later. One night in the studio we sewed together a set of wings out of three black gentleman's umbrellas. I'd been in Helsinki before; I'd taken a walk through a port and I recalled this amazing view of the sea from the previous visit. So when the wings were done, I knew where to go.

Magic is extremely difficult to pull off. But when it does, when all falls into its proper place, then oh, yes—it just happens, invigorating every inch of you, if and when all works perfectly at the end. That's how and when and where we captured an image that had been, to that point, only in my head. Looking at this photo of me, with my umbrella wings, leaping forward, you see a moment in medias res, after the action has begun (I've leapt) but before it's ended (I've

descended). Or that is the thought process, at least: Looking at the picture, you only see one thing, a person in midair. That's the reality the artwork generates.

Another event pushed me forward. I was on my own in Helsinki in the city center, on a street lined with tall trees and that incredible afternoon Nordic light. I was in a blissful state, just daydreaming. Then I heard a tune in my mind, and a voice, and then I saw something that became the basis for *Apnea's Rhapsody*, my New York gallery show.

The trees bowed.

Maybe this was the aftereffect of the various mind-altering substances I'd experimented with during *The Lovest* period. Maybe it was a daydream illusion? Half of my brain was consciously convincing me that this is not happening, while the other half permitted me to fully immerse into whatever it was I thought I was seeing. I followed that latter half.

These two elements, the trees bowing and my umbrella-wing leap, were the pillars on which I built *Apnea's Rhapsody*.

But that's absolutely not what Stephanie had in mind for my first solo gallery show in New York.

To my disappointment, when I sent her the photograph, which I called *Apnea's Rhapsody Action #1 with Umbrella Wings on a Fjord in Helsinki*, she flatly refused it. I sent it as an image to be used as an invitation to my show—the opening image that led into the whole narrative of the show—but she wasn't into it. It turned out that a classical gallery show in New York can be extremely conservative, playing it safe when risk with any kind of experimentation feels like a luxury a gallery cannot afford. It should feature a sort of top ten best works of the artist's last ten years and saying to the public: "Come meet this artist you don't know and buy from his greatest hits album." I wanted to do a brand-new show with new material that differed from everything I'd done before.

My ambition was not to alienate Stephanie. I just knew that I needed more time to produce new works and come up with a full cycle, and then convince her with the complete cycle. I accepted that the wing photo wasn't going onto the invitation and she selected something from my oeuvre, so of course there was give-and-take. If you're working with someone new, it's only fair to protect yourself. An artwork is never a thing on demand. Real art isn't, anyway. The creative process always demands space and a step forward, otherwise it's stale, repetitive, derivative. I wanted a shift. She, on the other hand, had seen and loved *The Lovest* and wanted me to do something along those lines at her gallery: art show as *Gesamtkunstwerk* event. I was actually planning something along those lines, but with very different form and content. Same orchestra, different symphony.

During *The Lovest* I felt that I'd seen it all: euphoria, madness, partying, drugs, booze, sex, my version of Studio 54. I'd tried it all, broken all the stereotypes around how people should behave within the context of an art show, and there was only one thing left untouched: a collective therapeutic experience of drug use.

MDMA was huge in Europe: It was the drug people experimented with at the time. MDMA was invented in California by a group of scientists and intellectuals looking for a recreational drug that would enhance openness to others and heighten conversations. The drug, in the form of ecstasy, would be the focus of rave culture. All my experiences with it had been extremely positive. It pushes you to open up hidden pockets in your mind. It's sometimes even used for types of psychotherapy, as it helps to overcome trauma.

Throughout *The Lovest* we pushed forward the ecstatic feeling of euphoria. I wondered if our events could be taken to the next level if our group consciously did something to expand our consciousness.

This wouldn't be done in a dodgy way, in a toilet at the club or what have you. Instead, we'd do it in the midst of an art project. We decided on an event that would run from 9:00 p.m. until 9:00 a.m. A gallery in Venice, a two-story space, hosted *Single*. I molded each room in the gallery so that it looked like a different chapter in a story that was visual, perhaps David Lynch–like, with some linking images and elements and feelings but nothing linear or traditionally narrative. Live music was a breathing, beating part of it. The heart was the Alchemist's Room. The event was open and it was hugely well-attended, more than triple what we'd imagined. Everyone who entered signed a declaration that they took responsibility for themselves and were given a cylindrical glass bottle and told where to find the Alchemist's Room, where the Alchemist was mixing personalized cocktails. The Alchemist was allowed to mix only one drink at a time, and only one person entered at once. We announced that at 11:00 p.m., the next level would unlock. Every guest got three drinks beforehand, and the fourth drink was called the Elixir—that was the one with MDMA in it. Our team and the gallerist knew what the plan was (as did everyone else). We were very overt, but when so many more people came than expected, the gallerist started to freak out.

Throughout, I had team members disguised as members of the public doing scripted things that looked natural and organic but were shaping the mood. None of the guests realized that there were scripted actions taking place around them. For example, I made one space that I called the Room of the Moon. I installed soft white cushioning all over the room and a light on the ceiling that looked like a full moon. A performer would come into the room, appearing to

be part of the general public, and talk to people by opening a conversation, but always leading his interlocutors through his telling of a specific scripted story.

Before anyone drank their Elixir, I witnessed placebo effect taking place, people behaving as if they'd already taken the drug. I still don't have the words to describe the feeling. It was a beautiful, ethereal positivity. Every detail felt just right. It was pure magic, pure poetry. These defined the space and time that night. And that was before the drug was consumed. Once the Elixir kicked in, the euphoria escalated to another level, as if the whole space became a color-infused cloud. You might be thinking that we all got naked and had a giant orgy, but no. This is a clean euphoria that makes you hyperarticulate and open to exchange, an intellectual augmentation. Those magical hours until nine o'clock the next morning were some of the most beautiful events of my life. It was icing on the cake to think to myself, "And this is my art show."

Because I had to join the Alchemist to deal with the flood of people, I was able to greet and engage with every person who came. Everyone felt the need to confide in me. That's a lot of intellectual augmentation. By the time we were done, I was completely drained, not just physically, but the drug encouraged unburdening of dark weights. Hundreds of people had felt compelled to tell me what weighed on their minds, and it wasn't all sunshine and lollipops.

## WILL PEOPLE ABANDON OR BETRAY ME IF I ACHIEVE A LEVEL OF SUCCESS?

All sweet dreams come to an end, and this resulted in some rude awakenings in the week that followed. I'd been aware of the Catholic guilt that runs thick through Italian culture, but now it reared its head. Everyone had so enjoyed themselves that many felt guilty about it afterward—the gallerist especially. Then there were just a few bad apples who had attended with an agenda. They didn't like the cut of my jib and saw this event as a chance to stick it to me. This is, alas, not the least bit uncommon in the art world—or anywhere, really—and a bit of anticipation can be a good anticipatory defense. Everyone involved had all the signed declarations that each person was solely responsible for their actions. We had been overt that guests could be given MDMA at some point in the night as one element of the art project. But some of those who attended later claimed that they hadn't been told, that we'd "drugged them" without their knowing, and one of them even fabricated an accident after leaving the event, just so they could press charges. Running parallel, another Accademia faculty member had attended but left early, before the Elixir was consumed. He'd long been jealous

of my position at the Accademia, and when he heard that some of the people wanted to press charges, he jumped on the back of the sharks in the water and tried to get me fired.

By the time the sharks were ploughing the canals in Venice, I was back in Helsinki with Meta and Bela. So I was getting all this information over e-mail and by phone. What saved the situation for me was that my old mentor, Carlo di Racco, called me to say, "Jaša, this will all be okay. It will all blow over eventually, or the perspective on it will correct itself. Until then I'll defend your position. You won't be fired. But it would be best if you took a year off." I did take a voluntary one-year hiatus before coming back to teach at the Accademia. Even today this remains a local legend among students. When I give a lecture at the Accademia, I'm aware of unsubtle whispers at the back: "That's the guy who did *the thing*. . . ." This was, of course, an extreme reason for the jealous to have ammunition against you. Jealousy is inevitable once you start to be part of the public arena, have shows, get coverage, because you have something others do not and that they long for. This is, unfortunately, normal and to be expected. Just recognize that any act of jealousy against you is a sign that the actor is weak and feels helpless and that you are doing something admirable.

*The Lovest* period and its peak, *Single*, showed me how far I could stretch in terms of bending reality, both what you see and feel (a sculptural, architectural approach) and in terms of experience in space and time. Somewhere along the way I wrote or said, "The material I am most interested in sculpting is the spectator's memory."

With *Apnea's Rhapsody*, I wanted to explore the more elusive feeling of daydreaming, I wanted to bring night into the day: what I discovered in my nocturnes, *The Lovest* and *Single*, into a daytime reverie.

I had trouble with the installation. The space was tiny, a window shop, far smaller than I was used to. Whenever we started working, a client or guest would pop by to see Stephanie, and we'd have to pause operations. So I needed to think on my toes to figure out how to actually move ahead with the installation.

One night, when I knew Stephanie would be away, Luka and I wrapped the whole gallery in a wallpaper painting, which defined the space and turned it in the direction it needed. We kicked in an all-nighter, as I desperately needed to show how I worked. In comparison to my other projects at the time, this gallery was amuse-bouche sized. That's why I endured the first days, knowing I would pull a magic trick out of my hat overnight.

When she came back the next morning her jaw dropped and she called me: "Jaša, this is amazing—wow! What have you done to the space? I never knew it could become something so beautiful."

Imagine the head of the hospital storming into an operating theater, as the surgeon stands above a patient who is open on the table, and shouting, "Will the patient survive? He looks like a mess!" This is how I feel when I'm installing. Give me a chance to actually complete my vision and then we'll talk about whether it was a success or not. These days I don't let anyone in, aside from my core team, while installing, in order to avoid the unnecessary stress of such a situation, but back then I didn't have that luxury.

After the opening, the plan was to reproduce the photo from Helsinki. The perfect spot was on the roof above the apartment where Zipora—one of Stephanie's artists who showed me immense support throughout—lived. The idea was to reproduce the photo from Helsinki, but here in New York, on a skyscraper above Broadway—and it had to be exactly the same, the choreography of the movement. The wind was strong, pulling my umbrella wings. Each time I jumped off a table toward the edge, I had to look upward, which meant I couldn't see my feet and it felt like I was going to jump off the building. The midsummer heat was unbearable. And that day, Stephanie had organized a cocktail get-together with VIP buyers who wanted to meet me. A photograph was already in the show, but there was an empty black frame next to it in the gallery awaiting this second photo. And we just couldn't get it right, perfectly aligned and mirroring the first photo. I must have jumped one hundred times, but it just did not work. I was exhausted, and downstairs they were waiting for us. "One more, come on, give it all," Luka encouraged me. And I did, gave it all.

"Finally got it!" were my thoughts just before I landed on the table from which I was jumping—and crashed my leg *through* the table all the way to my groin. My first thought then was, "Oh shit, I just broke my leg," followed swiftly by "and I forgot to get insurance!" The pain was ridiculous. Fucking Icarus had fallen is how it felt. Somehow I extracted myself, with help from Luka (who was choking from laughter, the fucker), and lay on the asphalt roof, which was like lying on a frying pan on the burner. There were no bones sticking out—that was a good sign. I could already see a violet hematoma (roughly in the shape of Australia) forming, but it seemed like nothing was broken.

I entered the drinks event downstairs covered in sweat and limping like a wounded soldier. Needless to say, this made an impression on the buyers, who wanted to buy that photo even before they saw it.

The gallery was small, and I didn't have room to present many works, so I invented a system. I created an archive in the basement and made a printed catalogue of items that were stored there. Any guest could request any item from the catalogue and a staff member would bring it up and place it on the pedestal

in the gallery or hang it on a wall, first removing the one before. And each new work triggered a performative element planned for each artwork presented.

For instance, there was a cast of my hand made of a strange foam. The white-gloved staff brought it up from the basement, placed it onto the cement pedestal, and asked the person who chose it to close their eyes. With their eyes closed, the person who requested it would be caressed by it (the staff member using it as an extension of their own hand) while the staff member whispered in their ear, "As you shine I dance to your heartbeat."

I also presented myself in a rather unusual way at the opening. I engaged four people to pretend to be me, the so-called five Jašas. None of the people at the opening knew what I looked like, so I played with this. Stephanie and Primož were in on it, of course. Each of the Jašas was dressed in a white shirt, black pants, and a black jacket, with brightly colored socks. We all looked different. We were positioned throughout the gallery. There was live music emanating from the basement and we timed it so that when the music changed, which meant Luka coming from the basement and singing (which provoked some teary eyes), we would switch positions: four within the gallery (one standing next to Stephanie, one next to Primož, one being a bad boy and standing in the corner, one lying on the floor moving tiny pebbles around) and one outside (playing with an inflatable globe, an idea borrowed from Charlie Chaplin's *The Great Dictator*). Each Jaša was speaking with guests as if they were me. When the music changed and the Jašas shifted, it was clear to the public that something was up, but they were accepting of this, trying to unpuzzle it. Doing this can, in a best-case scenario, invite guests into your dreamscape and they'll fall in love.

## HOW DO I MEASURE THE SUCCESS OF AN OPENING?

I wanted it to be a poetic show, a new project, an opportunity to grow, with new work and the sort of complications and involvements that I have in all my shows that eventually push you to do something remarkable. I invite people to get on board, but honestly, selling is not at the fore—or rather, it comes as a logical consequence of showing good art. My advice, in terms of finances, is that it's best to settle all your bills the day before the opening and do your best to be in a situation where selling anything, making any money at all, is icing on the cake. What you don't want (but that you can let the gallerist worry about) is for an opening to *require* a big sale otherwise it's considered a failure. That's a setup for misery for all involved. Hope for the best, expect no sales, and settle the bills before the opening so you know where you stand and can enjoy the opening

and focus on the magic, especially if your work includes ephemeral elements. If you don't do this, then first Monday after your big day can be like eating nails instead of a fucking cheesecake for breakfast.

What counted for me was that people loved it and were outspoken in their appreciation. That's Romantic, but New York ain't cheap. And there's so much going on that a hit yesterday might not count anymore tomorrow. It was a critical success: *Art in America* listed it among "new shows to see" in the United States, but the art wasn't selling. Stephanie's husband was a strong supporter of mine. When he saw that the magical opening hadn't yet resulted in a sale, he broke the ice. He bought two drawings. I'm not sure what else he did, but many others sold almost immediately after. When I came back home, like a gangster in a film, I was able to smack a stack of dollars onto my kitchen table. Fantasy fulfilled.

A bittersweet process followed. Everything is based on what's next: an epic triumph, then, "Okay, what's next already?" We artists, this army of Romantics, accept this and must enjoy it. But it doesn't work all the time. You throw your heart out onto a pedestal and don't necessarily have the next beating heart ready to be thrown out there just a few days later.

I kept coming back to Stephanie and making new suggestions. I thought that what we'd done was a good start. Her goal was paying the bills to keep her gallery alive. My goal was to keep the magic alive. I felt that Stephanie was slowly dropping me, that my pushing for the next show was becoming pushy. I saw that I'd have to do this on my own.

You have to be open to connections and new relationships, to fish and see who bites. It happened to me that way, too. I found myself at an amazing party in a giant loft, waiting for Patti Smith to appear while Anthony of Anthony and the Johnsons was at the piano, and I met some people who ran an artist residency in Red Hook.

A space was available in Pioneer Works, a vaulting, hangar-like space that you simply can't find in New York. I had a chance to work there.

## CAN I CHANGE PEOPLE, OR WILL THEY CHANGE ME?

*Crystal C* began with a utopian idea about a drug. I wondered if there could be an elixir that could permanently provide the benefits of drugs like MDMA, that could elevate your best attributes in the long term. After *Single*, I knew the potential for a project to tear in different directions. I wondered if I could extend the MDMA-type heightened reality in a show without giving out drugs?

I would make it happen in two sections, first in Ljubljana and then at Pioneer Works in New York.

As opposed to strategies in previous projects, this time I was front and center with my concept and content. I walked the city with my black briefcase, and when I spoke with possible collaborators or supporters, I showed them elements of the developing installation as miniatures all centered around a tiny bottle containing a violet liquid.

This was a new phase for me, post-Primož (who had to close his gallery due to the 2008 recession) and everything else. The messy bits in Venice were settled. I was never formally charged with any wrongdoing and I wasn't fired from the Accademia, but I was on voluntary leave until things cooled off. So I was out there looking for new comrades. Two people who changed my life came my way. First was Michele. We'd known of each other but had never really engaged. He was an Italian curator who'd married and lived in Ljubljana and was just finishing an MA in London. One night during a dinner at a friend's place, we talked and decided to join forces. Together we went to Paris, and on the train on our way back we developed the concept of *Crystal C*—a new drug.

The other new person who bent my horizons was Rosa, the daughter of a famous film director. She joined the ride in a producer's role.

In Ljubljana, the *Crystal C* show was divided into two spaces. The second space was for a performance. It contained a mountain of speakers droning a bass sound that penetrated the body. I also used a flickering lighting system that would make you dizzy if you remained inside the space for too long. I tried to re-create the effect of a drug through art: sight, sound, images. There was also a kinetic chair, a sculpture that, every ten minutes, fell to the floor with a thud and then automatically rose again, only to fall ten minutes later.

In the first space, I showed the drug. We suspended a dead tree inside the gallery, with the canopy spread out across the ceiling. A natural "mirror" was on the floor, water arranged into what looked like shards or crystals. Half the trunk was cut away, and inside was a floating crystal vial.

While in Helsinki, Meta had made a sculpture from scratch that used electromagnetism to "levitate" a tiny white box that weighed 5 grams. I wanted Meta's help to make a similar but more robust machine that could levitate 250 grams, the weight of a glass bottle that would contain the liquid drug. Meta and her Helsinki colleague Otto built the levitating machine.

I came up with a team of close collaborators who helped to design the "new drug," or the "new drug cocktail," as we figured out later on. One of them was a professional "psychonaut," dedicated to experimenting with drugs, ideal doses, and new versions. A painter uses pigment to evoke emotions; a shaman

uses powders to evoke emotions. Not that different, really. I was interested in the experiment: Can certain feelings, notions, and emotions be distilled, sealed in a bottle and archived for later generations to come? Could a drop of this new drug communicate to someone the atmosphere of this passing moment? We laid out various scenarios, recipes for a new drug, with the effects they would induce. One of the challenges was to create a drug that would replicate a song I'd recorded with my Kalu and Junzi, also named "Crystal C." Everyone involved had to sign a non-disclosure agreement that they would never reveal which drugs were involved or what the recipe was. None of us took the drug; it was entirely symbolic and theoretical. The presence of the drug was what produced an effect.

If, in Ljubljana, we cut down a dead tree and reconstructed it into a monumental suspended "crown" in the gallery space, in New York we would bring a blooming tree from upstate and suspend it in the air. You can't just uproot a tree. It will tear. You have to slowly rinse off the soil trapped in the roots, then wrap them in burlap and moisten them constantly, as my dear friend, the Tree Doctor Erik, as I call him, instructed me. I chose a weeping willow, my childhood favorite tree. We would be able to keep the tree alive, floating in the vast project space of Pioneer Works with Michele constantly moistening the roots (what only true curators do), for three days before we would have to replant it.

The Ljubljana show was a hit. As I'd hoped, visitors emerged dazed, almost stoned. It consisted of two chapters, standing on the summit of a mountain in the first space (the one with the reconstructed tree and the suspended floating vial containing the drug) and coming down the mountain in the second (with the mountain of speakers). This summit and descent of a mountain analogy is what I wanted the audience to feel: The moment they experienced something beautiful, they had to face the necessary antithesis of it.

Setting up the show felt pretty much like it, too: going up the mountain, then those few exhilarating moments of standing on the top, and then you need to descend again. Down from the high, into the void, the doubt, the "what now?" It's the same path, every time—or at least it has been for me. Ascent-summit-descent-void-ascent. Again.

## HOW DO I NAVIGATE A SHITSTORM THAT THREATENS TO DESTROY MY PLANS?

I boarded the plane, knowing that the bottle I had in my suitcase could potentially send me to prison when I landed at JFK Airport. We studied all the pos-

sible ways of getting *Crystal C* to the United States. Personal luggage seemed to be the least risky. The levitating machine and other works were sent in crates before my departure. But just days before I was to leave, I got a call from my contact at Pioneer Works with the dreaded words:

"I've got good news and bad news."

The bad news was that they couldn't do my show. The good news was that my residency was still on. I was planning to fly to New York a few days after this call, so I said, "Let's sit down then and figure this out once I am there."

Once I set foot on the ground (having somehow slipped through customs with my drug cocktail undetected), I tried to reach Stephanie but couldn't. I was on my own to figure this out. I stayed out all night long, walking and thinking (and drinking). The next morning, without having slept (and having binged), I stormed on over to Pioneer Works, directly into my production meeting. I was in an extremely vulnerable position—we'd agreed on a monthlong show, and they were now offering no show at all because they needed to rent the space to pay their bills. I managed to argue that they had to keep their promise, even if it was a shrunken version.

I told them I just needed the show to run for at least ten days, cajoled that surely they owed me at least that. But all along, I knew that three days would be okay. Three days was actually the maximum time I could expose the unearthed roots of the suspended and blooming tree before replanting it, so conceptually it would justify the length. I didn't tell them that. We haggled. I started at ten days, they said no days, then I said, "A week."

In the end I got what I knew I needed: the three days.

I still needed financial assistance from a gallery, so we agreed that I would hold a private viewing of my works and (hopefully) with sales, I'd secure the funds to produce my show. That's why I was in town ahead of when my show was scheduled to be installed.

Know this: even a successful art project never has enough budget. But I rocked up at Pioneer Works and told them, "All right, guys, no problem. I'll figure it out." The only problem was that I didn't know how I would figure it out. So, I got the show back (the three-day lite version), but I needed to figure out everything else from scratch. Not to worry; for me this was, by now, a common refrain.

In a situation like this, you start flipping every goddamned stone in your head, even if you've already flipped them. During the night I would think feverishly, then I'd look into options during the day. It wasn't just about funding, but about logistics. New York being New York, bringing in a tree from upstate to the city was far more expensive than I'd anticipated.

I first laid out what I had. Who could I rely on? What tools did I have at my disposal? When the spotlight is on you, everyone is available, everyone wants a piece of you, wants to chat, wants to be part of the story. I knew this well by now. I'd seen so many highs and lows that I thought I should know better by now. But every new chapter in your life, which coincides with a new art project, results in new challenges and can make it feel that nothing has changed. But this is only how you feel in the moment. Then you look around you and realize that you are indeed standing in a completely different spot than the one you inhabited ten years ago. You are exactly where you wanted to be all along: fighting for your vision.

And I was not alone. I had a gang of incredible people I could rely on coming to New York to work with me on the installation and the opening performance. Most of my team were friends or more, there on a gentleman's agreement that I would pay them what I could when I could, but without pressure or expectations. Rosa found an apartment we could afford for everyone where I stayed before they arrived. One of the collectors from Stephanie's gallery, Matthew, who'd let me stay in his loft during *Apnea's Rhapsody*, was a comrade during *Crystal C.* He'd even picked me up at JFK and broken the bad news gently, and he covered the cost of the tree when I found the right one.

Once everyone else came (Rosa, Michele, Junzi, and Meta), the game was back on. We knew how to beat the odds, grinning in the face of impossibilities and making magic happen. So we buckled down and went to work at Pioneer Works.

The fact of a work in progress with the artist present and a team of people at work gives off the vibe that something incredible is happening, and others want to be a part of it. This was the case here, and soon the tide turned. Again Stephanie's husband was the one to break the ice. He came by one day and bought one of the new pieces I'd made in my first days at Pioneer Works. After that word got around, and I sold enough other pieces to cover the basic expenses.

The opening was a dream come true. As per my preferences, it was a "walk-in" dream. It began my extended stay in New York. Rosa was crazy enough to remain there, so she worked her magic once again and we dropped anchor on Avenue B in the East Village.

After three days, the weeping willow was planted in the garden outside Pioneer Works. It remains there to this day, affectionately called "the queen of the garden." Today she grows with implanted metal letters that read, "All in 1 body," with "we walk" inscribed on a plaque beside her.

# 8

## BEHIND BIG SHOWS AND BIENNALES

### What's It Like to Be in the Midst of Such a Big, Career-Defining Project?

Then I got it.

It must've been one of the thrilling, exciting, blood-rushing, out of my skin, rolling down the street out of sheer happiness moments of any life. It was 2014 and I was walking down Broadway near Myrtle Avenue in Bushwick, where I kept my studio with Rosa, my head of production. I was thirty-six. It happened when I recharged my pay-as-you-go cell phone on a Saturday morning while having brunch with my friends at the (in)famous Bizarre Bar (where I'd once seen a guy put a condom on the end of a broomstick, apply some lotion to his posterior, insert said broomstick, and begin to dance like a ballerina).

I popped into one of those semilegal phone vendors and topped up my account—and then it started flooding in. E-mails and texts began to pop open. I had the news.

I've been in too many situations when big news came, either by classic letter or e-mail, with the gut-wrenching "Dear Sir or Madam" that gets the heartbeat pumping, the rush of heat that hits your head, and then, as you keep reading, a brutal slap in the face: another no. You gasp for air and try to calculate in the few seconds remaining before you slip down the cliff face and into the abyss of self-pity, you try to restructure what you're doing, why you're doing it, and why you're doing it well. Every no feels impossible to compartmentalize. But this one was a yes.

Oh man, opening that e-mail. . . . It wasn't even official yet, wasn't even from the officials. It was from a curator friend, and it was just two sentences.

"Jaša, you're getting it. You're going to Venice."

It was the stretch of Broadway that has a dark, gritty allure, fighting against the bright sun of the day. I was laughing and crying and probably looked like a lunatic, hugging strangers, calling everyone I could think of as I rushed back to the Bizarre Bar. It was an out-of-body experience—that's the definition of ecstasy. I screamed inside the bar. The waiter was close to running out, thinking we were under attack. Rosa and Ayal were looking back at me in dread, expecting the worst, so I assured everyone, with a big smile on my face: "Don't worry, guys. I just got the Venice Biennale!" Soon enough a calm Saturday brunch (d)evolved into pitchers of mimosas, margaritas, and Bloody Marys. I had been living at the time in the close company of an army of cardboard boxes. There were three of us in less than 70 square meters, but half of it was occupied by moving boxes full of goods. We were on the verge of driving each other crazy in this temporary sardine-box living situation.

Artists are frequently in panic mode, and this happiness triggered a different type of panic. Not a nihilistic, existential crisis panic; no, this was about the monumentality of opportunity. The project that I'd vouched for had been accepted. It almost felt like that's not supposed to happen. Now I had to do what I'd submitted in the application. I was almost at double the budget, and I didn't know how I was going to pull it off. But I pulled myself aside and said, "Jaša, give yourself the chance to celebrate the opportunity you've been striving for for over fourteen years. Party like Dionysus. Then get the hell to work." Prolong the mimosa brunches, because they're few and far between. But there was work to be done. This was such an important platform, it's such big news for an artist, that here's a danger that a recipient will just float on the euphoria of having been accepted and feel like having been accepted is the same as having used the platform to one's best advantage.

I'd been lucky enough to have worked on the team that helped install my mother's presentation at the Venice Architecture Biennale back in 2002. Now it was my turn. I'd been watching Biennales for decades, so I had a good sense of what worked and why some people bombed there and after. Getting it was like winning an award for something you haven't done yet. Then you have to do it.

On the surface, getting into the Biennale is glossy, shiny, and fancy. Behind the curtain, it's mud wrestling. If you come in with only your Romantic ideas, armed only with a pencil and a sketchbook, you'll get your ass kicked the moment you step inside the ring. But here's the thing: you won't realize you're getting your ass kicked until it's over. You'll end up wasting the biggest oppor-

tunity of your life, still celebrating in the local bar on the corner, still coming up with excuses as to why your work wasn't received as you'd have hoped. It's an arena of velvet-gloved, subtle ass whooping.

## WHAT ARE THE LOGISTICS OF BEING IN THE BIENNALE?

Working at the Biennale means two things: working in Venice and working within one of the biggest exhibition corporations in the world, which is called La Biennale. People think of the Biennale as a matter of prestige, but it's actually an enormous business behind the veil.

If my ass is seated on a mountain of money, then I won't be so bothered if I'm charged ten dollars for a one-dollar box of chalk. But if I know that my funds are (extremely) limited, and I know that my path is lined with future traps that will compromise my vision, then I'll find a million reasons to be worried and pissed off (and not want to pay ten dollars for a one-dollar box of chalk). Venice as a context and La Biennale as a corporation is an expensive luxury location and a luxury business. Like many businesses, La Biennale is built on the sweat and blood and tears of countless worker bees, in this case, artists.

But on that day, at the Bizarre Bar, knowing that I was about to face one of the most challenging processes that would establish me—or not—as an artist, I needed, above all, my own personal strength. So I said one, huge monumental "Hurrah!" before the shitshow began. Commence legendary partying. That day, even the gods blushed before our decadence.

Monday morning I sat behind my desk (and a lot of cardboard boxes) with Rosa next to me, called everyone I had to call, and began a process that lasted a year and a half. When I see fear in my daughter's eyes, as she's old enough to understand when she's facing a tough challenge, and when I see that this fear simply blocks her, freezes her ability to think or move, I turn to an old proverb, which I butcher into my own saying: "When you're facing a mountain, you see the enormity of steps needed to reach the summit. The concept feels too big to handle. But shift your gaze away from the summit and down to your feet. Take the perfect first step. The best second step you can, and so on. It's all you can do, to take the next step as best you can. Before you know it, you'll have reached the summit."

After I called everyone I could think of, I spent four days on my own in my Bushwick studio to draw out, on a huge wall, a mind map. During those four days I plunged headfirst into my fears. It's natural at the beginning of such a huge process that you doubt *everything*. You question the size, the scope,

the complexity, and a part of you wants to strip it down, to make it far easier. Because it feels like the hard work was done—you finished the race and are *in* the Biennale. But that's really just the start. The blood oath we took as part of Crash in Progress was never to take the easy way out, to challenge each other and ourselves with both monumentality of ideas and exponentially increasing complexity, and without compromise if the outcome would be the better for it. We upgraded and expanded ideas beyond what had been greenlit, a habit I continue to develop and push even further in my own work.

## IS THERE A TRICK TO WRITING A WINNING APPLICATION?

To make my application eligible, I had to go into partnership with a museum in Slovenia (UGM), a team of people with whom I've worked in past exhibits in Maribor (Slovenia's second-largest city), for a simple reason: They were the hardest working and most realistic when it came to production of any team I'd worked with. I knew that they were probably the only ones who would not try to stop me when things looked impossible. The deal with them was that my studio and I would take over the main production for the Biennale installation. Another option would be for a museum or gallery to take the reins and invite in an artist. By now my opus operandi was as it had been since the early stages with Crash in Progress: heading my own autonomous production that oversees all aspects of an art project, establishing project-based partnerships with other individuals or institutions.

When I applied and lobbied for the project, the system went like this: Only eligible institutions (museums and galleries) can apply. They will pick from a pool of artists in their country who have already achieved a level of international recognition. The Biennale is organized by national pavilions and a curator's show, so the first step for an artist is to compete with other fellow nationals to be picked by a museum or gallery in their country, which then applies with them. In most cases there's a single artist from each country accepted. The application needs to lay out a plan of the whole production, a conceptual presentation (the curatorial premise, with a statement of the curator leading off) and how the proposed project links to the general statement of that Biennale. In my case the Biennale's title was *All the World's Futures*, and the artistic director that year was Okwui Enwezor, who was the first black curator of La Biennale.

There's no general advice for a winning application. To say that "it's complicated" would be an understatement. The process for an American application will be different from one in Angola, but each national art scene is a sort of

quirky, closed club. You first need to penetrate the barely porous membrane of that club to get noticed, to be considered of the highest level that country has produced, and then an eligible institution must choose you to work with. Then there are further politics at the national level, as you might have multiple eligible institutions in your country all competing against each other, and each institution will have recruited a lead artist. So first you compete against other artists from your country, then the institutions applying compete against each other. It's basically so complicated, involving a collaboration with the institution and a measure of who knows who, and it varies so much from country to country, that it's not a situation in which I can say, "These are some tips for the application."

The core of the process is this: every time you start a drawing or painting, you begin with a vision, an idea, a feeling, and then you strike forward to capture it. If you are technically skilled enough, and stubborn and resilient enough, you'll reach a satisfactory result. Initial idea = final outcome. What was in my mind is now present on paper or canvas. That can be okay. But the actual work of art, what we have been focusing on in this book, is not about skill and its manifestation, or about art that mimics something else. We are talking about art that generates realities, and the only way to achieve that is through a creative process. A great work of art usually happens when something goes wrong in that process along the slippery horizontal parallel lines. The idea somehow slips, and the slip enhances the final outcome beyond what you expected. That slip can make things worse, can turn you face-first into walls, can frustrate and excite you. But when you do achieve it, you'll know it, and that will be the best of your work. It's the difference between completing a drawing as an autonomous artwork and completing an artwork as autonomous artwork. The first challenge with which you grapple is your own consciousness (and conscience). The second is the people you are working with and the options they give you. Those people ostensibly helping you launch your vision will present you with problems and obstacles, and will hope you'll say, "Ah, it's okay" and compromise. That you'll make things easier for them. That you'll take the path of least resistance. The trick is how not to do that.

It felt like going to the Olympics, and that's a good equation, to consider the Biennale the Olympics of art. So I needed to get training, to strengthen my core. As you take steps to move what you have in your mind onto a piece of paper and then from that paper to various materials and media as an artwork, the best way to start is mind-mapping. Take all the initial ideas and put them on paper. Name them. What I sent in the proposal was how I'd guess 98 percent of art projects begin these days: a project proposal, a conceptual description and list of technical details. It reads like a manual for a nonexistent thing. You cannot show the

actual end product yet, but you have to be able to compellingly describe it with words. That's its own sort of challenge. It gets that much harder when you're talking about an architectural sculpture combined with a durational performance that is centered around sound, based on a written script, carried out by a group of fifteen people (or more), which you initially laid out over a six-page proposal. That ain't easy. When you get scared of all the possible failures and roadblocks, my advice is not to close your eyes in front of these fears and say, "Ah, it's gonna work"—because it's not. Instead, dive into the most negative, pessimistic thoughts so that you can imagine and visualize them. This will help you freak out less when they actually happen. Pushing away negative scenarios, hoping they won't manifest, and then being surprised when they do is a good way to get knocked on your knees by them. Forewarned is forearmed; forecasting is a good defense. Then you can prepare, psychologically and logistically, with "if-then" situations planned ahead of time.

So often throughout the years I've heard: "Jaša, that's too complicated; we've got to tone it down." But I realized that this was not a reaction for the greater good; it was to make it easier for the person who said it to me.

After a week of preparations, the initial meetings began. These were the first steps, where your vision can be knocked aside. You had a dream to make it in. The dream is a reality. And now you have to make it happen, pull the dream from your head and the paper. Then the question becomes, do you have the money or not? I knew going in that I was two to three times over my feasible budget.

## HOW DO BUDGETS AND COSTS WORK?

Budgets are assigned by your nation, so the big-gun nations might allocate over €1 million. Gregor Schneider's budget when he was at the Biennale for Germany was over €1 million. We pulled off *Dafne* for around €17,000. Slovenia in 2014 had a budget of €90,000. That sounds like a lot, but it's all relative. It has to cover the budget for making your concept happen but also all the logistical expenses, like actually bringing your creation to Venice and getting it to your pavilion in Venice (by boat), then for you and your team to live in Venice (which ain't cheap)—and let's not forget that you need to get yourself and your work *out* of Venice at the end. In between the in and the out, you've got seven months during which you need to support an exhibition. It's not required, but throwing parties and feeding and watering people is part of the tradition, and that is another big expense. The main nations show in the Giardini, while nations that joined the Biennale later on have to rent their own spaces for their

shows in Arsenale (the second main venue) or in the city. And this is when the corporate thinking of La Biennale starts, with crazy high rents. In my case, I was lucky, as Slovenia for the first time was moving from a small, obscure gallery in Venice and renting a space in Arsenale. But you need to calculate everything: Who opens the doors each morning, what will the electricity bill be, who cleans or takes out the trash.

I knew, based on my student years, what it means to work in Venice and where the traps lay. I was prepared, and I thought that Venice was corrupt. What I didn't know is how problematic La Biennale as a corporation was, nickel-and-diming every step of the way. La Biennale offers you everything, handling anything you need, but there's an absurd fee for each aspect. Hence the ten-dollar box of chalk. It costs money to load materials onto a boat, to transport them from point A to point B, but it also costs a separate amount of money to unload it from the boat, and to bring it the 200 meters from the dockside to your pavilion. As a David before this Goliath, you've got to go full-on guerilla. It was important to recognize that I did not need to *appear* successful at every step of the way. That's what winds up costing the most. Rather, I had to be smart. Save your fancy dance moves for the opening and the show itself. Get down and dirty for all the in-between bits, otherwise you'll be hemorrhaging budget. Add one hundred more to all the negative scenarios you predicted, because this is Venice—and Venice during the Biennale. Everyone who can will rip you off. But Venice is also like a foreign planet. Water is not normally a constant obstacle to setting up a show in Berlin or London or LA. In Venice, a city composed of hundreds of tiny islands connected by narrow bridges and water taxis, it gets weird and wild. I headed up the project from New York, building in Slovenia, just a two-to-three-hour drive from Venice, but I still needed three trucks to bring all the material we built to install it.

To give one example of how this can shake down, I got a quote in the thousands to bring the material from Ljubljana to Venice, which meant to the dock in Venice. It was made clear to me that when we arrived, I'd have to get it from the dock into the pavilion on my own—though I could, of course, pay a few hundred extra in cash and then the movers would be happy to do it all for me. There are also a few docks, only one of which has the hydraulic crane that makes moving heavy things so much easier; they could reroute and take me there for another few hundred in cash. . . . You see where this is going. Multiply that by seven months in town, and budgets can thin quickly.

Did I mention that you are assigned a pavilion, but then you arrive and see the state of that pavilion. I came to Arsenale, full of beautiful brick walls, but also a surprise: many drywalls that were already there and could be removed

or moved. A representative of La Biennale greeted me: Maybe I didn't want the drywalls there, or I'd like more of them? The rep said, "Of course, anything is possible. You just tell us what you'd like and we'll tell you how much it would be." Sounds good, but then you hear the costs. Setting up a 4-by-6-meter drywall box starts at a few thousand more than it should be. These are just the barebones of setting up the space as you'd like it. New lighting? Sure, we can do that; here's the cost. Longer cables? Sure, but we need to get official approval and here's the cost. "But we can resolve everything for you, skipping the approval steps. We can use our architects and teams"—they want you to say yes to this, because they earn more and it's less complicated for you. If you can spare an extra $100,000 just setting up the space the way you need it, no problem at all. Life will be easy. But most of us, most nations, cannot. You also can get on La Biennale's problem list if you don't acquiesce to their elegant bullying to pay up for their services. I told them I didn't need to use their architect, as we had our own on the team, and I could tell that this was the wrong answer.

Walking into a space that will host my vision is a mixture of "Wow, this is actually happening" and surveillance for problems with the space that I'll have to surmount or control. I knew the building process would be difficult, but I didn't expect such a business challenge. Anything that needed to be done had to be done by locals, who had an oligopoly and collectively agreed to overcharge, or you had to bring in your own people from abroad, which also came at a high cost.

For years I'd been building this a cathedral-like space in my mind. The shape and concept shifted, but it was always monumental. However it was morphing in my head, I was driven for years by a vision of being able to walk into a sculpture. With *Utter: The Violent Necessity for the Embodied Presence of Hope,* as my project was called, I wanted to also integrate a durational performance. So the installation aspect was the construction of a two-story sculpture that you could move through. It required a proper architectural core made of wood, with crossbeams and trusses. The first floor covered the needs of the performance team, ongoing live music, and performance; the ground floor was for the public. I thought of it as a house-sized instrument. The durational performance involved a weekly scripted series of events (performing six days a week, repeated twenty-nine times over the seven months) that took place in and around the installation. I wanted it to be present and active throughout. But before the performance side began, we needed to build the installation.

That's where the hardest part of my process started. Believe it or not, I found a solution to sorting out the space within our budget only one week before my last deadline to start the installation in the pavilion. One local contractor con-

vinced me that he'd be able to build what I had in mind, but it took him two months to make me an offer. He did this intentionally, I'm sure, delaying as long as possible so I wouldn't have time to look for other options and would have to take his overblown offer, which was nearly twice the entire project budget. This contractor was soothing and positive in the first meeting, saying everything is doable. I eventually flew back into Venice just to meet with him, those two months later, and he presented me, over a friendly dinner, with a quote that was five times beyond the budget I'd already told him was the amount allocated. Two months wasted.

We wound up working with Riko, a big international firm based in Slovenia that specializes in wooden houses. I met with our museum collaborators. Everyone knew I was over the budget. Half the budget went to building and installing the architectural form I'd come up with. The other half was the durational performance, a group of people living and working in Venice for seven months. The museum director had said, early on, that if it came down to it, we may have to choose between sacrificing the installation or the performance. For me this was like waking one morning, facing God, and being asked, "So, Jaša, do you want to keep on walking with the left leg or the right one?" This is when you face a room full of people giving you the stink-eye, saying that you're the only one who still says everything is still possible. Rosa, Michele, and I were the only people in the overstuffed still believing, with everyone else saying to us, "Guys, it's not gonna happen."

## HOW DO I ORIENT MY MORAL COMPASS WHEN IT FEELS LIKE PEOPLE ARE OUT TO TAKE ADVANTAGE OF ME?

My father once said that if I channeled my talent in the right direction—by which he meant a not-misplaced creativity (i.e., not starting fires in our living room)—I could make something amazing (as opposed to the career of a professional arsonist). The only thing that got me through these meetings was that I simply bluffed. I would offer up a smokescreen, saying, for example, "Not to worry; I've got the money lined up elsewhere." But at that moment, everyone in the room realized I'd been playing the various collaborators against each other. I'd say, "Oh, this collaborator is going to do it for less." Then I'd tell the other collaborator, "I've got more funding from the first one." Now, all in the same room, there would be no more of this hope-and-lie balancing act.

When I walked out of the dinner with the contractor who had quintupled the offer, dismayed by him but also by the people who had vouched for him, I did

not see a solution. When I faced the museum staff, I had to come up with a lie that things were still moving along smoothly. If they'd known, they would have blocked access to the rest of the budget. The deal was that I had free rein but they controlled the budget. The director (Breda Kolar) had said, "You do your own shit, be as crazy as you like, but you've already said on paper you're at triple the budget, and that's not gonna happen. So we may have to choose between performance and installation or the size of the installation."

Sometimes you just need to lie.

It may not be a straight-up lie, but you need to come up with a cover story that makes complete sense in your own head, one you know that you can somehow make work with those closest to you. It may take a lot of risk and can only be pulled off if you madly, obsessively believe that despite all the reality checks, despite the numbers that insist otherwise, you can pull it off.

I'm not trying to say that you should live your life on the razor's edge between truth and lies (or stretchy truths), but when you're trying to achieve something great, unfortunately, up to now I haven't experienced a way forward that did not involve tiptoeing on, around, under, and over the razor blade. The difference maker is the people around you. As it was with the Crash in Progress boys back in the day, and many others in between, now it was Rosa and Michele who made the difference.

Out of nothing, during that meeting, I came up with invented explanations of funds from nonexistent sources. This may sound like a suspect practice, but it's common in the world of big business. It sometimes seems that New York runs on it. You make up that you've got investor X in order to convince investor Y to back your project. When investor Y is in, you go back to investor X and say, "Look, Investor Y is in, are you?" Then you've got them both. Does this sound unethical? Amoral? We're in the legion of artists who try to make this world a better place, right? Make no mistake, this whole circus and subterfuge isn't about profit. It's about realizing a vision, a dream, uncompromised, for others to experience and enjoy. The only filter in the process of finalizing a project—since, actually, nobody knows precisely what is being made (sometimes even you, the artist, may not know for certain)—the efforts to rein you in are just as often about less work for other people as they are about actual budgetary constraints. People don't want to work hard. The museum was on my side, but it felt that nobody else was.

That said, I bought myself some time, boarded a plane and flew back to New York. I was back in the studio.

To create a work of contemporary art you have to take the business meetings, but then you also have to push them aside and actually work on making it, making the art. In big projects like this, most achievements come through collabora-

tion. I adore collaboration. It adds value, content, relevance. I can develop my own ideas. I can be inspired by others. It allows me to spread into media in which I don't feel I have the grounding, the talent, but for which I do have an understanding and a desire. Maybe the best example is music. I've always loved music. Recall my grunger days, early on. But it was never my 1A talent. There's nothing wrong with that. We shouldn't feel hemmed in to do only what we're good at, what comes easiest, what others say we should continue to do.

Too many upbringings include someone (even a well-meaning someone) telling you what you can and cannot do. Early on, I was told by a music teacher that I should stick to tennis and hum occasionally. If you're told that in your teens, it's acidic. It sticks and eats away. So my approach became: if you want to make music, work with professional musicians.

Another theme like that, throughout the years, was architecture. Due to my upbringing (recall my misadventures), I learned to hate it. But everything that you hate bores away at you. I was so bothered by the paradox of "just" the material facade and what, in my eyes, drove the process behind it: emotion. To me, architecture was never about bricks and facades and walls; it's about how you feel inside spaces defined by walls and other elements.

I felt that any given space—a gallery, a room, a wall, a floor, anything that was predetermined and already there when I arrived, someone else's work and vision—was a limitation or a precontext to my own vision, something I could not ignore. I wished to bend it, to somehow tune it to my vision, especially if I felt that it was imposing something I did not want, or could not integrate. In my early days, my attitude toward space and its rationalized drawings was to openly smear those arrow-straight lines with my own turmoil—to knock the blueprint lines aside, to redo them, to deconstruct the space I was given, or at least the perception of it.

It took me years of practice and experience to get to the point where I was able to actually move walls. Sometimes you can move a wall inside a building without touching it.

In *Utter*, I was able to take that idea to a new level and use both approaches. One aspect is what I did with the object as an architectural structure; the other is that the structure became home to a performance that endured twenty-nine weeks. I sought to enclose myself and those collaborating with me inside the artwork, as a statement.

For years, I'd been working with the idea of how far art can stretch when it comes to generating reality. I decided that it's not about redefining but simply defining that slice of reality that you do have under control. The scope of the Venice Biennale means that the reality I create is one that many will see.

In any artwork the question is, what are we doing with reality? Are we depicting it? Are we deflecting it? Are we reflecting it? A mirror comes to mind. A mirror tends to flatten what you perceive as a reality. We perceive reality through the possibility of movement within space. Mirrors are flat and static. I then thought of a broken mirror. The breakages offer more angles reflected, more movement, a closer reflection of reality. But who is leading this dance with reality that is the making and experience of art, leading through all the performances and events, which were becoming more experiences that proactively involved the audience? It wasn't entering a gallery and looking at some paintings on a wall, thinking about them, then leaving. Contemporary art, with its blurred lines between various media, with its temporal aspect, conceptual, performative, multisensory molding of space, a gallery as a three-dimensional artwork you move through—this is a new type of reality, more visceral. At the same time, it's both highly conceptual and less theoretical, since it involves feeling and being and moving, rather than just looking at and thinking about.

That's what I was trying to accomplish: How do you create something that is immersive, expansive, multimedia, and enduring?

I returned to my studio with the stress of knowing that the funds were not secured, that at any minute the project could be shut down, that a miracle was required. Extra work in the studio is one thing you *can* control, so I threw myself into work. That always helped me regain my footing, pumping my confidence back up, so that others could feed off that and make things happen for me. I felt the architectural sculpture getting better, progress being made. When I wrote a new piece of the script, when I drifted in the studio from a drawing to a line to a note to a photograph, when I worked on things on my own and with others, this all gave me the power to pull off the miracle. But it's normal that before you do that, it feels tougher than ever.

After concluding our final preparations in New York and as I was moving back to Europe to start on the finalized elements, I got a phone call while I was literally at JFK Airport. It was the commissioner of the project (Simona Vidmar). She said, "Jaša, as we agreed, and it saddens me. . . . We're not seeing the results that we agreed upon, that you promised. . . . We need to shut down half of the project."

I can't remember what I said or how I reacted. I said something to the effect that I was on my way back, that I was aware of the issue, that I was solving the issue with a meeting that was long ago planned. However, while there was a meeting planned, I knew it wouldn't solve anything. I was bullshitting, trying to stay afloat until I could come up with a solution.

My plan all along had been to collaborate with the construction firm that specialized in wooden houses, just what I needed. They had already bought

two of my paintings, and the owner prided himself on his support of the arts. I needed help making a wooden house-like sculpture and they liked the idea of saying that they supported a project in the Biennale. It was a perfect symbiosis. They had agreed to fully support their side of the project, which meant offering the expertise and material for building the architectural element. If they did that, then the museum just needed to support the performance side of things.

Agreements like this are made by and with people. This may seem obvious, but people can change their minds. The company team member who was our contact, the one who bought art for the firm, loved the idea of collaborating and the Biennale connection. She had said yes to the idea, but then circled back with lots of questions, dilemmas, and issues. It was a long game of ping-pong. I'd seen this before. The middleman (or woman) hired by a big company to handle cultural outreach wants the relationship with the art and the artist, to have lots of coffees, to discuss, to feel that they're having input. Sure. But when confronted with a mountain of a project, with all of its complexities, all of its creative collaborators, then it feels burdensome to have to deal with someone from whom the contribution is not creative but material, logistical, financial. This middle woman was complicating. We had agreed on a form of collaboration that, in this case, was simply technical. They had the materials and the know-how; could they support my project with that—as in, can I not be the regular client, paying thousands and thousands to get this shit done? The architectural sculpture that I came up with (along with my magical collaborator on the architecture side of things, Kuno Mayr) was complex, and the company were experts in it. With them, I also circumvented the risk of building everything on-site. The company would prefabricate the woodwork in their factory in a week's time.

The company had promised to fully support us, which meant that the woodwork skeleton of the installation had to meet engineering approval as if it were a public housing project for safety reasons. Initially I wanted the audience to be able to wander the ground floor and the first floor, but the development brought me to the decision to move all the technical stuff, especially the audio equipment that allowed us to make live music every day, following the score and the script, to the first floor and have the audience only on the ground.

## I KNOW I'M SUPPOSED TO "THINK OUTSIDE THE BOX," BUT WHAT DOES THAT LOOK LIKE?

I still didn't have a building team after the awkward dinner with the local contractor (let's say "asshole") who wanted to charge five times what we'd set. The

complexity of *Utter* was at another level of construction, not to mention all the other things we needed to get done. It wasn't just about building a structure; the structure would become an instrument in which we would perform six days a week for seven months.

I tried to be as accessible as I could with the company contact, but I wasn't as accessible as she liked, as I had so much work to do. Many people in positions of power, if they feel neglected, seek revenge. It's not a bad idea to have a "designated *putana*" on your team whose primary job is to go for coffees, cocktails, and very long lunches with backers, sponsors, investors, and buyers. We didn't have that.

The company contact one day said, "We're still able to do this for you, but you have to pay for it like a normal client." She threw a number at me just for the building, not even the material or the transport to the site; it was more than half of the entire budget, certainly not what I expected. The promise upon which the architectural half of the project was built was swept out from under me. The company had not yet made the structure. They needed less than a week, they'd said. It was about three weeks before the installation period of the Biennale started, when I was supposed to start building. The end of the installation period, which was a month long, was opening day.

I'd initially said to the museum director, in response to this, "Fuck them, I'll find the money." But I hadn't found any. This meant Rosa mapping out the budget and working who-knows-what magic to cover so many things, just one aspect of which was the architectural sculpture. The museum director figured that under the circumstances, we'd have to get rid of most of the performance and erect something like half the planned sculpture. That would have fit the budget, but sliced off the limbs of the concept, my idea, the dream. The museum commissioner then called me when I was at JFK. I kept saying to her, "I'll figure this out." I had no idea how. I spent the transatlantic flight obsessing and puzzling out what the hell I could do.

When I landed, Michele called me with more news. The only apartment we'd secured in Venice, with a very friendly rent, was no longer available to us. We needed a place to live for the whole duration of the project. We had literally one week to figure this shit out. Rosa was still in New York wrapping all the other aspects.

I did what I usually do in these cases. Some people would crawl in a hole and give up. I felt like doing that, and I do have moments when I can be immobilized by despair. In situations like this, I shift up a gear, into hyperdrive, ludicrous speed. It's what I was indoctrinated with in my time with Crash in Progress: Crash through the walls, even if we injure ourselves. So I started phoning

everyone I could, put whatever pressure I could on the company contact and everyone who had been involved in the agreement. I called her. My approach was to insist and be very clear about my expectations. This can come across as unpleasant, but it is effective. I was the "bad cop"; the museum team would be the "good cop." The result was that my museum team was able to make her reconsider. It resulted in her coming back with a more manageable agreement. They made us pay for part of the work, which was far worse than they'd promised but far better than having to pay for it all as if I were a normal client.

In the end, the company team built what we'd planned (though charging something for it), but they left us to get it from the company factory to the site and erect it there. So I went to the meeting I'd mentioned to the director on the phone, knowing it was hopeless. My meeting was with the technical department at the company. The only thing I had to offer was my vision: "Guys, I need you to be with me on this. You're my last resort." That was the approach I was supposed to use, that they expected. Just prior to the meeting a guy I knew vaguely, the company director's brother, approached me with a strange smile on his face. I thought, "Oh shit, another guy ready to fuck me over." But he whispered into my ear, "Sit through this meeting. It's not the meeting you need. After we finish, we'll go somewhere else. I have a solution for you." I looked at him with the guardian angel askance glance. He winked at me and said, "Trust me."

Such angelic interventions are not something you can expect or rely on. Heaven forbid. If you believe in the power of positive thinking, that might be one aspect of it: good people with good intentions doing their best and willing the fates to support them. But you'll hit for a low batting average if this is your Plan A. Every now and then a miracle will occur, and I've been lucky enough to have had a few miraculous interventions in my life, but this was totally out of nowhere, when all hope seemed lost, minutes before the final, last gasp, hope-stripped meeting.

The meeting was, well, weird. I walked in knowing that I had to just sit through it. I'd had this otherworldly reassurance from the director's brother. We walked into the room together and he winked at me again. The technical team was entirely professional in the meeting. They approached the project as they would anything for a client. It was like me, without a credit card, walking into a Mercedes showroom and sitting down with a salesman. I wanted their expertise; I just could not afford it. But I'd been told there might be a Mercedes waiting for me around the corner, down the alley.

After the meeting, the director's brother said, "Now follow me," and we adjourned to meeting number two. We went outside the main company building to an array of sample prefab houses that they built. Meeting two was in one of

them. He said, "I have a solution for you. An incredible master carpenter who's a positive, enthusiastic man. The guy for you."

I looked at him in disbelief and said, "But you know the budget I'm dealing with, right?"

"What's the maximum amount you can pay him?" I replied.

Then he said the magic words: "That's gonna be more than enough."

I couldn't believe my own ears. "He can pull it off?"

"He's a magician. You'll see."

We walk into this non-living room, a mockup high-end prefab family home that has never seen a family, just a showpiece. In walks the carpenter, Janez, with a smile painted across his face. With the jet lag, the stress, the barrage of information, this was all seen through the gauze of fatigue and felt surreal. Janez clapped his hands together and said, "So, what're we doing?"

I liked him right away. He was positive, funny, full of energy. I dropped the sketches of the installation on the table. "We're building this," I said.

"Yeah, I know it. I've seen it." He asked me only three technical questions, which made it clear to me he was not bullshiting.

I went on. "You need to know how I work. I'll be there the whole time, We'll follow the plan, but details and finishing touches I'll need to decide as we go. This is a sculpture the size of a house. Are you fine with that?"

He looked at me and said, "Not only am I fine with it, that's what makes it fun."

Everyone else was trying to lock me and the project down into X hours of work, saying that if we go off the plan, that costs extra, that there's zero tolerance to change anything on-site. Knowing that the process could involve change, they pumped up the price, anticipating that they'd have to make multiple adjustments and that each one would cost hours and money. Here was someone who expected and welcomed changes. I told him the budget. He was transparently not only okay but happy with it.

This was a secret meeting. It might have been on the company property, but it was entirely unofficial, sanctioned personally and unofficially by the director's brother, who saw the need to rescue the situation. Janez would be getting the budget personally, and he was more than happy with it. It was not going to the megalithic corporation that had millions in profit each year. My guardian *tekton*.

I'd been promising the museum director all along that I'd find a solution, without any idea how I would. Suddenly I had it. I walked out of the secret meeting and called everyone I had to, including the director, and assured them all that we're going forward full-tilt, that the architecture component was sorted. I knew that I had the whole installation, the equipment, and two

months of the performances covered. That was going to eat up all the budget, but I figured once it was up and running we could sort out the rest as we go. The museum director pointed that out, but I said I was aware and would run the risk at this point.

And so we started.

## WHAT'S IT LIKE TO BE IN THE MIDST OF SUCH A BIG, CAREER-DEFINING PROJECT?

Starting a project like this is always a cocktail of contrasting emotions. So much depends on you. To be honest, this is a feeling I adore. This is what got me into big projects since we showed ourselves that we could do it with *Dafne*. I said that it was the best high we ever felt. It's true. It was an adventure, a voyage into uncharted territories where "there be monsters." The camaraderie, the life-or-career-threatening challenges, friendship, love—and betrayal. All the makings of a great opera. It's a wire walk balancing success and complete failure. But somehow it always comes down to this: if you manage to gather a core of people, teammates in it for the passion, for a call that goes beyond the mere business attraction, then you know you're ready to set out on the voyage.

This is how I felt the morning I climbed into a van packed with tools, riding with Janez and his assistant—two almost complete strangers who, two days before, I'd decided to give my complete trust to pull this off. And off we went, from Ljubljana to Venice.

At the beginning we hadn't yet found an apartment, so Michele and I slept on friends' couches. I felt like I was a student again, back at the bottom, but with a project that couldn't be more at the top. This felt appropriate. I wasn't there to be handed a luxury suite, I was there to make some amazing art. There's something utterly romantic about getting up off a friend's couch, taking a cold shower in the early morning half-light, pulling on the same jeans you've worn for days, and rushing off to Arsenale to join the team at 7:00 a.m. and push, push, push to build dreams.

There's something about the sound of machines, the dust, the fresh breeze of the lagoon before the heat of the day hits. The city and your mind are still foggy, as you stayed up late drinking with friends. But your whole presence is present as it has never been before—part of the process I have always loved.

My production was a tiny pirate ship in a gulf packed with oversized commercial liners, each representing major art productions for national pavilions. We had to employ all the tricks I'd learned over the years on how to pull

something off against all odds. But by the time we'd finished, no one would guess from what we presented that ours was built and run on a miniature budget and the other installations in other pavilions had bundles of cash. If you compare your budget to others, it can either invigorate your guerilla stance—one you can take pride in—or it can crush your spirits, castrate you. We had a month to pull off a miracle, which is either a lot of time or hardly any, depending on your perspective. But I knew that we had to approach this as if the installation was happening in days, not weeks, which was by now my standard approach. So we kicked things off in the highest possible gear. I launch things on day one with all possible pressure but with an important distinction: I'm not asking other people to work hard while I watch and crack the whip. I'm the first in line, on the front lines. When I've worked for a long time to get the chance to work with collaborators to build what I've imagined, I will seize that opportunity with everything I have. That means that on day one, I ran into the space before anyone else had arrived, switched on the lights, plugged in the machines, rolled out the plans, pumped up the music, greeted each teammate with a smile, and started building with passion and pace. If I'm the leader, I want to lead by example. If you and your team are under stress together, it unifies.

Don't get me wrong: everything that could go wrong did go wrong. Miscalculations of materials we needed, misunderstandings in conversations and agreements, dialogues with other projects, and all of this boiling more rapidly as we approached the opening. We were the first project to start building and the last to stop in that section of Arsenale. If you think the art world is not about competition, look again. Don't be fooled by the glamor of big openings. Before it comes to that, behind the curtain it's the sleaziest dog-eat-dog fight you can imagine. Remember the Tonya Harding/Nancy Kerrigan knee-smashing incident? That's about right.

There was an artist working next to me who started his installation incredibly late. We asked the Biennale representative who would be working next to our space, as we were concerned about pollution and interference. They showed up very late and acted schmoozy and boozy, soaked in their own self-importance for being part of the Biennale and acting shocked and annoyed that all the work hadn't already been done for them, that they would actually have to work themselves. When the artist and his team saw the progress of our project, he decided that he would feel better if he could interfere with the progress we'd made.

In Arsenale, there are spaces for display where you don't have a section exclusively to yourself. The potential to step on toes is high. Artists also often like to change things as they go, and making compromises and shifting plans is par

for the course. The Biennale's contracts left everything to the artists to sort out among themselves—they weren't playing referees or parents to the potentially childish behaviors of the artists. Art wears a cloth of "whatever we're doing, we're doing it to make the world a better place." This is nowhere more pronounced than with the Biennale, which is meant to be the pinnacle of prestige. We're talking about the content, not about how things get done. When it comes to relations and working conditions, in my experience, the art world is as far as it could be from the pretext of beneficence.

## ARE OTHER ARTISTS AT BIG SHOWS COMPATRIOTS OR RIVALS OR A MIXTURE?

At the start, when everyone arrives, we're all wearing ear-to-ear smiles. You feel part of the biggest stage in the world, just happy to be there, seeing the crates and cranes and teams of artists you admire and never thought you'd share a stage with swooping around you, as you stare, in your work pants, smoking a cigarette and pinching yourself because you're actually here. Very quickly you remember—or rather, others remind you—that it's a competition, not just for who will win the Golden Lion for the best work of the Biennale, but for who will get the most attention while there, and subsequently whose career will be launched farthest and fastest thanks to this platform. Any group show has the same dynamic: smiles on the outside and rivalry on the inside.

When we arrived, Arsenale felt like a colossal abandoned movie set, a ghost factory. But the closer we got to go-time, the more life was pumping back into it, space being eaten up by other arrivals and projects. It was a great feeling for me to see so many great artists at work. I loved walking through vast spaces and watching other artists at work, and that observation was crowned by then climbing into my work clothes and feeling good about getting my own hands dirty. But I also observed a lot of people and teams and projects in crisis. When the initial can't-believe-it smiles fade, people grow frightened. Maybe this platform will showcase my failure and not my success? Maybe I underestimated the cost or work involved? And fear leads people to do nasty things to each other. All of a sudden, your failure is a plus for me in comparison. This is nowhere more evident than behind-the-scenes in the art community.

I was building next to the three other national pavilions. The one next to me came in very late. They saw that their installation space was inhibited by the progress of all the other projects around them. They tried to push me back. It started with getting regular visits from inspectors about fire and

safety regulations. They had registered complaints or suspicions and sought to slow us down by throwing monkey wrenches into our gears. Michele's role as curator shifted to a defender of our process against complaints by other teams. When he and I had to invest energy and time into useless meetings with officials and other pavilion teams, rather than putting it all into our artwork, it was a frustrating swim through bullshit. I remember a whole day lost to dealing with issues that weren't actually issues. They went away by the end of the day, but it was a day of work vanished, and it pissed me off. And when the other teams saw that they'd forced my process to stop for even a day, they felt they'd "won" that round. Once they even sent an inspector to check all the boots of our team to make sure they were regulation.

We were careful to follow the written Biennale guidelines down to the last sentence. But we had a strategy that I'd recommend to anyone.

I knew that I would need to demonstrate compromises to make the other teams feel that they'd won. But I figured out a way to do that without in any way hurting my project. There was jostling for space within Arsenale. That was the real issue. So I had us set up our lights in our section precisely along the borders of our assigned area. But I had in mind that the very outermost borders of our area were actually half a meter larger than I needed. But that's where we set our lighting, which was rigged nine meters off the ground. When we got into a heated meeting with the neighboring pavilions, I put on a show of angrily and reluctantly agreeing to move my lights—at great expense and inconvenience, I emphasized—in a half a meter. But, I said, if I'm going to do this, then you're going to have to do X, Y and Z. The X, Y and Z involved erecting barriers of light and sound to separate our pavilion from the others, so there wasn't installation pollution encroaching on our project. The other teams felt they'd won, that we'd caved and compromised and, this was implied, our project would suffer, which was a bonus for them. In fact, I'd planned for this and had this "yielding" in mind as a tactic.

On the day of the official opening, when the Slovenian minister of culture was giving a speech outside, when all the protocol was covered (something I managed happily to avoid, because I was performing), I was indoors, inside the installation, upstairs. On the far-left side, where I'd created a space of my own—a space that would become my go-to space for the next seven months, six days a week—I could see everything going on around us. I had a desk there, I could manipulate the sound equipment, I could work out the direction of the day, and I could meditate and gather my thoughts. That day, day one of week one, I was so extremely exhausted I couldn't stand up for long. I'd hoped for a

week's break between the end of the installation and start of the performances. The problems other teams created for us ate up this time, so our installation was finished only a day before the opening. I had to prep the performance component while still installing.

I changed into my black pants, white shirt, and brown leather shoes for the performance—my uniform for the next twenty-nine weeks. Instead of walking out, I lay down on the floor of this space of mine, which was just above where four giant bass speakers were located. I felt the soft rumbling of the speakers in the room beneath, me lying on its ceiling, as the speeches finished up outside. I just lay there, feeling like life was flowing out of my body, vibrating to the bass. I thought, *I made it to this point, but there's no way I can go on.* I did what my father always recommended: "Take a twenty"—give yourself a twenty-minute break doing whatever you need to do. My father would take a nap. Others might have a cigarette. I lay on the floor and vibrated and tried not to die. I wound up falling asleep. Let's call it a preopening power nap. As sleep, lovely sleep, slowly weighed upon me, I felt I'd slept not a moment and was too quickly drawn back into wakefulness. But what a wakefulness! I was vibrating on the floor of an installation I'd built, that I'd dreamed of for years, and I was about to perform at the fucking Venice Biennale. I sprang up, bursting with joy and energy. It was the best feeling I could imagine.

## WHAT'S IT LIKE TO ENJOY (OR MAYBE ENDURE) A BIG OPENING?

When it came to the opening week, if I'd known then what I know now, I would've acted totally differently. Consequently, I would've enjoyed it much more. I've done my fair amount of kick-ass, fully buzzed, crowded, explosive openings. I was experienced in it. I knew how to deal with the attention, the last-minute problems, with my own personal exhaustion. It's important to take a moment to recognize what you've done, to stand on the mountaintop and soak it in. At openings there's so much going on that you might find the moment of maximum satisfaction passes you by, that you're flitting around looking for approbation from others, when it should first come from within.

In Venice, the situation is unique. Everyone you've ever met in your professional life, working around the globe, somehow manages to come to the first week. They're there. Everyone. And because the Biennale is recognized as your having reached the top, everyone who comes wants recognition from you. I

wasn't ready for this. It was a beautiful thing, trying to give a little time to each person, but I felt it like pressure. Look, I know that if you want that big of a stage, you have to be ready for it and take it when it's offered. The Biennale is as close as an artist gets to playing Woodstock. But I made a beginner's mistake and turned into an "Oh, I don't want so much attention" artist. Long ago, when my father saw me during an opening I'd worked so hard for and had wanted so badly, but for which I was wearing the tired, clichéd artist's face—"Oh, I worked so hard and just leave me alone now"—he said to me, "If you wanted this, then be here with a smile on your face or don't be here at all." He was right, but we got into a big argument over it at the time.

That happened again at the Biennale opening. Instead of enjoying a family dinner after the opening, I ended up in conflict and with some family members in tears, with me feeling undervalued and misunderstood. It was a repeat of the evening when my father had told me that so many years ago, and with fifteen years of shows and openings under my belt, I'd have thought I had it under control. But the scale of this overwhelmed me and I reverted back into a childish reaction.

If I could do it now? I would glide above the floor on a cloud of extreme satisfaction. I would kiss everyone who came. I would hold every hug a moment longer. I would order dinner, choose the wine, crack jokes, wave to all who passed, jump around the table, tell stories, introduce various guests to one another, cover the bill, walk everyone to their hotel, and carry on to the next party. That would be the ideal first week.

The reality wasn't so different, but it was over-spiced and not to everyone's liking. I did most of this, but I was carrying an edge along with me, dragging it behind me, that I couldn't hide in a sheath from those closest to me, especially my father. He felt that, and out of care and love, he asked, "Is everything okay?" I could not grasp what was happening and therefore decipher and translate into a simple answer to his simple question. I should have said, "This is the most magical and incredible moment that I felt I was ready to fully enjoy, but I expect you to understand what I'm feeling even before I understand it myself. This is completely unfair of me, and the only thing I should do right now is shower you all with gratitude, happiness, and love." But at the time all these conflicting emotions ricocheted around inside me. I couldn't articulate it. I couldn't articulate that I couldn't articulate it. Instead, I offended everyone at the table by simply and pretentiously saying, "You can't possibly understand what I went through." The bullshit of a tired artist.

Creating an artwork is a process that usually asks you to go through many hidden passages, lonely moments of hard core and dry wood and cold wind and

other people fucking you over. You carry on because you have this lust, passion, and vision to create and to create something better. That's why you're in this muddy pit with all the demons blubbering beneath the surface while all around you everyone is saying, "Hey man, you did it! You pulled it off!" A part of you goes in reverse and selfishly wants to put people closest to you into a simulation of what you just went through. That's missing the whole point. But you're so tired and wired and peeled out of your skin that you can't articulate anything. You're not really aware of it; you're barely conscious. And this against a background of all of Venice celebrating simultaneously. The fatigue I felt was a level higher, perhaps, because this wasn't just installing an artwork and then watching what happens afterward. Every day I was performing, which is as draining as a sport or live theater.

This was also compounded because, at the Biennale, the spaceship of the VIPs, the art world elite, show up for pre-week and then fly off when it opens up for the general public. My plan was to make no distinction between pre-week and the general public and all of those twenty-nine weeks to come.

## HOW DO I KNOW WHO I CAN TRUST?

The core of the core was Rosa, Michele, and me. Then there were Simona and Breda, representing the museum. And then there were creative collaborators: Junzi, Kuno Mayr, Meta, Otto, Simone (as photographer), Lisa Vereertbrugghen (choreographer), Etan Nechnin (script coauthor), and Bowrain (a musician). Then there were a handful of other people involved. There was a gallerist who appeared to be helping us but actually sought to undermine our project to demonstrate that she needed a more central role in order for any Slovenian artist to succeed at the Biennale—and that required her receiving some of the budget allotted to the artist.

When we realized, only slowly, what this rotten apple was up to, I thought of *Hamlet* and the Mousetrap scene. We re-created it. We held a fake production team meeting. We shared good news: There's hidden money that we can get, since we're in financial troubles, we said, a second budget for the venue. Rosa, Michele, and I met with the cocurator to present the happy news. The cocurator's external calm was impressive, but I could read her well enough to see that she was boiling. This was a reference to the real second budget that she'd known about, because she'd always gotten it herself, but that we hadn't known of at all. She'd been caught in our mousetrap and failed to foil us.

I simply wasn't suspicious enough, and I'm still not, even when I've been burned on occasion. I guess the best advice is to trust your initial vibe about people, ask around about the experience others have had with your potential collaborators, and ask the question: Could I be perceived as an enemy by anyone on my team? It's inevitable that you'll find snakes in the weeds, but they'll teach you, as she taught me, how to defend yourself and rebound, catlike.

## HOW DO YOU HANDLE A DURATIONAL PERFORMANCE, ESPECIALLY WITH A TEAM?

I tend to put all the weight on the art part. This makes sense, but the business side of things is very present and necessary to handle. You have to manage people, working with and for and around a sea of people who will surprise you in myriad ways, positive and negative.

I wanted to feel direct feedback from the public, not through reading what critics write after the fact, when they're at home in front of their laptops, but by being present when the audience is present and feeling the vibe, as theatrical or musical performers do.

When I spoke to Michele, curator of the project, while still in preparation, I said, "This is why the person performing next to me has to be you. Because you're the official curator."

He looked at me and said, "Which means?"

"You and I will be the first two performers in the installation, six days a week, for twenty-nine weeks."

He took a long sip of dark, bitter espresso, swallowed noisily, looked at me, and said, "Okay." A curator performing in the Biennale show may have happened before. I don't know. We weren't in it for firsts and superlatives. But it felt it was the right thing to do. *Utter* was utterly unique, and we had to deal with our own challenges, not concerning ourselves with whether it had been done before. Our biggest challenge here was duration. Could it last, would the public interest last, could we last for such a long fucking time?

After the pre-week's frenzy, the density of people's attention, the pressure—a week that felt like it was drug-infused (alas, it was not)—out of the blue everyone was gone. Then a moment later, everyone else came: the general public. You might think that the first few weeks would be crazy and then it would get quieter, but no. The public came in droves throughout. As with theatrical performers or bands on tour, we used the first week to click together and lock into a clockwork pattern. We followed a written script each week, divided into six

days, then restarting after a day off. Every evening we ended with a complete feeling of triumph. There wasn't a standing ovation, as actors and musicians would enjoy to cap the performance (even if there were on several occasions). The feeling of elation was just insane. I'd collapse in bed each night and think to myself, *How the fuck am I going to do this another day? And another?* But I did, focusing my energy each morning; every day I was a rusty, under-oiled machine that needed many cranks to start. And those cranks kept me rolling through the performance and the inevitable parties each night. In between, an odyssey of small, precious, unique moments befell, things that are almost impossible to describe. Nothing about *Utter* sought to mimic life. Whoever walked into the pavilion on a given day felt like they'd walked into something in medias res, that they'd missed the beginning and, no matter how long they stayed, they'd never see the end of it. Just like life.

You had this huge installation, a walk-in sculpture, an instrument. As with any instrument lying in a corner, disused, that instrument was full of potential. You walked into halls of crisp, cold white walls, and you'd realize that the walls were part of a self-standing structure. The flat forms of the structure appeared to bulge out of a core. There were four entrances, and the audience could enter and pass through any of them. Inside was a contrasting environment: warm, yellow, and almost gloomy. There was a world's-end feeling inside, but filtered through a decadent salon-like feeling. There was no evidence of luxury aside from an old piano that had a mic inside it, while other ambient mics outside the structure captured and broadcast sounds. Traces of sentences were written in chalk on the floor. Writing these sentences was one of the repeating actions in our script. But the public would erase the chalk with their footsteps or with their bodies when they sat within the structure. The chalk produced an atmospheric layer of white dust hanging in the air throughout the space. The first-floor installation was called the "sound room," with a big, proper, many-channeled sound-mixing table. Every day we would use this to generate live sound, each day with a different score. The music was written each week by Bowrain, Meta's brother, an incredible musician, and there would be a mood of the day emphasized by certain songs that might run four to six minutes. But then we would play with the sounds, loop, add ambient noise, and let it spool out for hours. When it came to words, we would sometimes speak or sometimes project prerecorded words into the space, a disembodied voice. You might see a performer drawing a line, Sisyphean. Another time you might see someone poking a wall with a pencil, but since aspects of the structure, the walls, had mics integrated, the sound was hugely amplified and became a rhythm. The beauty lay in the architecture of these gestures.

I started keeping a diary from day one: "Notes on Accumulated Knowledge." I dreamed of turning this into a book that would reveal and share with many others all of the vast experiences and moments we had with the public in those twenty-nine weeks: how you navigate this electric chemistry experiment that all performances depend on, the magic that happens in the black box, the fairy dust that pushes the musician when he's already left his soul out there night after night, to go back onstage again and re-create it for a new public. I realized quickly that there was no way I could keep track of the complexity of individual experiences of the thousands of people who passed through our pavilion. Those feelings were destined to remain where they happened.

They were the most magical seven months I'd ever lived. The magic never happens on its own. You need to put all you've got into each performance, because for the visitors, this is the only piece of the performance they'll ever see. It may be the same for you, but it's brand-new for the public. There are many days when you don't feel like doing it, when you hate having to, when you hate the public because you just don't have it in you that day. Step one is handling your own emotional state. But as the main artist, you've got the responsibility for the others who are helping you fulfill your dream, which became the dream of the whole team.

At the beginning of each day I'd give just enough individual instruction to propel the situation, but I always asked how the team felt on that given day. So if I felt someone wasn't there that day, I'd try to use that for an action that allowed for an emotional absence. Each action of the day was scripted, and so I assigned performers (including myself) actions that seemed to suit their mood. The only thing that counts in performance is presence. A presence that resonates can be created through any extreme emotion, even anger, disillusionment, non-presence, not just openness and enthusiasm and eye contact. There were always at least three of us performing—Michele, Junzi, and me—but others rotated in, with as many as ten performers at once. One would always be in the sound room, working on the mixing board, while others would inhabit the ground-floor space.

An important element of the project was collaboration with students. Venice was where I was a student and where I'd since been teaching at the Accademia. It was my second home, and the Biennale represented my homecoming. I was living in New York at the time and I'd been globetrotting. Getting the Biennale gig was amazing in and of itself, but that much more so because it was a victory on my home field. It was special to me to have students participate as performers, too.

## WHAT CAN STUDENTS EXPECT IN TERMS OF INVOLVEMENT WITH A PROFESSIONAL ARTIST?

I'd been teaching part-time at the Accademia, as an adjunct member of Atelier F, the studio where I'd grown up under Di Raco's vigilant eyes. Di Raco was one of the first people I called when I was told I'd gotten the Biennale. I called to proudly share the good news. I also wanted to involve him in the project from the beginning. I wanted to share the experience of working on a monumental multimedia installation that entailed a dizzying array of production needs and involved a group of students.

It was a win-win situation. I got a group of sensible, talented young artists handpicked by Di Raco. There were fourteen of them altogether, but rarely were all present at the same time. Their number meant that they could rotate and I wouldn't be relying on them each day. They would be part of the ongoing process, get to see it from the inside. I would be a guide, a tutor. I didn't involve them in the difficult and potentially dangerous building of the structure itself. We left that to a professional team, as we did for the electricity, lighting, and audio. The students observed all aspects, and I'd make short presentations on-site explaining what was happening and why. I also kept them abreast of what couldn't be seen directly, for instance, talking them through the logistics of putting this all together, in order to show them how something as complex as this gets done. It was an experience I wished I'd had as a student and I was delighted to offer it to them.

Art students in any big city will visit the big galleries and exhibitions, but rarely do you get to see beyond what the general public does. They are like mirages or miraculous visitations. You see them as possible, but you don't often see what it takes to make them happen. You can fantasize about the day your exhibition will replace the one you admire at the big gallery, but unless you have hands-on experience, it's such a leap to go from "Wow, that could be me one day" to being able to actualize it and pull it off when the opportunity arises. Being an art student in a big city should offer more than what you'd get being in the same city but not as a student.

I didn't want them to just feel dazzled by the various pavilions; I wanted to help them stitch up the differences between the realities of the pavilions and artists so they could understand the variety of projects and budgets and what went into creating such installations. I was aware of the cliché that the main artist would let some students watch him work, as if that alone were a privilege, and the artist would take advantage of the free labor, and it'd be an ego trip for the

artist and a bit starry-eyed for the students. I vehemently did not want to fulfill this cliché. It didn't interest me. Never did. I demonstrably did the opposite of that and really let the students feel that I was nearer to their level than they thought and that I was there for them.

## HOW DO YOU JUDGE THE SUCCESS, FROM THE EXTERNAL POINT OF VIEW, OF YOUR EXHIBIT?

Every artist's wet dream is the following checklist: get a big gallery to represent you, be included in a big art fair, and appear in the Biennale. Simply being in the Biennale felt self-actualizing, but once you're in, you have to make a meal of it. Everything that I'd hoped for happened.

The public seemed to love my work. During the Biennale, though, everything was happening at such speed that I didn't have the time and headspace to follow it and realize what was going on. You hope for a certain exposure through Biennale. You hope for a series of approvals and pats on the back. Those came in the first week, and there was such an intensity and quantity of positive feedback that I was almost saturated. I started to feel I didn't need this now that I suddenly had what I'd long wanted. I had enough of the prosecco and schmoozing. I've been there enough, to enough fancy hotel couches and lux dinners and Bellinis at Harry's Bar. These were regular events during the Biennale. The taste of success is intoxicating. It can make you a better person and it can also turn you into an asshole overnight. Think of the stereotypes and they happen. The people who didn't like you, who you didn't like, who you thought wouldn't give you the time of day, all show up and want to be (or pretend to be) your best friend. At thirty-six, I was already a seasoned piece of meat before the Biennale. I knew the game. I spent days physically engaged while performing, nights relaxing and celebrating under the summer sky with friends, collaborators, and anyone who saw *Utter* and was moved enough to want to meet us.

The exposure provided by the Biennale led to great benefits. To mention but one, recall that we had only enough budget to cover expenses for two of the seven months of the Biennale. Our salvation came when the president, Duccio K. Marignoli, owner of the Marignoli di Montecorona Foundation purchased the initial preparatory sketches for *Utter* before the Biennale even opened. He became the number one fan of the project. He bought a large painted sculptural element (4 meters high), shaped like one cup on top of the other, that was outside of the main structure. The daily diary notes I was making ended up in five

notebooks. He purchased these as well, toward the end of the project. These sales allowed the project to continue through to the end.

How did I feel when it was all over? Exhausted doesn't describe it. I was elsewhere. What I needed was to grab my backpack, fill it with what I could, and set off on other projects as soon as possible. Some incredible opportunities to make art around the world opened to me—solo, with others, with the same team. I'd accumulated such a mountain of experience during the performance, those seven long months, I didn't have a clue what the next step should be. I don't even mean in terms of my career; I mean in terms of my artistic path. I was already imagining the next *Utter*-sized project, but even bigger. That had been the Crash in Progress approach and was still mine. Then I realized that I should do something that was the opposite of *Utter*. Something completely ephemeral. To let go again, to experiment, to be out there, unattached.

I flew back to New York and, among my various projects, I did a precious gig with Ulay, then off to London for Frieze, rollercoasting from spaces and concepts until I arrived at the Atacama Desert in Chile, where I was so far from everything (literally and in terms of headspace) that I was able to reset.

The Biennale had been a climax, but it was also a beginning.

# EPILOGUE

## The Endurance Strategy: Dance with the Bear

R elationships. It's the only word that can describe something as complex as making and showing art, of everything you go through on a daily basis, emotionally. You need relationships with people and institutions. And there are all manner of relationships between you and your thoughts, creations, materials, *your* creative process.

Here we are. Condensing all my adventures and stories to date has been a challenge. I've barraged you with information and now you need time. Time to digest, to grasp, to slide my story and advice into your own life and work and see where it is useful to you.

Look, though many an article will claim otherwise, there is no step-by-step system that will lead you to create a masterpiece or become a great artist. If there's any rule, it's that making art and being an artist is a process. As with anything that brings you somewhere, as processes do, it requires time. Working on this book, thinking about all the steps I took, you'd think I would say that I would have done many things differently with the clarity of hindsight. But my personality, my stubbornness, makes me still sleep in the same corner of the bed, and so I likely would not have done things differently, even if given the opportunity. The mistakes helped me become who I am and developed how I believe in art. Mistakes help you make it. There's a quote attributed to James Joyce that may sound a bit pretentious, but is actually resonant: "True genius does not make mistakes. His errors are volitional and are portals of discovery."

Mistakes are not something to be embarrassed about or to flee. Understand that the projection of success is mainly based on a projection of perfection:

unerring, all the right moves. But that perfection is an unrealistic, curated version of reality. Every artist who seems perfect has made, and continues to make, innumerable errors behind the scenes. They just show you the clean final result and hope you think that it emerged, whole, from the ether thanks to their genius.

This is not a new phenomenon in the art world. The Italian term *sprezzatura*, the idea that artists should never reveal the amount of effort that went into their creations—was important in the Renaissance. All should appear easy and effortless. It's the sort of facade that made Michelangelo frantically burn scores of his preparatory drawings to try to cover up the massive effort that was required to pull off his finished masterpieces.

I personally have always been most inspired by the artists who are able to show you the magic trick *and* how it was achieved at the same time. And there are many incredible creators out there who do not fear showing their hand. On the contrary. Not long ago I was on the fifth day of a laborious installation. I thought to add a few little grace notes that would take me about twenty minutes. Six hours later, I was still at it. I decided to hit the coffee machine and I stumbled, puffing and steaming, toward it. The curator I was working with was seated nearby. I grumbled aloud, "Why, after all this time, is it still so fucking difficult? I mean, every time I start a new work, I think it should go more smoothly this time, but it never does!"

"Jaša, magic is difficult," the curator replied. Then I rolled up my sleeves and got back to doing what I love.

Magic *is* difficult. Of course it is. Knowing more makes it even more difficult, because you know what it takes and how you could and should achieve what is needed—what the artwork you are dealing with demands. Experience helps you see better and makes you more demanding, or at least it should. There's a danger of plateauing and allowing yourself to coast along that horizontal: Once you achieve a certain status, you can get carried away and simplify things for yourself, making your life easier, by repeating a successful formula, emphasizing the popular appeal element of your work. You might rationalize that the more thoughtful and emotionally provocative elements of your work are things of the past, of younger, bygone punk days.

Bullshit.

Art is all about pushing the boundaries, going further, experimenting, discovering, questioning, doubting, celebrating, falling in love, falling out of love, losing yourself in the process, meeting people, losing them, moving on, looking back, feeling it, not feeling it, partying, waking up depressed, waking up un-

dressed, running like crazy, bumping into things and people, dancing like mad, in your own personal arena, in the studio, or in your mind, with your demons or with a bear in a tutu—flirting with danger, dancing with the bear, as I love to call it—while you scream, "I wanna live forever!" to everyone who's there to see it all, to be with you, to fall in love, to be loved, to stay, to stay for you, to stay for that fleeting moment or for longer, or as long as it takes or is given, when you are making it or about to, because you scored a hit, a sale or won something, as a whisper or as a rock-n-roll primal scream into a microphone hooked to a stadium sound system that broadcasts your euphoric state of mind through every possible channel to every living soul out there.

The reason we create is to make a legacy that will outlive us, to reach those who might never meet us.

Have I made it? I'm still making it. I'll never be able to say, "I've made it." I'm making it every day.

Making art is, always and above all, an opportunity to grow, to evolve, to move forward. Changing anything is hard, so it's only natural to have second thoughts when problems occur, to consider evading the extra work by asking yourself, "Do I really want or need this?" I mean, who will know in the end but me? I do not know what sort of state of mind accompanies you in bed at night, but I know that my mind will never give me rest if I feel that the process is not completed. It's a haunting. And if I do get this notion as I lay in bed at night, I will go against any possible tide to achieve what I feel I could do the following morning. Call it narcissistic, egotistical, pain-in-the-ass, pretentious—but we'll push against anything to make art.

While we run, we want to rest. When all is mad and blasting, we dream of quiet nights. Too much makes you doubt why you are in this whole thing to begin with. Not enough sends you to the edge of depression and despair. It's wire walking, bear dancing, chewing nails most Mondays instead of cheesecake, mostly uphill and yet incredibly uplifting and flying into moments of ecstasy when it's done, every day and all the time, when you live with and for your art.

There are no fixed rules because it is not a fixed or stable situation. It's a perpetuum mobile, a continuous and ongoing, never-stopping, ever-evolving process. It's a ride and it's always a bumpy one, no matter how many tools are at your disposal.

So you'd better enjoy it. The ride, not the destination. That's what you should tell yourself and that's what I tell myself still. I am as madly determined as I was when I worked on *Dafne* with the boys. Not much has changed, actually, when it comes to what can be achieved and why it should be achieved. Still, every

step I take, every new work or project, is an opportunity for change. For me now, wrapping this up and handing it over to you, concluding this precious process with a final sentence is, again, an opportunity to grow. To step out there with a big smile on my face and run swiftly into a new adventure.

Go.

# A Thank you

# FROM JAŠA

If there is anything I got wrong and if anything offended you in some way, none of it was done intentionally. We have changed a detail or two on purpose, just to avoid unnecessary misunderstandings. All the rest is true to fact, at least as I have seen and lived it. I wrote this book thinking of everyone who made me, everyone I had the privilege to meet and share precious moments with on this incredible journey. My love goes to all of you, even if you do not see your name inscribed here.

The format and purpose of the book did not allow me to include you all, as we had to cut out whole passages in the editing process, all in our pursuit of universality—of my story talking to as many as possible out there, those who do not know me yet.

To YOU, my dear reader.
To everyone else who knows I'll forever
bring them along in my heart,
one MORE big
thank you.　　JAŠA
1. 4. 2021

# INDEX